DIGITAL INFRARED PHOTOGRAPHY PHOTO WORKSHOP

Deborah Sandidge

WILEY

Wiley Publishing, Inc.

Digital Infrared Photography Photo Workshop

Published by
Wiley Publishing, Inc.
10475 Crosspoint Boulevard
Indianapolis, IN 46256
www.wiley.com

ISBN: 978-0-470-40521-5

Manufactured in the United States of America

10 9 8 7 6 5 4 3 2 1

For general information on our other products and services or to obtain technical support, please contact our Customer Care Department within the U.S. at (877) 762-2974, outside the U.S. at (317) 572-3993 or fax (317) 572-4002.

Wiley also publishes its books in a variety of electronic formats. Some content that appears in print may not be available in electronic books.

Library of Congress Control Number: 2009924576

About the Author

Deborah Sandidge has made photography a part of her life since she picked up her first camera — it has evolved into her passion as well as an award-winning profession.

Following her formal study of art and photography at the University of South Florida, she began dedicating her time to the art of digital photography, establishing a name for herself as a leading infrared photographer. Deborah is the cofounder and Creative Director of the League of Creative Infrared Photographers, (www.irleague.com) which was established to promote the joy, excitement, and creativity of infrared photography.

Residing in Oviedo, Florida, allows Deborah easy access to her favorite photography subjects: Florida's birds and other wildlife, as well as its landscapes. Her travels have taken her from border to border of the United States and beyond to yield photography that stretches the imagination. She has had the joy and privilege of photographing areas ranging from Namibia, Africa, with its stunning dunes, primitive tribal villages, beautiful people, and sweeping coastlines; to the cities and towns of Switzerland, Germany, and France with their rich history, majestic mountains, tiny churches, soaring cathedrals, and captivating night scenes.

Deborah's passion is not only capturing images of people, places, and things with her digital cameras, but also in the enhancing, creative work she does in the digital darkroom.

Deborah's tutorials have been published in *Photoshop Creative Magazine* and in *Digital Close-up Photography*. Her photography has been published in *Nikon World Magazine*, *Nikon World Calendar*, and in various Nikon publications and at photography events including PhotoPlus Expo, PMA and Macworld. An interview on her photography is published online at DoubleExposure.

Deborah was a featured photographer at the Orange County Administration Building in Orlando, Florida. Her creative digital image, *Cormorant Conversation*, along with photos from the Orlando Camera Club, earned Best Nature Portfolio by Nature's Best magazine for the prestigious Windland Smith Rice International Award 2008. The image was exhibited at the Smithsonian's National Museum of Natural History, Washington DC.

Deborah's work is represented by Danita Delimont, Positive Images, and Novastock.

Credits

Senior Acquisitions Editor
Stephanie McComb

Project Editor
Chris Wolfgang

Technical Editor
Joe Farace

Copy Editor
Lauren Kennedy

Editorial Director
Robyn Siesky

Editorial Manager
Cricket Krengel

Business Manager
Amy Knies

Senior Marketing Manager
Sandy Smith

Vice President and Executive Group Publisher
Richard Swadley

Vice President and Executive Publisher
Barry Pruett

Project Coordinator
Kristie Rees

Graphics and Production Specialists
Ana Carrillo
Andrea Hornberger
Jennifer Mayberry
Brent Savage

Quality Control Technician
Melissa Cossell

Proofreading and Indexing
Melissa D. Buddendeck
Broccoli Information, Mgt.

Acknowledgments

Rick Sammon, a well-known author and photographer has helped more than a few people get into writing books. I am one of them. His introduction to Barry Pruett, Vice President and Publisher at Wiley Publishing, resulted in this, my first book. So a big thank you goes to Rick and Barry.

During the production of this book, I worked with several talented people at Wiley Publishing. A special thank you to Stephanie McComb, senior acquisitions editor and Chris Wolfgang, project editor, for always being so enthusiastic and supportive of both my photography and words.

A special thank you also goes to Joe Farace for agreeing to be the technical editor for this book. His encouragement and support early on is much appreciated.

My sincerest thanks to the following people:

Lewis Kemper, whose friendship and encouragement is valued. Lewis provided Photoshop support and guidance, and contributed his skills through helping me, and providing wonderful infrared photos for the book.

David Twede, who has a brilliant mind and is a truly creative photographer. David provided expert advice and was the source for the graphs and charts comparison photos for the first chapter. I appreciate being able to ping ideas back and forth and always have a quick response.

Anna Cary, a kindred spirit who is just as likely to share web apps as dessert with me, and who so generously screen-shared to a higher understanding of the world of Mac.

The artistic Tom May, who always levels with me, helps keep me grounded, and makes me laugh.

Jyotsana Agarwal, a most gifted friend who shared with me the experience of spreading our wings to fly in our Carnegie course.

Dimitri Rellos, whose friendship, encouragement and perspective is a gift — "we're never lost, we're exploring new destinations."

The wonderful and talented contributors to this book: Kathleen Carr, Anna Cary, Joe Farace, Lewis Kemper, Jean Miele, Joe Paduano, Ken Sklute, David Twede, and Andy Williams. I am truly inspired by the excellence of their photography and accomplishments.

Barry Tannenbaum and Lauren Radigan at Nikon who have been supporters of my work. I appreciate the opportunity to be included in *Nikon World Magazine*, the Nikon World Calendar, and other publications and venues.

Will DeRooy, whose superb editing skills helped me immensely as I wrote this book. Will reviewed every chapter, making suggestions and comments that were invaluable.

A special thank you to my mother, whose tireless support, encouragement and phenomenal editing skills have helped me immensely throughout the creation of this book. Thanks go to my husband and everyone in my family for their patience, help and support as I delved into writing this book. I could not have done it without them.

For my mother, Sally Chambers, who read every word first and was my compass
throughout this book. You are a true wordsmith.
Thank you for always being there for me.

Contents

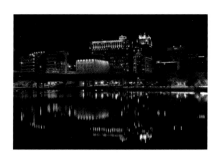

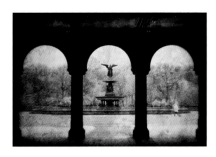

CHAPTER 5 Special Effects for Creative In-camera Images 85

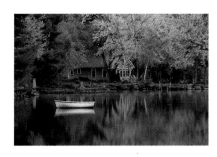

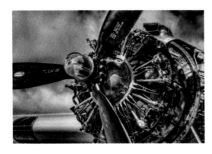

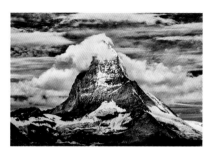

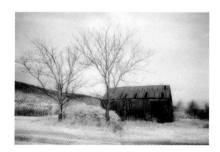

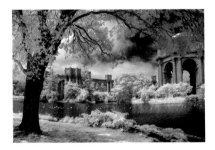

Introduction

I am so excited to be able to write this book and share with you what I have learned about digital IR photography. Infrared photography is easily attainable by the novice and professional alike. Why? Because it's digital! We have transcended film photography and now have the wonderful opportunity to be able to photograph digitally. No darkrooms, no chemicals, no worries about light leaking in and ruining precious film. We are free to experiment over and over; the learning curve is much less steep. We can truly be artists and are limited only by our imaginations.

Does digital mean you have to have fancy or expensive equipment? Not at all; some of my very favorite images have been captured using an IR-converted compact camera. I always have it with me.

Although I enjoyed developing film and making my own black and white prints, I feel much more empowered in the digital darkroom. The tools available are endless and ever changing. If you are able to communicate yourself through your photography, your photography will be able to communicate with others. Your passion will be projected in your photographs.

It's equally exciting to me to be able to open an image in Photoshop and be able to push the boundaries of traditional photography, to create an image that is more artistic than what was captured by the camera. Digital IR allows a lot of leeway with photography. We are not limited to what is captured by the camera. Not only can we create IR images that look like they have been photographed using traditional film techniques, we can create stunning images combining foliage rendered white by IR light with a vivid blue sky and endless other creative possibilities.

Throughout this book, I will be your guide to choosing a method to record in IR, whether that means purchasing an IR filter, or having your camera converted to photograph in IR. I'll walk you through the steps of creating a white balance preset, making the best exposure, and optimizing your images. You'll create beautiful panoramas and HDR images in IR. You'll have fun with various in-camera effects and find fulfillment in artistically enhancing your images in Photoshop.

The tools and techniques that I use are chosen because I love using them, they work for me, and I'm sure they'll work for you too. Use this book as a springboard to experiment and see what works for you! I'm a big fan of Capture NX, Photoshop, Nik, onOne, Lucis Pro, Alien Skin, and Topaz Labs. As I write this, I've come across new Photoshop filters that I'm anxious to explore and see the effect that they have on my IR images. Old images are gifted with new life when portrayed in a different way.

A Greek proverb states that wonder is the beginning of wisdom. It's a way to be inspired and learn more. Let your motto be "what happens if."

Please contact me at www.deborahsandidge.com if you have questions or just want to show me what you are creating in the world of IR photography! I'd love to hear from you.

Infrared (IR) light surrounds you — you just can't see it. However, when you use a special filter on your digital camera, it is capable of recording IR light. The camera can capture this invisible light to transform ordinary landscapes into something magical and ethereal. Compare what you see in normal light in 1-1 to what the camera sees in IR in 1-2. You can see how incredibly beautiful the world is in this different light.

Photographers from the novice to the professional can photograph in IR. And although you can't detect IR light in your surroundings, you can learn to envision its behavior and effects — see it in your mind's eye — to help you create surreal photographs that utilize its marvelous qualities.

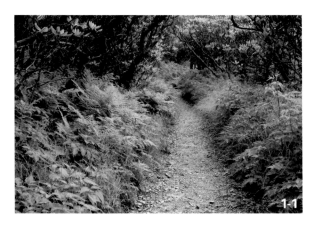

ABOUT THIS PHOTO *A winding path in North Carolina's Craggy Gardens creates an inviting composition in color. Taken at ISO 100, f/16, 1/6 sec. with a Nikkor 28-70mm lens.*

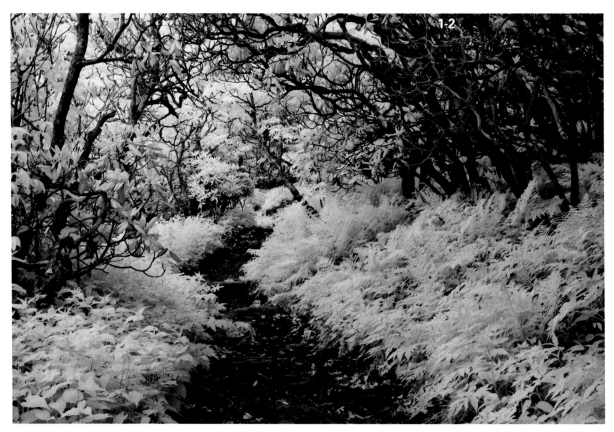

ABOUT THIS PHOTO *Photographed in IR, the same path shown in 1-1 creates a magical composition. Taken at ISO 100, f/16, 1/10 sec. with a Nikkor 24-70mm lens.*

WHAT EXACTLY IS IR LIGHT?

Like sound, light travels in waves. When its wavelength is measured in nanometers (nm) or billionths of a meter, the light you typically see ranges only from around 400nm (the color violet) to around 700nm (the color red). This narrow band, also known as the *visible spectrum*, enables you to see violet, blue, green, yellow, orange, and red colors, and all their combinations.

Light at wavelengths shorter than those for the color violet is aptly named *ultraviolet* (UV) light. Most UV light is invisible to the human eye. The IR spectrum begins at the other end of your range of sight, at wavelengths longer than those for the color red. The range of light from around 700nm

to 1,000nm is referred to as *near IR* because it is near the visible spectrum (1-3). Digital cameras can record light in this range when they have an IR filter in place. The sun emits IR light including UV and visible light. You can create exquisite photographs using IR light from the sun (1-4),

ABOUT THIS FIGURE *This chart shows the wavelength ranges of UV, visible, and IR light.*

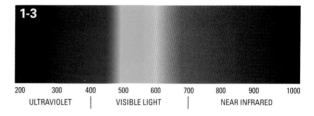

1-3		
200 300 400	500 600 700	800 900 1000
ULTRAVIOLET	VISIBLE LIGHT	NEAR INFRARED

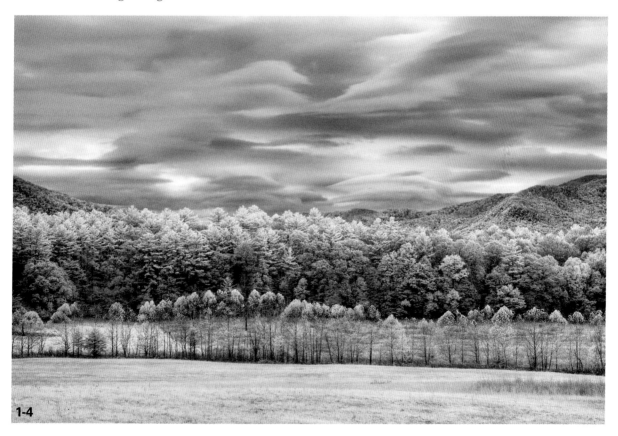

1-4

ABOUT THIS PHOTO *Cloud cover over Cades Cove in the Great Smoky Mountains, North Carolina, makes an exquisite statement in IR. Taken with an IR-converted camera at ISO 100, f/11, 1/25 sec. with a Nikkor 18-70mm lens.*

but light from sources such as candles or incandescent bulbs can also be recorded with IR photography. In other words, you can creatively photograph IR light at night (1-5).

SEEING IN IR

You can record invisible light using an IR filter (available at camera stores) on the lens of your digital camera. Alternatively, you can modify your digital camera by removing the *hot mirror* located over the camera sensor, and replacing it with a filter that allows IR light to pass through to the camera sensor. This is shown in 1-6. Either choice allows the camera to record the IR light that you can't see with the naked eye.

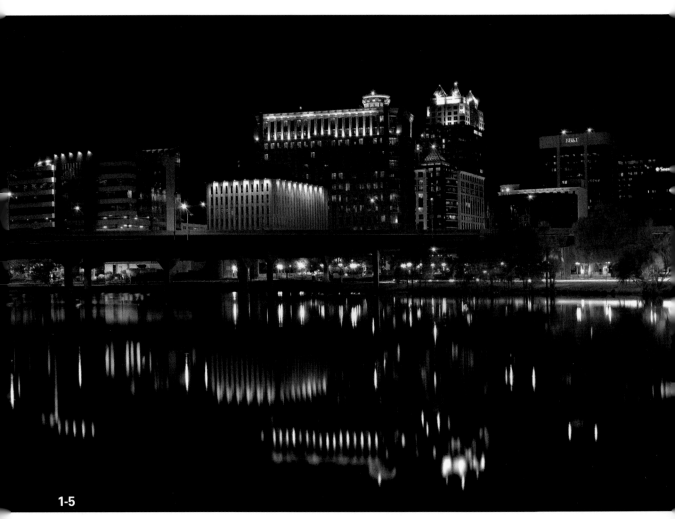

1-5

ABOUT THIS PHOTO *Night proved to be more interesting than twilight in this IR photograph taken in downtown Orlando, Florida. Taken with an IR-converted camera (enhanced color IR filter) at ISO 100, f/11, 13 sec. with a Nikkor 18-70mm lens.*

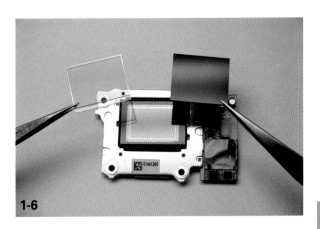

1-6

ABOUT THIS PHOTO *This photo shows the camera sensor, hot mirror, and replacement IR filter. © Life Pixel (www.lifepixel.com).*

A digital camera is a very sophisticated device. Its imaging sensor is responsive to wavelengths from about 350nm to 1000nm. It also can record ultraviolet light in the near UV range (1-7), and with a special filter, light in the near IR range. A digital camera is so sensitive that camera manufacturers place a hot mirror inside the camera. The hot mirror reflects most IR and UV light, serving as a filter, and transmits visible color by allowing it to reach the camera sensor.

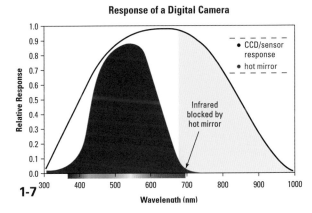

Response of a Digital Camera

- CCD/sensor response
- hot mirror

Infrared blocked by hot mirror

Relative Response

300 400 500 600 700 800 900 1000

Wavelength (nm)

1-7

ABOUT THIS FIGURE *This chart shows the response of a digital camera to UV light, visible light, and IR light.*

Using an IR filter on or inside the camera allows IR light to reach the camera sensor but blocks most visible and UV light. The camera can now record IR light and you can create stunning photographs in IR. A whole new world of creativity lies before you. You are an instant artist. When the natural color is removed from the scene, some of the reality is removed, and when some of the reality is removed, your pictures become more creative and artistic.

> **tip** With a little practice, composing for IR will become second nature. This is covered in Chapter 3.

From a photographic perspective, the world is captivating in an entirely different way. Many subjects reflect or absorb IR differently than they do visible light. In an IR image, the contrast range between the sky and clouds is often quite wide. There is more clarity in shadows, and bodies of water can appear very dark. Foliage appears white and is unexpectedly beautiful and unique.

Skin tones take on an ethereal appearance that is very attractive for wedding photographers and for fine art nude photography. IR photography can look similar to timeless black-and-white photography, yet there is something enchantingly unique about it.

With an IR filter, digital cameras capture light in the near IR range, recording how light is reflected and absorbed by various surfaces, not the actual temperature of the surfaces. When some people think of IR, *thermal imaging* (the capture of recorded temperature patterns) comes to mind.

A common misconception about digital IR photography, or even IR film, is that it records heat patterns or thermal energies — it does not. The much-coveted halation effect that is typically associated with capturing IR images using Kodak

high-speed IR film (HIE) causes a visible aura around the very light areas in a photograph. This is explained by the lack of an anti-halation layer on that specific type of IR film, and is not the outcome of IR light, body heat, or thermal energy. An example of the desired halation effect is shown in a film photograph (1-8) taken by professional photographer and author Joe Paduano.

Thermal imaging sensors, on the other hand, register IR energy emitted by subjects in the mid- and far-IR ranges. This is in comparison to digital cameras recording near IR light that is reflected from subjects. Two interesting applications for thermal imaging processors are night vision for the military, and enhanced vision systems in ultra-sophisticated business jet avionics that employ the use of mid- and far-IR light.

CHECKING YOUR CAMERA FOR IR SENSITIVITY

Many ordinary, unconverted digital cameras can detect IR light. To determine how sensitive your camera is, point your TV remote control at the

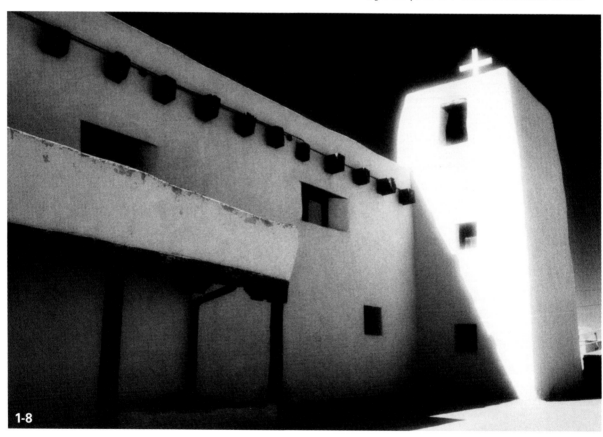

1-8

ABOUT THIS PHOTO *The much-admired halation effect that occurs with certain kinds of IR film is evident in this image Joe Paduano took of the Acoma Pueblo church in New Mexico. © Joe Paduano*

camera lens and press a button. If you are able to view the illuminated light on the camera's LCD, or if you can photograph it, the camera should be sensitive enough to record in IR with the use of an IR filter (1-9). Most IR-capable cameras that can be converted are listed on professional IR camera conversion company Web sites, such as www.lifepixel.com or www.maxmax.com.

ABOUT THIS PHOTO *This photo shows a TV remote control showing the illumination that the camera can detect (which is not visible to our eyes).*

1-9

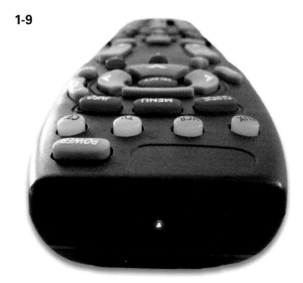

METHODS OF RECORDING IR LIGHT

How do you capture something you can't see with your own eyes? Basically, there are two methods that enable you to shoot in IR. You can place an IR filter (1-10) on the lens of the camera, or you can have a digital camera converted to photograph in IR only (1-11). The former requires long exposure times and the camera may not autofocus or auto expose properly. The latter is more expensive, but the camera operates normally with the major exception being that you can no longer use

it to capture images with visible light. The difference in cost may be well worth the investment considering the cost of a premium 77mm IR filter.

1-10

ABOUT THIS PHOTO *An IR filter in place on the lens of a digital camera.*

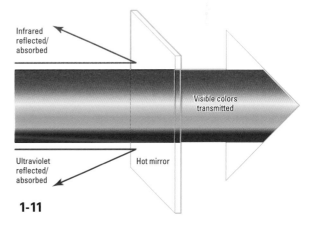

Infrared reflected/ absorbed

Visible colors transmitted

Ultraviolet reflected/ absorbed

Hot mirror

1-11

ABOUT THIS FIGURE *The function of the hot mirror in a digital camera is to prevent UV light and IR light from reaching the camera sensor as shown. In the IR conversion process, it's replaced with an IR pass filter, which blocks most visible light.*

In either case, each method allows the camera to now record invisible light — the IR light that is allowed to pass through the lens to the camera's sensor. With an IR-converted camera, the filter that blocks IR light is removed and replaced with an IR filter that blocks nearly all light except for IR.

IR FILTERS

You can choose from several types of IR filters. A numeric system called *Wratten* is used to identify IR filters and can be a bit daunting especially when combined with many filter manufacturers' own proprietary numbering systems. The simplest way to understand how an IR filter functions is to look at the filter number. The higher the number, the smaller the amount of visible light that reaches the camera sensor.

For example, a filter labeled R72 means that the cutoff point for visible light is 720nm. This filter may also be called a Wratten 89B. It offers a good mix of bright foliage and some color.

If you choose a filter such as the 87C (830nm), the cutoff point for visible light is higher, producing an image that has more contrast in IR, the brightest foliage, and very black/white IR images. Singh-Ray (www.singh-ray.com) produces an IR filter called the I-Ray, which blocks most visible light.

The 665nm filter is often referred to as the *enhanced color filter*. This filter allows the most visible light to reach the camera sensor and creates an image that is very detailed and has many options for creative color use. The tradeoff may be noticeable on cloudy days where the foliage appears less white than with the 87C (830nm).

In a nutshell, the 665nm filter has the most color options; the 720nm is the most common and can be used for the blue-sky effect; and the 830nm allows the least amount of visible light, which creates strong black-and-white IR images. Comparison photos of an image in color and in IR, using the R72 and 87C filters, are shown in 1-12 and 1-13, and 1-14.

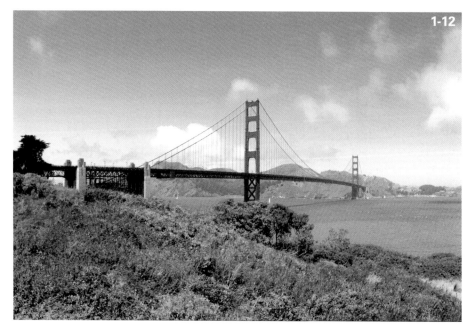

1-12

ABOUT THIS PHOTO *A color photograph of the Golden Gate Bridge, San Francisco, California.* © David Twede.

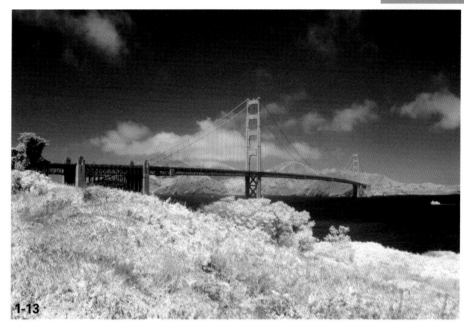

ABOUT THIS PHOTO *A photograph of the Golden Gate Bridge using the standard R72 filter. Images produced using this filter can achieve the blue-sky effect with enhancements in Photoshop, or can be converted to black and white. © David Twede.*

1-13

Each filter is very dark red, almost black. When you use an IR filter in front of the camera lens, exposure times are longer because the hot mirror is in place and doing its job to block IR light. Once you attach the IR filter to the lens, it is so dark that seeing through it is impossible. You'll need a tripod for the long exposure, and a cable release to prevent camera shake. This unfortunately prohibits spontaneous, in-the-moment IR photography.

The filter you choose depends on your desired outcome and budget. I used a Hoya R72 filter (1-15) until I had a camera converted to photograph in IR. The filter is easy to use and provides great results.

x-ref | You can create the blue-sky effect discussed in Chapter 8 with an R72 filter.

You need to consider some factors before purchasing a filter or having your camera converted. If you are just starting out, you may want to see the effect of IR photography before jumping in and having a camera converted. The lens you use most frequently will determine the size of the filter, and in turn, the cost. If you purchase a filter to fit a 77mm lens, it can be quite expensive and the incremental difference in cost might be better put toward converting a camera. If you use a filter on the lens of a compact camera, you may find that the camera's lens lacks a lens thread. It may be a bit of a challenge figuring out an adaptor system to allow for the use of an IR filter.

You can purchase IR filters online from companies such as LDP Net (www.maxmax.com), Adorama (www.adorama.com), B&H Photo (www.bhphotovideo.com), and Singh-Ray (www.singh-ray.com). I discuss converting a compact camera in the next section.

ABOUT THIS PHOTO *A photograph of the Golden Gate Bridge using the 87C (830nm) IR filter. Very little fine-tuning in Photoshop is needed. This filter is great for black-and-white IR images with good tonal range. © David Twede.*

1-14

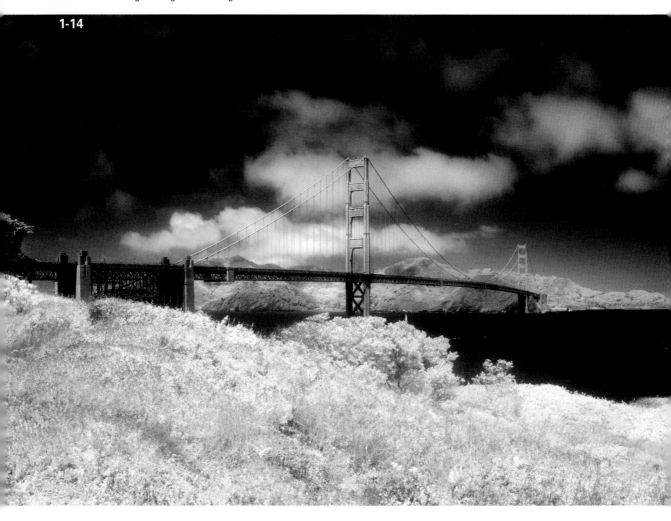

1-15

ABOUT THIS PHOTO *The readily available Hoya R72 filter mounts on the camera lens.*

IR-CONVERTED CAMERAS

Quick and candid IR photographs are best accomplished with a converted camera. The camera functions just like an ordinary camera with similar exposure times but without slow shutter speeds that require setting up a tripod.

If you have decided that you want to be more spontaneous and tripod-free, then camera conversion is the choice for you. There are several

companies (Life Pixel, LDP Net, among others) that will convert either your digital single lens reflex (dSLR) camera or your compact camera, or both.

Capturing in RAW format is desirable for the serious digital photographer, but many compact cameras photograph in JPEG and cannot photograph in RAW. While JPEGs are smaller in file size and take up less space on a memory card, there is less flexibility because the dynamic range is often reduced with the JPEG format. Therefore, many adjustments, such as white balance, exposure compensation, and recovery of over- or underexposed shadows and highlights, are unavailable in post-processing unless you open your JPEG in Adobe Camera RAW 4.0 or later. This capability was recently introduced in Photoshop CS3 and allows for only a limited amount of fine-tuning with JPEG files. On the plus side, compact cameras fit in your pocket, and they're easy to bring everywhere — just point and shoot.

Following are some of the advantages of having your dSLR camera converted to photograph in IR:

- The camera can usually record in RAW format for better image quality.

- The images have less digital noise than if you were to use an IR filter or a compact camera in JPEG format.

- You can adjust and fine-tune images in RAW, such as recovering under- or overexposed images.

x-ref

You can find more information on the RAW file format in Chapter 2.

Another benefit to a converted dSLR is that you can use your favorite lenses, and you don't have to purchase a filter for each lens. Note that you may need to manually focus for different lenses. Life Pixel provides a standard lens calibration or you can choose a specific lens to be calibrated to autofocus in IR. An IR filter is now inside the camera and you can hand-hold the camera. There is a huge advantage being able to look through the camera viewfinder and easily see and compose your subjects. A tripod isn't necessary unless you intend to use longer exposures — the same as color photography.

If you have a digital camera that you're no longer using (perhaps you upgraded to the latest and greatest model as the older camera no longer suits your needs) this is the perfect opportunity to convert your old camera to an IR camera.

It is possible to convert your own camera, but it requires a measure of comfort in disassembling and reassembling sensitive electronic camera parts as well as a steady hand — not to mention a dust-free environment. If the engineer in you wants to attempt it, tutorials and resources are available online. You can purchase IR filters to use inside the camera through Life Pixel (www.lifepixel.com).

Life Pixel converts a wide variety of digital cameras using various conversion methods, ranging from enhanced color IR to standard IR and deep black-and-white IR. They adjust the focus for certain Canon or Nikon lenses so that autofocus can be used, or a custom calibration is available for a specific lens of your choice.

LDP Net has a great range of services and products, including IR camera conversion and IR filters you can use on the front of the lens. LDP Net also offers a wide variety of ready-to-use dSLR bodies and compact cameras preconverted to IR. They also provide IR flashes for various cameras such as Nikon and Canon.

Assignment

Starting to Capture in IR

I created my very first IR photograph using an R72 filter. I took a photo of a bottlebrush branch on a black background. I was surprised at how much detail there was in an image that was basically shades of white.

For your assignment, photograph both IR and color images of the subject of your choice — a landscape, a lake or pond, the sky, or people. View both color and IR images on your computer monitor at the same time and compare the differences. Note the most significant differences between your color photograph and your IR photograph. What surprises you most about the differences? What inspires you and what would you like to try for your next IR photograph?

For my example, I liked how IR enhanced the definition of clouds that surrounded the majestic Matterhorn in Zermatt, Switzerland. I used a camera that was converted to IR using the enhanced color filter, and then converted the image to black and white in Photoshop, giving it a timeless, traditional look.

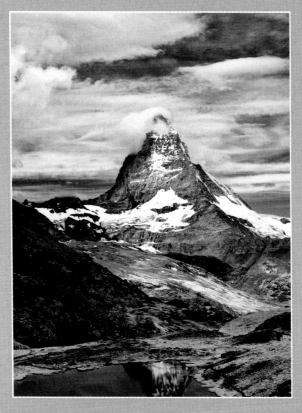

Remember to visit www.pwassignments.com after you complete the assignment and share your favorite photo! It's a community of enthusiastic photographers and a great place to view what other readers have created. You can also post comments and read encouraging suggestions and feedback.

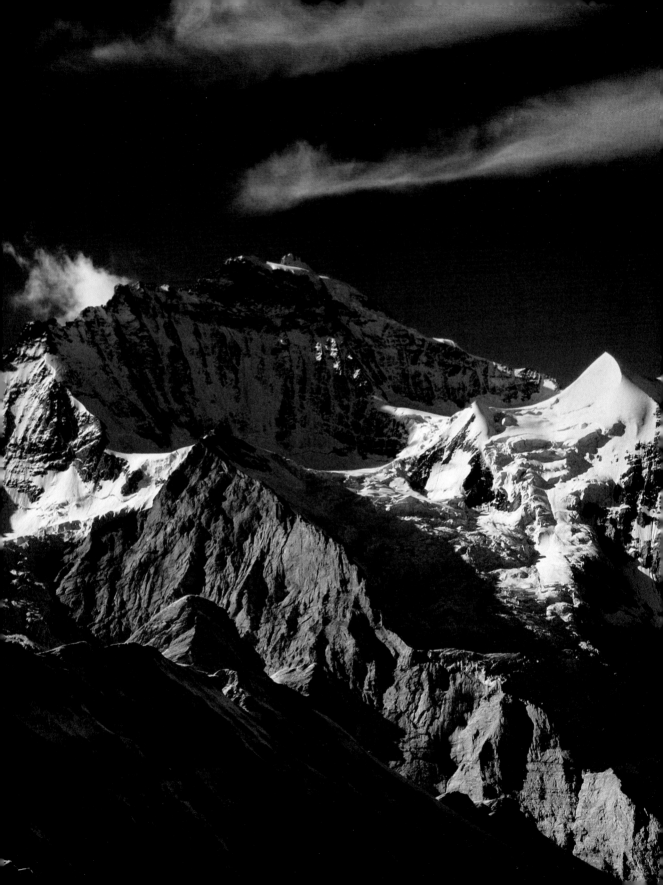

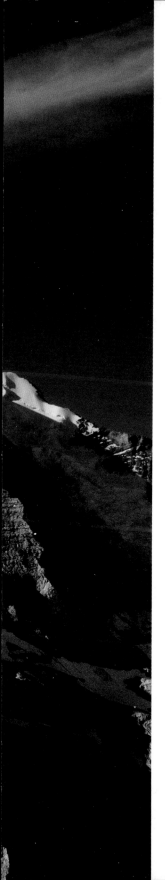

VISUALIZING AND CAPTURING IR IMAGES

IR photography can give you a new outlet for artistic expression by allowing you to shoot traditional subjects in novel and interesting ways. When you shoot IR, you employ many of the same techniques and skills you use with color photography, though the IR image looks much different.

In this chapter, I cover the important setup steps to take to get the best possible in-camera exposure — along with techniques that will expand your creativity.

I discuss the various settings, shooting modes, and file formats that you can choose when using an IR-converted camera, or an IR filter on a digital camera. I cover white balance and how it relates to IR photographs. Unlike standard color photography, you will see how shooting midday can give you dramatic results (see 2-1).

In this chapter, you will learn how to fine-tune an exposure and the pros and cons of shooting in RAW or JPEG. I also cover the all-important histogram on your camera's LCD screen, and show you how to use the histogram's information to your advantage.

You can create beautiful images in IR with an IR-converted digital camera or by using an IR filter on the lens.

COMPARING RAW AND JPEG FILE FORMATS

Depending on your camera, you may have the option of choosing which image file format to use for recording your photographs. Shooting in the RAW format simply means that your image is unprocessed data, or "uncooked." No data is discarded from the image with RAW as it is with JPEGs. Using RAW, every bit of data is kept and is adjustable with RAW conversion software.

JPEG stands for Joint Photographic Experts Group, the name of the group that created the standard for compression of photographic images. When you use JPEG format, the camera software discards a portion of an image's information. During the processing and compressing of the file, the software eliminates some of the image data, mostly in the highlights. These over- and underexposed areas that are discarded are not recoverable, and any changes you would like to make to the image become more challenging in JPEG format.

Most often, it can be advantageous to work in RAW format instead of JPEG; take at look at the differences. For starters, JPEG images are 8-bit files and only contain 256 levels of brightness, whereas the 16-bit RAW file contains literally thousands of levels of brightness.

However, with the JPEG setting, your photos take up less space on a memory card and on your computer. This means JPEG files write faster to a memory card and open faster on a computer. This format is great for family snapshots. Newspaper and wedding photographers often photograph in JPEG as they rarely have the time to devote to post-processing RAW files. For journalistic purposes, the images are ordinarily used immediately. These photographers can use JPEGs because, with their experience, their exposures are usually quite accurate. RAW files are much more forgiving for the rest of us!

The photographer who wants to have the most post-processing options needs every bit of image data possible — this is why RAW rules. Post-processing is an important part of the digital photography workflow. Having all the data to work with gives you the ability to change white balance and exposure, as well as to fine-tune and make adjustments to the image. This includes processing images for High Dynamic Range (HDR), which I explain in Chapter 6.

ABOUT THIS PHOTO
McKee Botanical Garden, in Vero Beach, Florida, is a tropical paradise for photographers. A vivid blue sky allows this palm tree to stand out and create a surreal statement in IR. Photographed at a time when the light may be too harsh for conventional color photography, IR shines. Shooting in color mode allowed me to take advantage of the false color left in the digital IR image. I adjusted the Output and Source sliders in Channel Mixer in Photoshop to attain the blue sky. Taken at ISO 100, f/11, 1/200 sec. with a Nikkor 18-70mm lens.

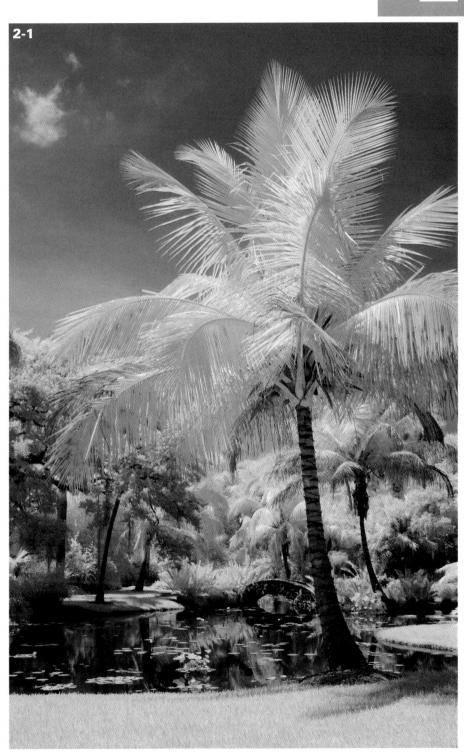

2-1

x-ref Chapter 6 includes more coverage
 on processing images for HDR.

SHOOTING IN DIFFERENT COLOR MODES

Many digital cameras have the option to capture image files in black-and-white mode. This is a personal preference and depends on how you want to render the final image. If you want to produce black-and-white images only, this mode may be your best choice. You can review your IR black-and-white images immediately on the camera's display and perform any desired fine-tuning later in post-processing. This shooting mode is a good choice for IR-converted cameras that have been modified with a deep IR filter or are using a camera filter such as the 87C/830nm filter. This filter blocks most visible light from reaching the camera's sensor, and produces black-and-white IR photographs. An example of shooting in the black-and-white mode using an IR-converted digital camera is shown in 2-2.

If you want to work creatively with the color that is in digital IR images by using filters such as the standard 720nm IR filter or the enhanced color 665nm IR filter, then you may wish to photograph in the color mode and convert to black and white later in Photoshop or through other digital-imaging software.

My IR-converted digital compact camera has the option to record in color, black and white, sepia, and other modes. As the file format for this camera is JPEG, there is no option to convert the black-and-white image back to color (as with RAW format). My IR-converted digital single lens reflex (dSLR) camera has an enhanced color IR filter, which allows more color to pass through to the camera's sensor. Shooting in RAW format while using the color mode allows for many artistic options later in post-processing.

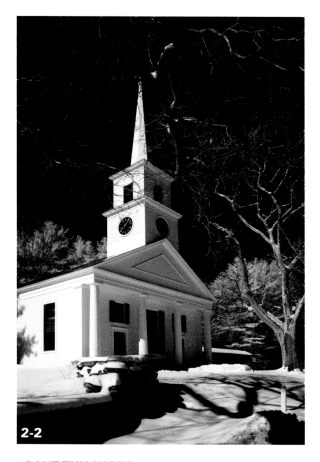

2-2

ABOUT THIS PHOTO *I liked the traditional look of this historic church in Sturbridge, Massachusetts. To convey timelessness in my IR photograph, I used my camera's black-and-white mode. Taken with an IR-converted digital compact camera.*

SETTING WHITE BALANCE

The first step in taking a good IR photograph with a converted camera or when using an IR filter is to start with a *white balance* setting that correctly measures the color temperature of the light falling on the subject. You can repeat this step for each scene you photograph.

x-ref See Chapter 1 for more information
 on working with a camera con-
 verted to IR.

Setting the white balance enables your camera to correctly record the color of light (the light temperature measured in degrees Kelvin) illuminating your subject. It is a basic adjustment you make to ensure you get the color you want.

CHOOSING WB OR AWB

Most digital cameras have the built-in white balance (WB) settings Automatic, Cloudy, Sunny, Shade, Incandescent, and Custom. With a digital camera that is not IR converted, you can choose to match the kind of light you are working with. For example, if you take a photograph with a standard digital camera outdoors on a sunny day, the white-balance setting Sunny would be correct if you want accurate color. The alternative is to choose automatic white balance, or AWB, in which case the camera chooses the white balance setting for you.

KEEPING RGB CHANNELS IN BALANCE

When you set an automatic white balance in an IR-converted camera or with an IR filter on the lens, images may appear overly red or magenta. This results in an image that is overloaded in the red color channel. Compare a photograph with a correct white balance (see 2-3) to an image that has an overly red cast (see 2-4). An accurate white balance for your IR image can be achieved by creating a custom white balance preset. These easy steps are explained in the following section.

2-3

2-4

ABOUT THIS PHOTO *A white balance set accurately renders nice skin tones, compared to a white balance that is overloaded in the red channel, as shown in 2-4. Taken at ISO 100, f/8, 1/320 sec. with a Nikkor 24-70mm f/2.8 lens.*

ABOUT THIS PHOTO *A white balance setting of Automatic may record images that have a red or magenta hue. Taken at ISO 100, f/8, 1/320 sec. with a Nikkor 24-70mm f/2.8 lens.*

To correctly set the white balance, follow these steps:

1. **Take your modified IR camera, or camera with an IR filter, outside.**

2. **Locate a brightly sunlit patch of green grass.** Typically, grass is highly reflective of IR light, which makes it a great choice for a custom white balance.

3. **Aim your camera at the grass, fill the frame with the green, and follow your camera's user manual for setting the white balance manually.**

If you are unable to find your camera's user manual, check online. Most camera manufacturers have them available as a PDF that you can view or download.

UNDERSTANDING EXPOSURE IN IR

When you use an IR filter on your digital camera, exposure times will be much longer than when you are working with a camera that is modified for IR capture. Longer exposure times make using a tripod necessary. Here are a few easy steps to follow when using an IR filter on the lens:

1. **Place the camera on the tripod.** Focus and compose for the subject.

2. **Turn off the camera's autofocus.** The camera may try to refocus with the IR filter in place. Although some cameras will focus through the filter, it depends on the specific camera/filter combination. Turn off AF to be safe.

3. **Put the IR filter on the lens.**

4. **Adjust exposure with the filter in place.**

Using an IR-converted camera is like using a regular digital camera. The IR filter is now a component inside the camera, and exposure times are normal.

SHOOTING MODES

You can use any of the exposure modes, such as Manual, Aperture priority or Shutter priority, depending on your subject. It is a good idea to take a test shot and check the display and histogram on the back of the camera to see if you need to make any changes in exposure.

When I am composing landscapes, I choose either Manual or Aperture priority exposure modes, which work equally well. In Manual mode, I choose the aperture based on the depth of field needed for the composition. With landscapes I often want everything in sharp focus from the front of the image to the back. Using a small aperture, f/16 for example, provides a greater depth of field. You can adjust the shutter speed to make a correct exposure: When you reduce the shutter speed, more light is allowed to reach the sensor; when you increase the shutter speed, less light reaches the sensor. When using Aperture priority mode, you can use the exposure compensation control to make adjustments in exposure.

Most lenses can't focus IR wavelengths on the same plane as visible light. That's why you may have to slightly shift the lens' focus when shooting in IR. Typically, the smaller the lens' aperture and the longer its focal length, the greater this shift will be. That's why many manufacturers place an IR mark on their lenses to help you make this shift. If your lens isn't one that is marked in IR, you can focus manually. It is easy enough to work in either Manual or Aperture priority mode. Simply choose the mode that you are most comfortable using — there is no right or wrong.

Check the histogram on the LCD screen on the back of your camera and make exposure compensation adjustments as needed. Refer to your camera's

user manual to set up the LCD to alert you to over-exposed highlight areas found in the Playback Menu, Display Mode. If after taking a photograph, you see blown-out highlights flashing on the camera's LCD, adjust your exposure by changing the shutter speed or aperture setting. Reduce the exposure using the +/– Exposure Compensation feature on your camera if you are in Automatic mode. I always refer to the histogram and highlight alert feature because it is a clear and concise way of seeing how information is being recorded in the image.

THE HISTOGRAM

The histogram appears as a graph that looks like a mountain range on the camera's LCD. It shows the distribution of the brightness levels in the scene, the shadows, the midtones, and the highlights. You can identify loss of detail by reviewing the histogram. If the image is overexposed, losing detail in the highlights, the light values are

clipped or stacked on the right. If the image is underexposed, the histogram shows light values stacked up on the left side, which indicates detail is being lost in the shadows.

Some cameras also show this information in each channel: red, green, and blue. The histogram is a simple and fast tool to double-check exposure. If the image is too dark, increase your exposure; if it is too bright, reduce your exposure.

Photoshop can recover some information from RAW files, but in JPEG files highlights that are more than a stop overexposed are lost and gone forever. That's another great reason to work in RAW format.

Outdoors, the light always changes, or a subject can move into different lighting conditions. This affects exposure, and exposure in IR can be tricky in general. Review the LCD and histogram frequently, and make adjustments in your exposure as necessary. See the histogram in 2-5 for an example of a balanced exposure. Don't be overly

ABOUT THIS PHOTO
This image has a well-balanced histogram, as shown on the LCD screen on the back of a camera.

2-5

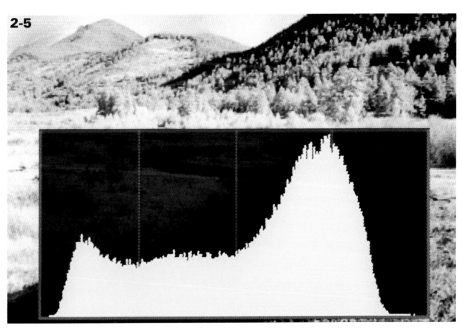

concerned if yours does not look just like this. You can adjust images during post-processing to even out a histogram that isn't quite stretching to either edge. In addition, you can recover a degree of over- or underexposure if you are working in RAW format. The goal is to get the best exposure possible. Sometimes light conditions are less than ideal, but you can make adjustments in contrast in Photoshop. See Chapter 7 for more information on post-processing IR images.

ISO

Another benefit of digital photography is that you can quickly change the ISO (International Organization for Standardization) to increase or reduce shutter speeds, or make smaller or wider apertures. In layman's terms, the ISO number indicates how sensitive the camera's sensor is to light. The higher the ISO, the greater the sensor's sensitivity to light. Note that as the ISO increases, more digital noise, or *grain*, appears in an image (most noticeable in the shadow areas). This may or may not be desirable to you, depending on your intentions for the image. If you wish to replicate a grainy IR film look, then a bit of digital noise may work for your image.

Most dSLRs have a built-in noise-reduction feature that you can enable through a custom menu setting. Adobe Camera Raw software, part of Photoshop and Photoshop Elements, has adjustment sliders for the two types of noise reduction — chroma and luminance — in the Detail pane. Photoshop also includes digital filters (Filter ➪ Noise ➪ Reduce Noise), and you can apply plugins during post-processing to reduce some noise. The goal is to get the best image possible while you are taking the picture, which results in less time in the digital darkroom. Chapter 7 covers solutions to noise reduction.

PRIME TIME IR PHOTOGRAPHY

While most digital photographers wrap up their mornings working in the golden hours with warm light and long shadows, many digital IR photographers just keep on shooting. One of the great things about digital IR photography is that not only are mornings and evenings good times to shoot, but the middle of the day is often the best.

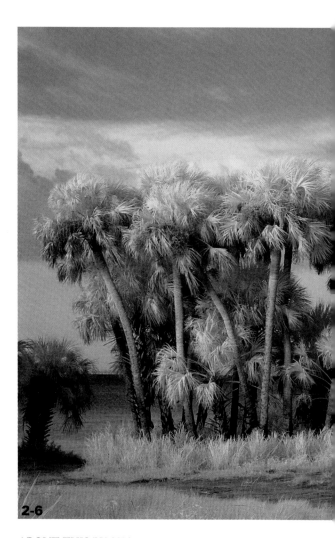

2-6

ABOUT THIS PHOTO *I captured this image with a slight breeze blowing through tall grass and palm trees near a lagoon in Florida. Taken at ISO 200, f/8, 1/50 sec. with a Nikkor 18-70mm, f/3.5-4.5 lens.*

One of my favorite places to photograph is Merritt Island National Wildlife Refuge on the east coast of Florida. Soft light on palm trees near the Indian River Lagoon created the tranquil image shown in 2-6. I took this photograph early in the morning in the Color mode, using an IR-converted camera with a standard IR filter. I made color adjustments in Photoshop using the Channel Mixer (Image ⇨ Adjustments ⇨ Channel Mixer).

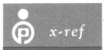

x-ref

Chapter 8 covers how to use the Channel Mixer to create blue skies in your IR image.

Early mornings and late afternoons are when low-light angles cast long shadows, adding texture, interest, and drama to your IR photograph as shown in 2-7. Light rays shining through a forest

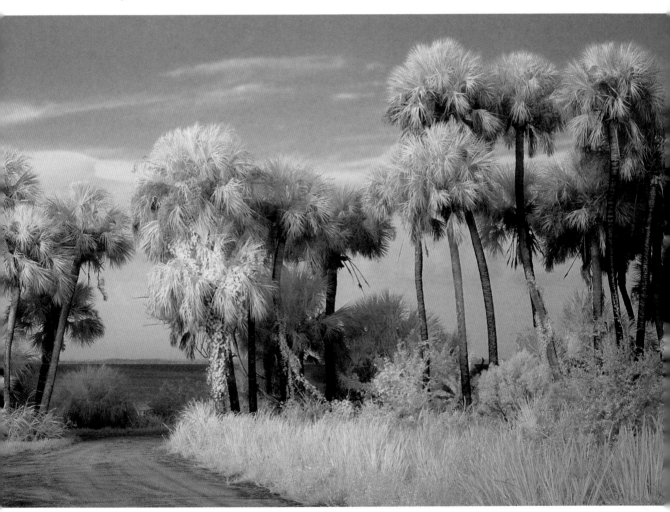

A tree line below this rocky cliff casts dark shadows, creating an image strong in contrast and repetition of shapes. Taken with an IR-converted compact camera.

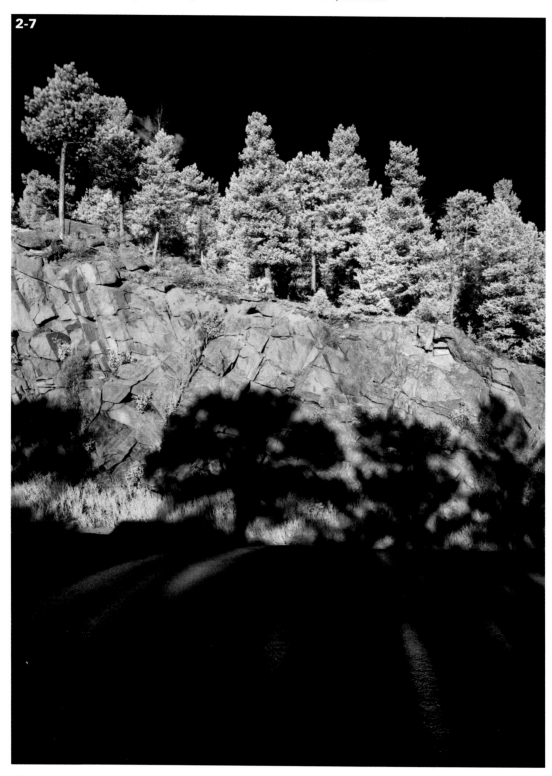

2-7

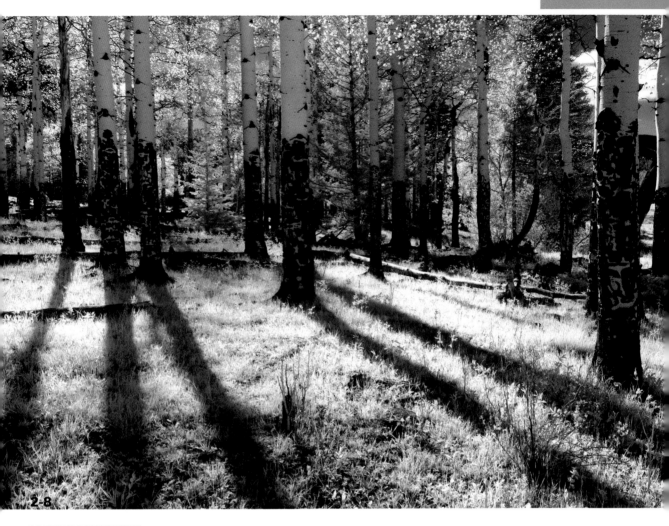

ABOUT THIS PHOTO *Long shadows cast by aspen trees provide strong leading lines into the photograph. A glimpse of blue sky is captured in the background. Taken at ISO 100, f/11, 1/50 sec. with a Nikkor 24-70mm f/2.8 lens.*

of trees casting shadows are every bit as captivating in IR as they are in color. For example, take a look at the aspen trees photographed in Endovalley, Rocky Mountain National Park in Colorado, as shown in 2-8. I used the early morning light to its full advantage and allowed long shadows to create strong visual elements to lead the viewer into the photograph.

Midday, sunlight is often at its strongest, and clouds may begin to form in a previously cloudless sky. In IR photographs, the sky may appear very dark, which creates great contrast for cloud formations. It's often the very best time to photograph in IR. Expressive clouds that take over the sky can be a subject alone. In 2-9, I waited for the clouds to move past a rugged snowscape in Rocky Mountain National Park and then photographed the peaks.

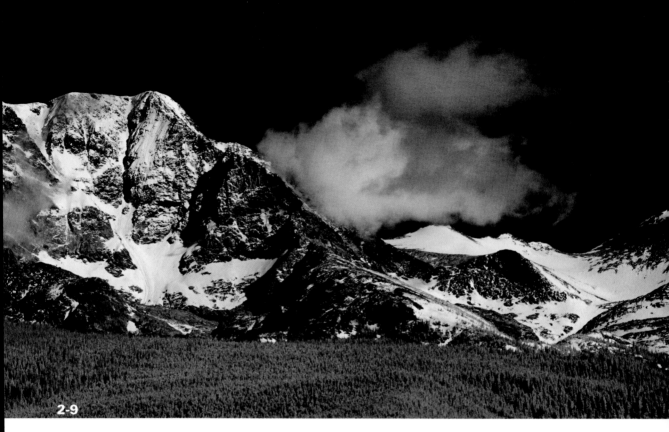

2-9

ABOUT THIS PHOTO *Delicate clouds punctuate a dark sky and snow-capped peaks in Rocky Mountain National Park. Taken at ISO 100, f/11, 1/100 sec. with a Nikkor 24-70mm f/2.8 lens.*

You may have been cautioned to avoid the bright midday sun for photography in general, but this is where digital IR photography shines. There are no hard-and-fast rules when it comes to digital IR photography. For example, in 2-10 professional photographer and author Joe Farace took advantage of noontime to photograph in IR at Zion National Park, Utah.

Experiment with photography at various times of day, as well as in different lighting conditions such as when a storm is approaching. Take some fun risks and you may be pleasantly surprised with the results. Remember Winston Churchill's expression: "Success is moving from failure to failure without loss of enthusiasm." So go ahead! Be the one to try what you aren't certain will succeed, and you'll learn from your experiences and be better for them. It's one of the best ways to learn and grow as a photographer. Shooting in IR with specific subjects in mind is covered in Chapter 4.

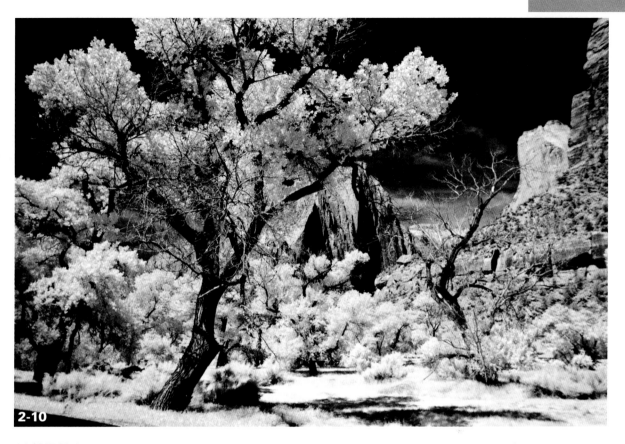

2-10

ABOUT THIS PHOTO *Have lunch later in the day like professional photographer and author Joe Farace did when he got this shot of Zion National Park at noon. Exposure with a Canon EOS D30 was converted to IR-only capture. Taken at ISO 200, f/8, 1/125 sec. The final image was digitally toned using PhotoKit's (www.pixelgenius.com) Photoshop-compatible plug-in. ©2006 Joe Farace*

USING EXTRA EQUIPMENT AND ACCESSORIES

In some respects, photographing in IR is similar to photographing in color. Basic equipment and accessories that you may already own for color photography will work great for IR. Once you have purchased an IR filter, or have had your digital camera modified, you are ready to start photographing. You may already have a flash, reflector, memory cards, and a tripod. There is no need to go to a lot of extra expense purchasing new gear, and that is an attractive plus with IR photography.

FLASH, REFLECTORS, AND DIFFUSERS

Because a flash unit emits both visible and invisible IR light, consider using one to improve images of specific subjects in IR photography. Although a flash is not needed for landscapes, you can use it for portraits of people. You can also use a reflector or diffuser to illuminate or balance light on the subject. These photographic accessories have the same applications for IR photography as for color or black-and-white photography.

Reflectors bounce light onto the subject as well as balance shadowed areas of the subject. Diffusers soften bright light and help eliminate harsh shadows on the subject. They are often sold in kits and are available in a variety of sizes. For example, I use the Westcott Illuminator Reflector 4 in 1 Kit. This kit has a reflector with one gold and one silver side and a diffuser; both the reflector and the diffuser collapse and fold into very portable, lightweight sizes.

The flowers shown in 2-11 made a great subject to photograph in IR, even on a gloomy day with little hope of sunshine. I experimented with various outputs and positions of the flash unit to create an appealing image in IR.

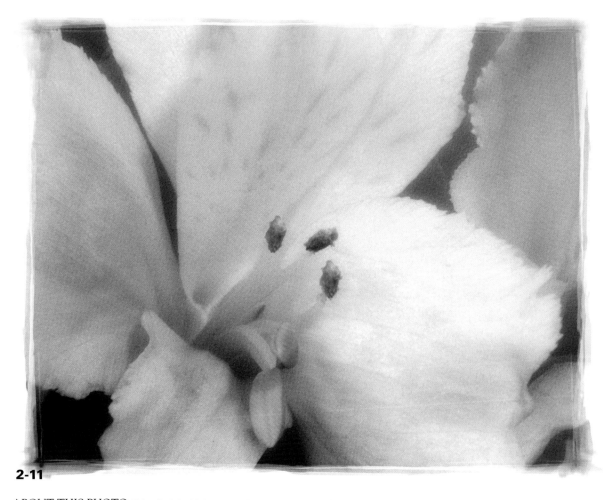

2-11

ABOUT THIS PHOTO *Using flash in this image made the subject more lifelike and added tonality and contrast not available on a rainy day. Taken at ISO 100, f/11, 1/60 sec. with a Nikkor 18-70mm lens.*

TRIPODS

If you are using a filter on your camera, then you will need a tripod because of the slow shutter speeds at which you will be shooting. As with conventional color digital photography, a sturdy tripod will help ensure sharp images by reducing camera shake. A tripod that is undersized or unstable may transfer undesirable vibration to the camera during exposure.

Many manufacturers make various types of tripods to suit the needs of photographers from beginners to professionals. Weight is a big consideration as every pound can make a difference when you are carrying camera gear. Look for a solid, lightweight tripod that is easy to carry and can be packed in a suitcase or attached to a backpack. Carbon fiber tripods work well, especially when you are traveling. An example of a tripod that is great for traveling is shown in 2-12. At 22 inches with a tripod head, it is compact and very lightweight.

Although they are usually a bit more expensive, carbon fiber tripods are a good investment. You can set them up quickly, they are stable, and much lighter than a heavier metal tripod. When you have a lightweight tripod, you are more likely to use and appreciate it. However, for heavy lenses such as 400mm and up, you need a heavier-duty tripod. Spend time researching tripods and choose carefully, finding one that meets all of your needs.

Gitzo (www.bogenimaging.com) makes a variety of tripods. The 1325 carbon fiber model is light-weight, sturdy, and very easy to set up and take down. I use a smaller one (see 2-12) for travel, and some of my professional photographer friends recommend Induro tripods (www.indurogear.com).

TRIPOD HEADS

The tripod head, upon which you mount the camera, is equally as important as the tripod. I found that my first tripod head, a pistol grip, was difficult to adjust accurately, and it often sagged, causing me to have to readjust for my composition. I eventually upgraded to a ball-head style tripod head, which was more accurate and securely held the camera in place. Really Right Stuff (www.reallyrightstuff.com) makes a variety of tripod heads for many sizes of cameras and lenses. I have used one by this company for several years and am impressed with the quality and ease of use. There are many tripod heads on the market, so it pays to do your homework and find the one that will work best for your photographic needs.

CABLE RELEASE

Using an IR filter on the lens blocks most visible light, which means exposure times will be longer. You will need to use either a cable release or the camera's self-timer setting to avoid transferring

ABOUT THIS PHOTO 2-12
Shown with a ruler for comparison, this lightweight, compact travel tripod is easy to carry and pack. Constructed of carbon fiber, it's sturdy enough to support the weight of a professional camera and lens.

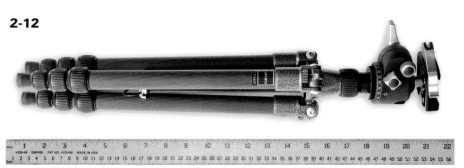

any movement that might be recorded during the exposure. A cable release is helpful for the times you use an IR-converted camera for longer exposures. Some cameras come with a cable release or you can purchase one separately. Many types of cable releases are available.

MEMORY CARDS

Memory cards record digital data from the camera. There are different types of memory cards, and the one you use may depend on your camera. Compact cameras often use the small, thin Secure Data (SD) card. Or you may use the larger, more common CompactFlash (CF) card that most dSLRs use, as shown in 2-13. These cards can widely vary as to the amount of information they hold. As of this writing, 4GB and 8GB are common, and even 16GB cards are becoming the norm.

How do you know how "big" of a memory card you will need? The answer depends on the type of subjects you are photographing and which format you shoot in: RAW, TIFF, or JPEG. If you are shooting in RAW format, a larger card is recommended because this format holds more data than the JPEG format. If you do a lot of action photography, such as shooting birds in flight or sports,

the larger the card, the better, because you'll be taking more pictures. With IR photography, you may be working at a different pace, shooting specific subjects such as landscapes or portraits, and may not require a higher capacity card.

 tip Some travel photographers purchase many memory cards for trips, and use them as an additional source of backup, rather than reformat each card to reuse each day. These cards are compact and reliable enough to be a valid and attractive source of backup.

FILTERS

As with conventional color photography, a *polarizer* may reduce glare and reflections on surfaces such as water or windows. Some photographers use a polarizer to darken the sky, which may already appear dark in IR. As with color photography, a polarizer is most effective 90 degrees away from the sun. Pointing the camera toward the sun, or having the sun behind you, will not help with polarization. To cut down reflections, rotate the polarizer until the least amount of reflection is visible in your image. Dial back the filter just a bit to avoid overpolarizing the image (which can create a dark area in the center of the frame).

Neutral density filters add to exposure times, which may make them preferable when you are photographing scenes where you want longer exposures. For example, you may want to capture waterfalls so the water appears silky and blurred. You accomplish this through a longer exposure. A neutral density filter helps by slowing down exposure times. Examples of such filters are shown in 2-14.

2-13

ABOUT THIS PHOTO *CF memory cards with 4GB and 8GB capacities.*

2-14

ABOUT THIS PHOTO *Neutral density filters can slow down exposure time, and balance the light in a composition. This image shows a filter that will hold back light for the overall image, and a second filter that is considered a soft-edge graduated neutral density filter.*

A graduated neutral density filter is divided — half clear and half dark. As with color photography, you can use a graduated neutral density filter to hold back light and balance the exposure in a composition. Using this filter prevents washed-out skies and allows more detail to be recorded. Neutral density filters are available in values of stops, such as 0.3, 0.6, and 0.9. They are also available with different degrees of graduation — from hard to soft.

Lee Filters or Tiffen make a variety of neutral density filters that fit in a mount for various sizes of lenses and are available from B&H Photo Video (www.bhphotovideo.com). Singh-Ray (www.singh-ray.com) makes excellent neutral density filters.

Using a graduated neutral density filter may not be as effective when the contrast is too great to be balanced by the filter. In this case, many digital photographers choose to create an image in HDR by taking several exposures and blending them in Photoshop or other software. This allows detail to be captured in both the deepest shadow areas and the brightest highlight areas and then merged into a single photograph. This is more like what we see with our eyes, but our cameras are unable to record it in a single capture. You can create stunning IR images in HDR. I cover photographing in IR and HDR in Chapter 6 if you are ready to jump ahead.

tip A polarizer or neutral density filter is much easier to use with an IR-converted camera. If you are using an IR filter on the lens, the combination of any of these filters with an IR filter will make it difficult to view any of the effects they might produce. If that doesn't bother you, there's always the instant digital preview on the LCD screen.

Assignment

Shooting Midday in IR

Midday is often the least favorable time of day for the digital color photographer. Shadows are often harsh, and contrast is too great when compared to early morning or late evening. When you photograph in color, you are very familiar with the golden hours of early morning and late evening and shoot accordingly for the best advantage of light.

The middle of the day opens up new opportunities with digital IR for you to take advantage of. For this assignment, I encourage you to explore the differences in photographing midday in color as compared to IR. Photograph several landscapes or cityscapes during the middle of the day, in color and in IR. Compare the differences between color and IR and upload your favorite image to www.pwassignments.com.

I photographed a lake around noon in Rocky Mountain National Park, Colorado. I first photographed the scene in color, and then in IR. The two compared side by side show a dramatic difference between how the scene is interpreted in color and in IR.

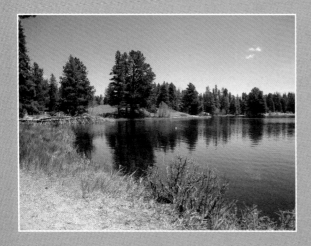 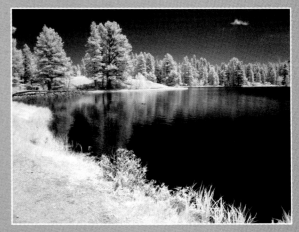

 Remember to visit www.pwassignments.com after you complete the assignment and share your favorite photo! It's a community of enthusiastic photographers and a great place to view what other readers have created. You can also post comments and read encouraging suggestions and feedback.

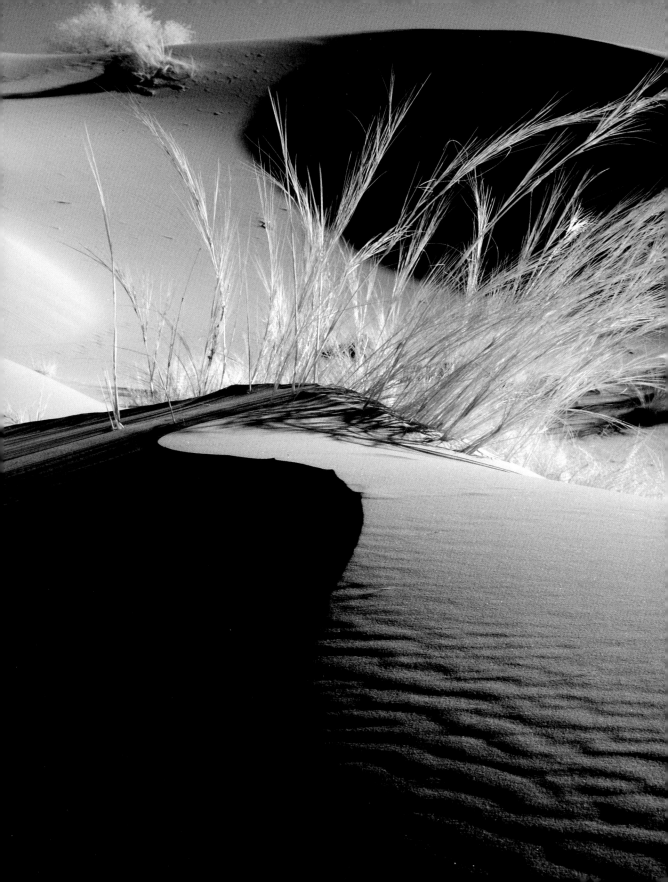

ESSENTIALS OF IR COMPOSITION

How IR Composition Differs from Color

Choosing Your Lens

Creating Your Own IR Style

This chapter covers essential techniques to use to get the best possible IR results. I discuss the compositional differences between IR and color photography and how subject placement can make the difference between average and excellent images.

You will learn how lines, shapes, and patterns add interest to an otherwise ordinary image, and when to use them to bend or break the traditional rules of composition.

I also cover the importance of color in IR photography, and when and how to use it to your advantage. With these tips, you will be able to infuse mood, emotion, and creativity into your IR photography. You will also learn how lens choice and personal style impact your image composition.

Armed with this information, you will be ready to go out and have fun photographing in IR.

HOW IR COMPOSITION DIFFERS FROM COLOR

IR and color photography share the same basic objective — to create a compelling composition that will draw in the viewer, and at the same time, present the photographer's perspective of the world. However, to improve your IR photography, you need to understand the significant differences between them.

You need to take into account how IR light affects your composition and how it alters the way a subject appears within the scene. While color photography can use bright or dramatic color to attract a viewer's attention and add impact, IR relies on, in addition to a great subject, tonality, contrasts, textures, and a surreal element to excite the viewer and add interest, as shown in 3-1.

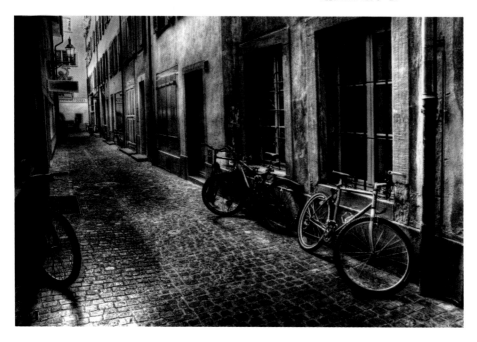

ABOUT THIS PHOTO *I photographed these bicycles in an alley in Lucerne, Switzerland. I liked the cobblestone road, the repetition of windows, and the bicycles in the foreground and background. The texture and light in this composition were enhanced by the Photomatix Tone Mapping filter (www.hdrsoft.com). This filter is designed to accentuate light, shadow, contrast, and texture in a High Dynamic Range (HDR) image. Although this is a single exposure, I liked the effect the filter provided. Taken at ISO 400, f/11, 1/4 sec. with a Nikkor 18-70mm lens.*

For example, in a color composition, an orange sunset against a blue sea provides a colorful end to the day. An IR composition of the same scene requires you to consider other elements when composing the shot. For example, an IR image may be just as dramatic by capturing the cotton candy-like clouds framed with the texture and foliage of a cluster of palm trees. It is the same scene, but with a different composition of elements within that scene.

SUBJECT PLACEMENT AND RULE OF THIRDS

You may be very familiar with the rule of thirds, shown in 3-2. The rule of thirds enables an image to be divided into nine equal parts, with two horizontal lines and two vertical lines simulating a tic-tac-toe grid. The subject can be placed on any of the points that the lines intersect to create a more dynamic image.

Some cameras have a grid in the viewfinder or LCD screen to help you compose your photographs based on this rule. Other cameras can work with a grid-focusing screen, such as Nikon's B Type or Canon's EC-D Laser Matte, that replaces the standard focusing screen. But, as you might imagine, rules are meant to be broken or at least expanded upon. Consider moving past this rule sometimes, using other approaches to become well rounded as a photographer. In other words, don't become so immersed in photographic rules and rituals that you lose sight of what moved you to take the picture in the first place.

ABOUT THIS PHOTO
This photograph, taken in Rocky Mountain National Park, Colorado, is shown with a grid using the rule of thirds. Notice how the shadow of the small tree follows along the lower gridline and that the tree itself is close to the grid points on the bottom left. Taken at ISO 100, f/8, 1/250 sec. with a Nikkor 24-70mm lens.

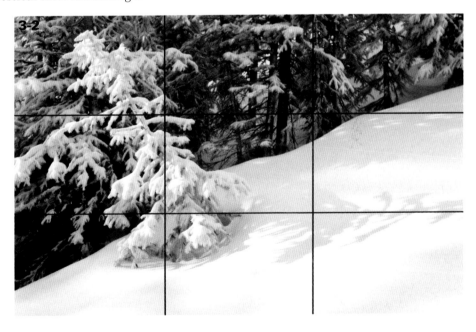

It may be a first impulse to put the subject dead center in the frame, but usually dead center is deadly. Many cameras have a default focusing point that's dead center in the viewfinder, often influencing the photographer's choice of composition.

Use the rule of thirds if you'd like to give your subject an anchor point in the scene. Strong subjects may dictate being placed in the center of the image, but in general, some part of the image should be off center enough so that the composition flows nicely within the frame.

Look back at the placement of the small tree in 3-2. This image was composed using the rule of thirds to create a well-balanced image and is shown with the rule of thirds grid in place.

There are many rules that you can break. And you can feel good about breaking them. What's more, there are many times when you would be better off not following them. One rule that you might bend involves the horizon line, and its placement within an image. It might be distracting to have an image split right down the middle by the horizon line, or it might be quite compelling in its symmetry.

A good bet is that if one part of the image is more interesting than another, you should work to include more of the interesting part (top or bottom) of the image rather than the less-interesting part. This means the horizon line should be placed lower or higher in the frame, rather than dead center.

As British author and leader in creative thinking, Dr. Edward De Bono said, "Creativity involves breaking out of established patterns in order to look at things in a different way."

LINES AND CURVES

Much has been written about how the eyes of the viewer move through an image, and how compositional elements work to draw the viewer into the photograph. Leading lines, S-curves, C-curves, diagonal lines, and so on, bring the viewer into the image and provide overall interest in the photograph.

IR landscape photography is enhanced by all of these elements. Because foliage is recorded as white, the curves or lines of a dark road or path become more intriguing to the viewer, providing contrast and interest to the overall image. Consider this image of an old barn photographed in North Carolina (see 3-3).

The fence line begins at the corner of the frame and leads to the subject. It's a timeless technique used by photographers and painters alike to lead viewers toward the subject, while providing a lot of interest along the way, as shown in 3-4.

In this photograph taken in Lucerne, Switzerland, I composed the lower-right edge of the walkway to lead the viewer toward Chapel Bridge. Leading lines are powerful compositional elements, so be sure to look for these opportunities as you're out photographing.

ABOUT THIS PHOTO *The fence provides a leading line to draw the viewer toward the subject. I used an effect in Photoshop to create the impression of snow beginning to fall. Taken at ISO 200, f/16, 1/125 sec. with a Nikkor 18-70mm lens.*

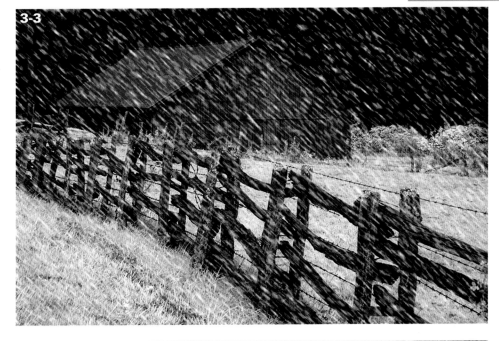

ABOUT THIS PHOTO *Visitors to Lucerne, Switzerland, enjoy the view near Chapel Bridge. Digital toning gave this IR image a timeless, vintage appearance. Taken at ISO 200, f/11, 1/180 sec. with a Nikkor 18-70mm lens.*

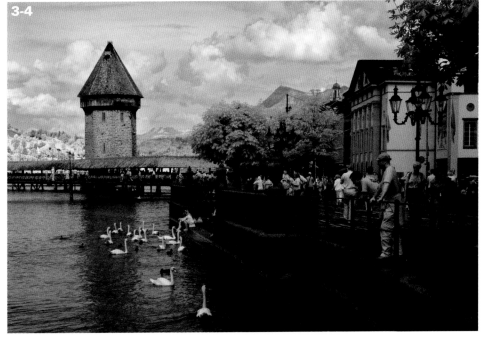

SHAPES, PATTERNS, AND ATMOSPHERIC PERSPECTIVE

Shape is a strong consideration, along with positive and negative space within an IR photograph. Circles, squares, and triangles appear everywhere in nature. Positive space relates to the shape itself, while negative space defines the area around it. As you are composing the photograph, learn to identify and work with shapes to create a visually compelling image. You can often simply change the camera viewpoint to attain this goal.

Rhythm and pattern are important compositional elements as in an interrupted pattern. There is beauty and simplicity in repetition, and visual fascination with a pattern that is unexpectedly interrupted. Look for these existing elements in nature, landscapes, and architecture. The repetition of brick and headstones, shown in 3-5, creates an image with interest. Don't hold back in creating patterns with multiple exposures in-camera if you have one of the few dSLRs, such as Nikon's D3, D300 or other Nikon cameras, that

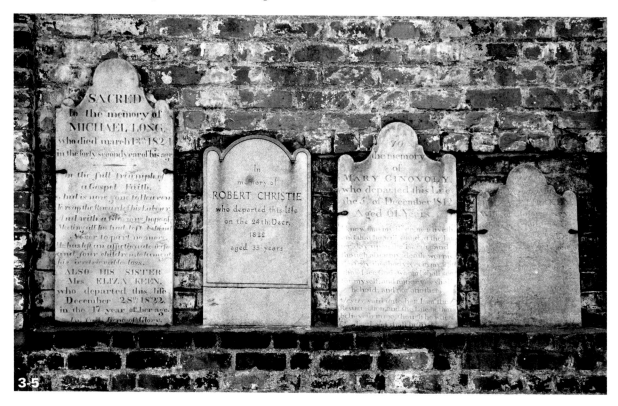

ABOUT THIS PHOTO *Old cemeteries hold a certain fascination for some IR photographers. Bricks and headstones, photographed at the Colonial Park cemetery in Savannah, Georgia. Taken at ISO 200, f/5.6, 1/100 sec. with a Nikkor 18-70mm lens.*

can do it. These cameras have the ability to simultaneously capture from two to ten exposures, providing a beautiful effect that suggests motion. You can use this technique to punctuate barren trees on a beautiful landscape. Even if your camera isn't multiple exposure-enabled, you can create this effect in Photoshop. I explain this technique in detail in Chapter 8 so you can try it on your own photographs.

Atmospheric perspective relates to how objects appear over distance, or to the effect of particles in the air between the subject and photographer. This is another intriguing consideration when you are composing photographs. A foggy morning softens details, and can add an ethereal glow, creating mystery and drama in a photograph.

An IR image may also benefit from a slight sepia tone, so if you're not quite satisfied with the result out of the camera, experiment in the digital darkroom with the various filters in Photoshop. Sometimes it's just the gentlest touch of digital toning or creative effect in post-processing that can make or break an image, as is with this castle that I photographed along the Rhine River (see 3-6).

3-6

ABOUT THIS PHOTO *This castle has an almost storybook appearance in IR. In Photoshop, I sepia-toned the image and used filters for an illustrative look. Taken at ISO 200, f/11, 1/180 sec. with a Nikkor 70-200mm lens.*

BALANCE AND SYMMETRY

Balance is another compositional consideration of importance. Visually analyze how the subject relates to other elements as you compose your image. This may mean moving to the left or right, or up or down.

With IR photography, invisible light is recorded very differently than visible light, the color that you normally see. Think of Ansel Adams, the famous landscape photographer, and how he used tonalities ranging from black to white to create

phenomenal images. In 3-7, I composed the dark curves of this stream on the left side of the frame, leading toward the shadowed mountains in the background. The contrast of grass rendered white in IR against the dark water of a stream creates an image with interest.

Symmetry is compelling and commanding to the eyes of the viewer. The visual weight shifts equally throughout the image, providing just enough tension to draw in the viewer. In 3-8 palm trees and reflections form a nearly symmetrical image, which I captured using a fisheye lens.

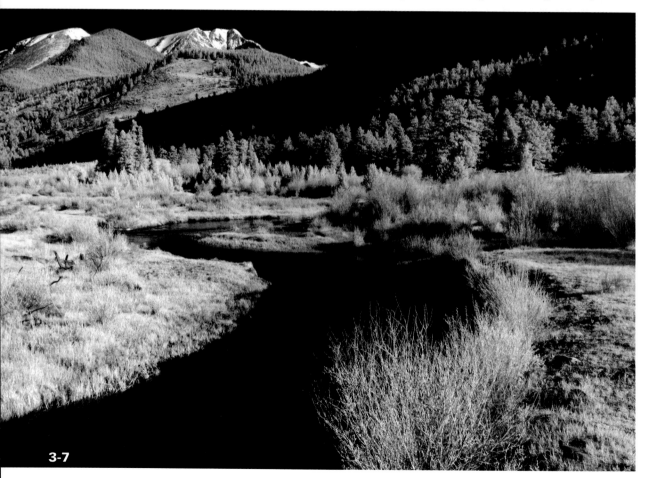

3-7

ABOUT THIS PHOTO *In this image, I worked with contrasts in black and white provided by IR light to create a dramatic image. Taken at ISO 200, f/11, 1/8 sec. with a Nikkor 24-70mm lens.*

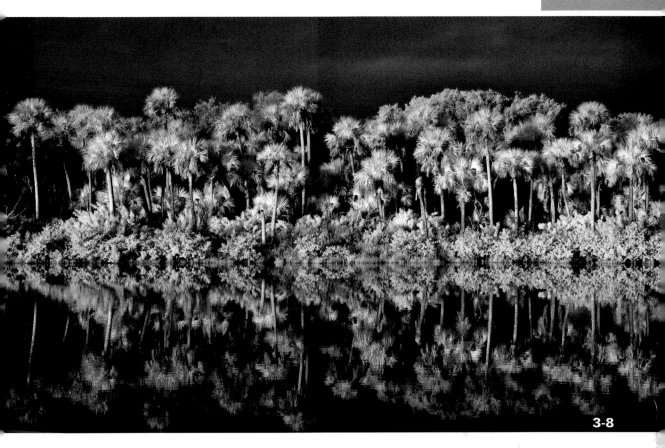

3-8

Symmetrical images can engage the viewer, as shown in 3-9. Here I divided the image in half and replaced one side to mirror the other. The image is at once magical and compelling, real but not quite reality. Images like this one are fun to work with and will often benefit from the addition of a subject that is not mirrored on the other side. IR images tend to lend themselves very well to this concept, as they are already far removed from reality. The mirrored IR image becomes even more enchanting.

ABOUT THIS PHOTO *The reflections cast by palm trees captured with a fisheye lens creates a nearly symmetrical photograph. Taken at ISO 200, f/11, 1/100 sec. with a Nikkor 10.5mm fisheye lens.*

3-9

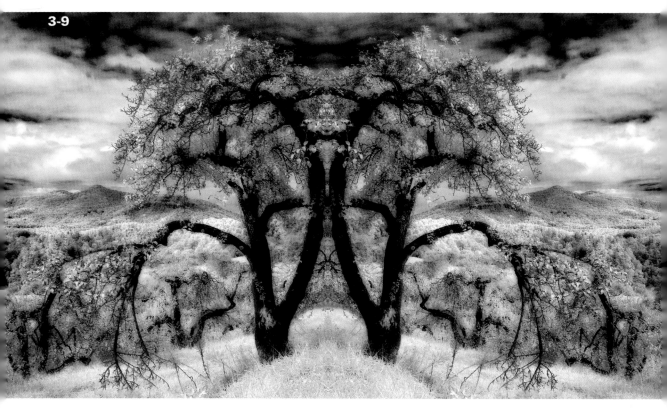

COLOR

Although you're working with digital IR photography, you can still use color as a strong compositional element. It could be something as simple as a single color accentuating a black-and-white IR photograph. Or as broad as an overall tint to an image, such as a blue hue to convey coolness or a golden hue to suggest warmth.

Certain colors can evoke emotional responses. For example, blue suggests tranquility or coldness, depending on the context of the photograph — as well as the country or culture in which the photograph is viewed. For example, in Mexico blue signifies mourning.

Violet, blue, and green are generally considered cool tones whereas red, orange, and yellow convey warmth. Study your subject and the light at different times of day, and use color to suggest a feeling or mood that you want to communicate through your photograph. See 3-10 for an example of how a deep shade of blue transformed a rural barn scene.

I took this shot of the barn in the afternoon with a cloudless, dark sky, as rendered in IR. With deep blue toning and the addition of a moon, the image appears to be photographed at night. I show you how to easily tone your IR photographs in Chapter 8.

You can achieve a different look in IR using an in-camera IR filter other than the R72 filter with a converted camera. Life Pixel (www.lifepixel.com) converted my camera using the Enhanced Color IR filter, 665nm. This filter enriches the image with more color and allows a little more creativity, as shown in the boat-racing photo in 3-11. Rather than convert the digital IR image to a black-and-white rendition in Photoshop, I used the Channel Mixer along with contrast adjustments to achieve a colorful IR rendition of hobbyists racing their sailboats.

Sepia tones can suggest nostalgia and memories. You may find many uses for sepia and similarly toned colors as you post-process your IR photographs. In 3-12, I toned the image with sepia in Photoshop, and used filters to blur it to create a vintage effect for visual interest. I liked the tree line and buildings in the city background. I felt with a slight blur and sepia tone that the image was more dreamlike and suggested reminiscence, rather than just a recording of the scene at hand.

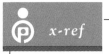

x-ref I cover how to create vintage effects with your IR image in Chapter 8.

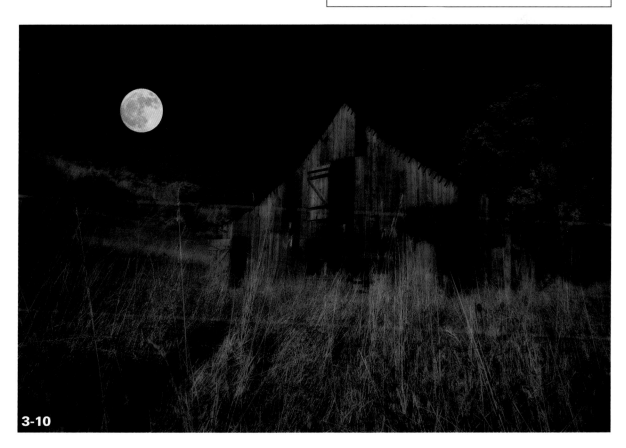

3-10

ABOUT THIS PHOTO *Photographed during the afternoon, dark shadows and deep blue toning create a scene that appears to be shot at night. Taken at ISO 200, f/11, 1/250 sec. with a Nikkor 70-200mm lens.*

3-11

ABOUT THIS PHOTO *This IR image represents multiple compositional elements, with an emphasis on color. Taken at ISO 200, f/11, 1/125 sec. with a Nikkor 18-70mm lens.*

3-12

ABOUT THIS PHOTO *Photographed in winter, when most of the trees were barren, IR gave the scene an even more desolate look, which worked well in the overall photo. Enjoy the chance to photograph in winter. You could be pleasantly surprised that IR works well for your cold-weather scenes. Taken at ISO 200, f/11, 1/100 sec. with a Nikkor 24-70mm lens.*

PEOPLE IN COMPOSITIONS

Something as basic as the human element can provide a more engaging image. A graveyard is fascinating with the rhythm of many headstones, but when it is punctuated with a single soul, it becomes far more dramatic. An arched doorway may be exquisitely intricate in its shape and form, but with the addition of a figure, it can become irresistibly intriguing. Reflect on the desired end result of your composition and how to compose it to make a stronger image. Take a look 3-13 to see how the leading line of a forest path is impacted with the presence of a solitary hiker at the end of it.

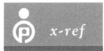

x-ref I cover photographing specific subjects, including people, in Chapter 4.

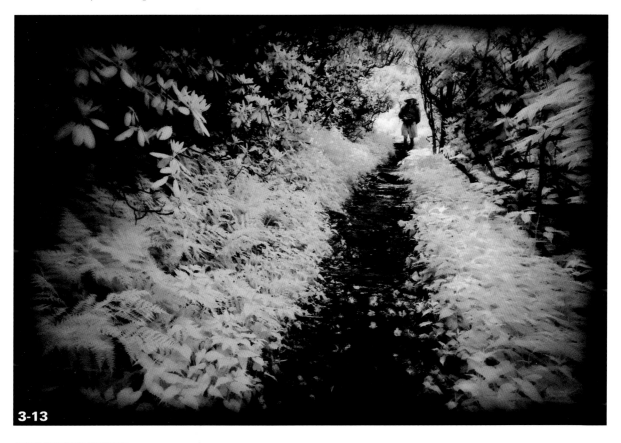

3-13

ABOUT THIS PHOTO *Foliage rendered white in IR surrounds the path and leads the viewer toward the lone hiker. In Photoshop I added a vignette blur filter effect to simulate a vintage camera look. Taken at ISO 100, f/16, 1/125 sec. with a Nikkor 18-70mm lens.*

SILHOUETTES

Silhouettes are one of my favorite ways to attract the viewer's attention. They are dynamic, dramatic, mysterious, and create impact all at the same time.

Silhouettes occur in backlit situations, and the subject is revealed only by shape. Under these conditions, the subject often becomes more compelling. Look for these photographic opportunities at sunrise and sunset, or with a light source behind your subject. Sunsets traditionally photographed in vivid color can also be rendered quite beautifully in IR, as shown in 3-14.

ABOUT THIS PHOTO *Photographed at Lake Dora, Florida, this trio of silhouetted palm trees contrasts nicely with the cloud cover. Taken at ISO 200, f/11, 1/125 sec. with a Nikkor 70-200mm lens.*

Dramatic cloud formations with an interesting foreground element in silhouette are as captivating in IR as in conventional color photography. One caveat to be aware of is *lens flare*, which is light falling into the lens. As with standard digital photography, the opportunity for lens flare is higher when you are photographing toward the sun. When photographing silhouettes, be careful to protect your eyes from the sun.

AVOID BACKGROUND DISTRACTIONS

When composing your images, remember that overly bright or dark areas pull attention away from your subject. Simply moving right or left may eliminate that distraction. Also look closely at horizon lines. Does one dissect your subject right through the head? Not a good thing. Move yourself or your camera so the horizon line isn't in the area of the head. This applies to subjects ranging from people to birds. In addition, be aware of distracting background elements. You don't want tree branches interrupting your scene, causing your subjects to sprout antlers or antennae.

CHOOSING YOUR LENS

Your lens choice is an important compositional element. Traditionally, wide-angle lenses are used for a photograph where everything is in focus from front to back and all the elements tell a story.

With a wide-angle lens, the depth of field is larger when using a smaller aperture than when using a wide aperture, and most everything is in focus front to back, as shown in 3-15. Conversely,

ABOUT THIS PHOTO
I photographed this old weathered barn using a small aperture and wide-angle lens. Taken at ISO 200, f/22, 1/10 sec. with a Nikkor 12-24mm lens.

3-15

a single or solo subject may benefit from just the subject being in focus, with a narrow depth of field to soften and blur the background. This is how I photographed the bird in 3-16, where I used a wide aperture and zoom lens. These are two completely different techniques of creating a more interesting image by a simple choice of lens. Also, you can use the telephoto lens you might ordinarily use to photograph a singular subject successfully to isolate a particular area in a landscape. Don't hesitate to use your lenses in a variety of ways.

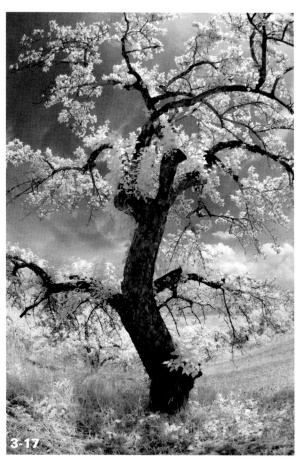

ABOUT THIS PHOTO *The frame is filled with a gnarled old apple tree, and backlight gives the white leaves a translucent appearance. I used Channel Mixer to create the blue-skies effect in Photoshop. Taken at ISO100, f/11, 1/180 sec. with a Nikkor 10.5mm fisheye lens.*

WIDE-ANGLE

When you use wide-angle lenses, you aren't limited to just wide-angle viewpoints; you can use them in a variety of ways. For example, a 10.5mm fisheye lens can create a wonderfully wide point of view, but when you point the camera up or down, you get interesting distortions. Don't be afraid to have some fun and experiment! I filled

ABOUT THIS PHOTO *A posing egret at the Alligator Farm in St. Augustine, Florida. The bird's yellow eyes are rendered white in IR. Taken at ISO 200, f/5.6, 1/250 sec. with a Nikkor 200-400mm lens.*

the frame with an old apple tree using an ultra wide-angle fisheye lens, as shown in 3-17. The café shown in 3-18 benefits from the same lens but with a very different look as a result.

Take the opportunity to see what happens when you use a lens to its advantage in a new way. I've found that my 70-200mm f/2.8 lens is fantastic for catching birds in flight. When paired with an extension tube (which moves the lens farther

ABOUT THIS PHOTO *South Beach, Florida, provides great opportunities for IR photography with a fisheye lens. Taken at ISO100, f/11, 1/180 sec. with a Nikkor 10.5mm fisheye lens.*

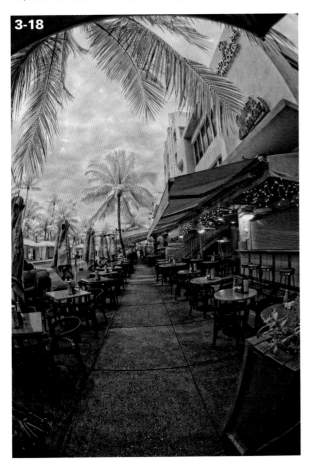

3-18

from the camera body) this lens becomes an attractive choice for close-up floral photography or floral abstracts.

LENSBABY

A Lensbaby (www.lensbaby.com) is a selective focus lens that gives a beautifully soft, blurred effect to a photograph with a sweet spot of focus. Bending the lens creates a different area of focus. You change the aperture using discs or aperture rings. In addition, aperture rings that provide creative effects in the highlighted areas, such as sparkling stars or hearts, are available for the Lensbaby. A Lensbaby is a wonderful addition to your arsenal of creative tools. With IR photography, the Lensbaby gives the image a pure, soft look, as shown in 3-19. This lens blurs the background effectively while giving attention to the main subject.

If you don't have a Lensbaby, you can achieve a similar effect with FocalPoint. This filter simulates the effect of a selective focus lens and is available at www.ononesoftware.com.

When you consider your lens choice, think about various ways to approach composing an image. Your point of view is important. Once you've decided how you want to compose your image and have photographed it, think creatively about other ways you can approach capturing the same scene.

This way you expand your photographic horizons, and you may like or enjoy one of the variations better than your initial photograph. For example, if you photograph a scene in landscape orientation, let portrait orientation be your next choice. If you've composed the scene at eye level, see

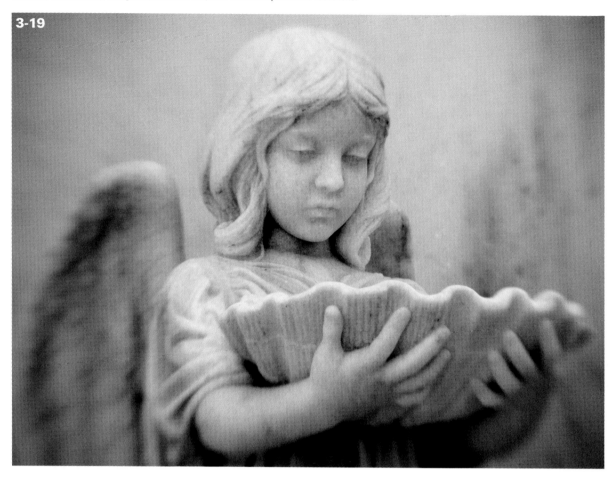

3-19

what happens if you lower or raise your vantage point. What happens if you move left or right, or move behind the subject? Or use a creative technique to tell your story. Try using the disequilibrium effect by tilting the camera to one side, rather than holding it level, to create more dynamic interest. "What happens if" should be your photographic mantra.

CREATING YOUR OWN IR STYLE

As you work with your camera, with both IR and conventional color photography, you'll begin to develop your sense of personal photographic style. I've found that my own style has formed around the way that I work with my images

in-camera. I love the up-close and personal style. There was a time when I worried about the way my style was taking shape, but a wise photographer told me that it was simply part of my personal style. His advice helped me to relax and trust my judgment when composing images.

To give you an idea of how you can develop your own style, study one of my favorite bird images, shown in 3-20. The eyes, which many photographers consider essential to a successful nature photograph, aren't shown. I was enthralled with the gesture of the bird, but not concerned or aware of its

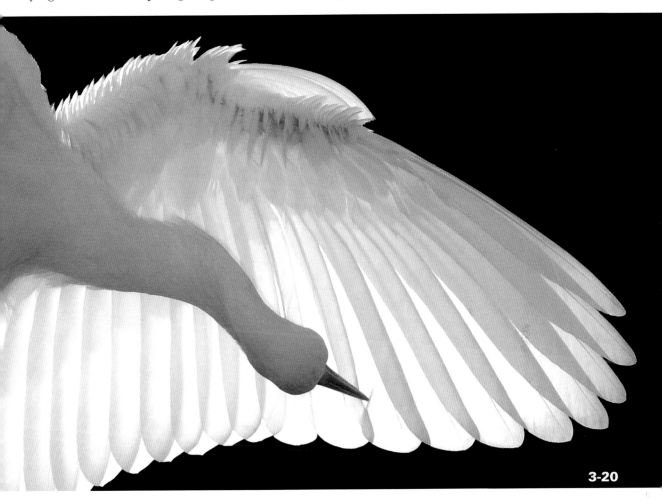

3-20

ABOUT THIS PHOTO *Originally photographed in color, this image was already near black and white in tonality. I liked the graceful gesture of this young egret preening her wing. Photographed at Alligator Farm, St. Augustine, Florida. Taken at ISO 200, f5.6, 1/640 sec. with a Nikkor 200-400mm lens.*

eyes. The resultant image tells a story; and story is what drives me and shapes my personal style.

Some people love storytelling images, others are fascinated with environmental portraits, and still others see drama or interest through wide-angle lenses. Perhaps you, like I do, tend to instinctively work with parts of the whole, and it's reflected in the way we compose our photos. When I need to stretch myself, not quite satisfied with my image's composition, I know I need to move past my first instinct; for example, consider the magnolia blossom shown in 3-21. I could have photographed it exactly where I found it, comfortably nestled within the leaves of its tree, leaving it in context. But I was drawn to photographing it close up, following the rhythm of its petals. I wanted the image to be pure white with shadow and light. IR met my goals within the composition. Trust and follow your feelings and senses, and experiment; you'll soon find your own unique and personal style.

3-21

ABOUT THIS PHOTO *Magnolia blossom photographed following the curves of the petals. Taken at ISO 100, f/16, 1/3 sec. with a Nikkor 70-200mm lens with a 12mm extension tube.*

Assignment

Compose a Dramatic IR Photograph

Invisible or IR light enables you to photograph the world in a unique way. Allow the qualities of IR light to help you compose an image with impact and drama. For example, use a zoom lens to isolate your subject in IR with a wide aperture. Or, use a wide-angle lens with a small aperture to incorporate many elements in focus front to back. Other alternatives are to have fun with a fish-eye lens, use the disequilibrium effect, or try the special effect, selective-focus Lensbaby. This assignment is to encourage you to experiment with a variety of lenses and compositional choices to create a compelling image in IR.

The palm tree scene offers many compositional elements. The white fronds contrast against the black sky, and the clouds punctuate the bottom third of the image. Further, the leading line of the dock and the diagonal sway of the trees combine to create visual interest and make a dynamic IR image. I used a wide-angle lens in portrait orientation to better capture all the elements within this image. I took this photo at ISO 100, f/11, 1/200 sec. with a Nikkor 12-24mm lens.

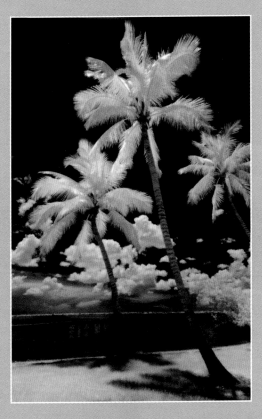

Remember to visit www.pwassignments.com after you complete the assignment and share your favorite photo! It's a community of enthusiastic photographers and a great place to view what other readers have created. You can also post comments and read encouraging suggestions and feedback.

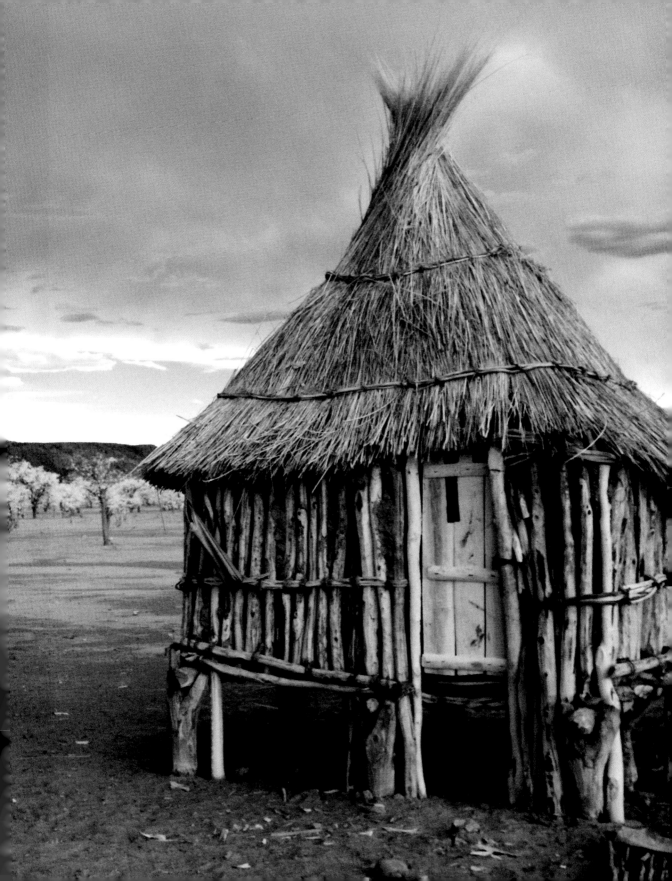

CHAPTER

4

CAPTURING SPECIFIC SUBJECTS

Opportunities for IR photography are all around us. They are limited only by the imagination. IR enables you to create unique and beautiful images using subjects that might not be as powerful when photographed using the visible spectrum. IR allows you to photograph just about anything in a new and creative way. It's fun to imagine and explore all the possibilities, and then implement your ideas.

In this chapter, I address specific subject types such as architecture, foliage, water, and the sky, with an emphasis on how each responds to IR light. People make fascinating subjects in IR as well, and I show you how to use them in your compositions. I also cover several methods to use when photographing birds and other animals to successfully capture them in IR.

Your IR photography can be inspiring when you nurture the themes that emerge in your images. To do this, start building bodies of work, such as portfolios, adding to them and conceiving new projects along the way.

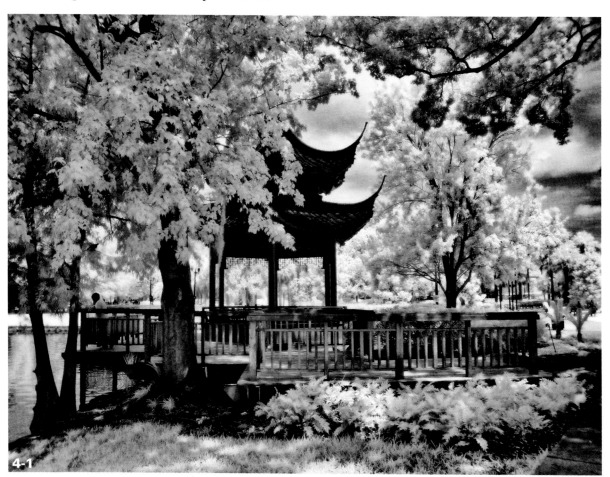

4-1

ABOUT THIS PHOTO *This gazebo overlooks Lake Eola in downtown Orlando, Florida. The texture of the wooden structure and surrounding foliage makes a compelling subject in IR. Photographed with an IR-converted compact camera.*

There is always a different technique you can use, another time of year for your favorite subject, or new conditions to shoot under; this will keep a subject fresh. As you develop your creative vision and expand on bodies of work, you may choose to exhibit your photography in galleries or other venues in your community. Whatever your photographic goals might be, IR gives you endless opportunities to create unique and artistic images.

ARCHITECTURE

Architecture, from primitive structures to contemporary buildings, can make dramatic statements in IR.

Bridges, covered walkways, or gazebos make great subjects when foliage or water is included in the composition, as IR capture dramatically adds both contrast and interest. The gazebo shown in 4-1 overlooks a lake and is surrounded by maple trees. Notice how the dark tones and texture of the wooden walkway and structure are balanced by the lightness of tree leaves rendered white in IR. Visually, there is a lot to explore. IR generates interest because it is familiar, yet surreal. Foliage can add especially strong visual impact in an IR photograph, as you can see in the lighthouse shown in 4-2.

Chapels can be quite romantic and might be a setting you wish to explore. Throughout the world, there are many charming chapels and old churches that can make lovely subjects as an ongoing theme in your IR photography. In 4-3, I was intrigued by the poetic look of this chapel isolated on a hillside in Europe. Powerful clouds contrasting with the sky make the subject an expressive architectural composition.

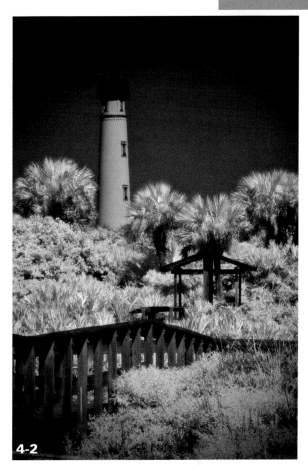

4-2

ABOUT THIS PHOTO *The Ponce Inlet Lighthouse in Florida can be photographed from a variety of angles and perspectives. I photographed it from the beach to include palm trees and vegetation, which provides interesting contrasts in texture in IR. Taken at ISO 200, f/16, 1/125 sec. with a Nikkor 70-200mm lens.*

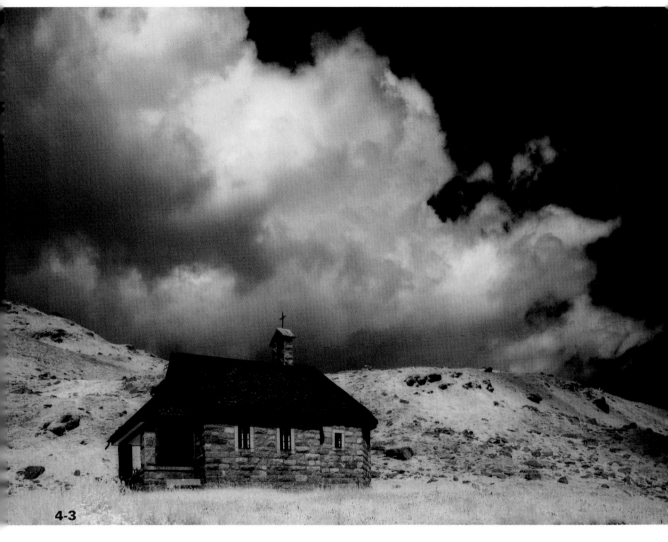

4-3

ABOUT THIS PHOTO *Cinematic cloud formations converge on a small church in Switzerland. Taken at ISO 200, f/11, 1/500 sec. with a Nikkor 18-70mm lens.*

Contemporary buildings offer intrigue with their unique angles and perspectives, and they can look very impressive against an IR sky. In 4-4, I photographed one of the many Art Deco-style hotels facing the ocean in South Beach, Florida. Photographing this image in IR allowed me the freedom of creating a pastel version in LucisPro (www.lucispro.com).

Architectural details can be interesting subjects in IR, too. In 4-5, I composed the photograph to include the unique carvings on the column and wall leading to the statue in New York's Central Park. IR provides an image that is mostly monotone. To provide a nostalgic and dreamlike appearance, I added toning and a blur effect in Photoshop using various filters.

ABOUT THIS
PHOTO *South Beach is all about beautiful beaches and colorful architecture. Taken at ISO 200, f/11 1/500 sec. with a Nikkor 18-70mm lens.*

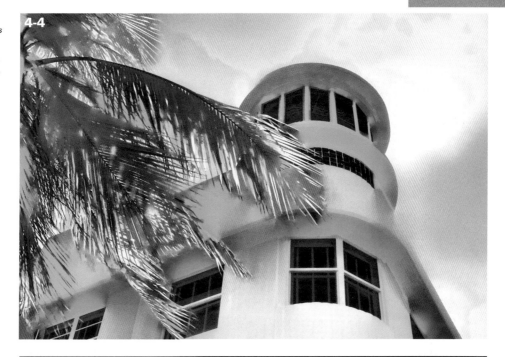

ABOUT THIS
PHOTO *The detail of birds and foliage carved into the column inspired me to photograph it from an angle so that I could include both the unique foreground of the column, and the interesting background that included a statue. Taken at ISO 400, f/16, 1/60 sec. with a Nikkor 18-70mm lens.*

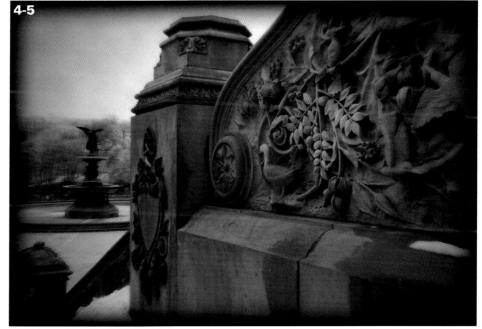

IR transforms graveyard scenes into something surreal and compelling, and perhaps even a bit eerie. Consider 4-6, which is of a cemetery in Boston. I was drawn to the dramatic shadow patterns falling on gravestones in the snow. IR rendered the sky very dark in contrast to the pristine snow that had fallen on the branches and the ground below. Monochrome and a slight glow gave the image a timeless look. In this photo, not a soul is visible, which adds to the existing sense of cold and isolation.

You have many options when you are photographing architecture, and digital IR provides even more. When you choose your subject, consider the various points of view you might use to create a dynamic IR image. You can compose a scene to include grass, trees, and other elements that illustrate the effects of IR. Or perhaps you want to create a panorama. I move my camera from left to right, photographing from different

angles, taking several photographs. In 4-7, I photographed a magnificent castle in Europe from a low perspective. This angle can provide a powerful, commanding presence to a variety of subjects.

It's a good idea to keep a keen eye out for interesting light or shadows when composing your subject. Are any dramatic patterns cast over your subject that you can capture to enhance your architectural image? In 4-8, dappled light patterns fall across the fountain and surroundings, creating unique, shimmery highlights. Shadows or light rays cast in a dark area create a wonderful cinematic approach.

Framing is an essential compositional choice — so frame your subject carefully before you press the shutter release button.

Move around; see how you can artistically portray your image. In New York's Central Park, a trio of arches nicely framed an image that included a

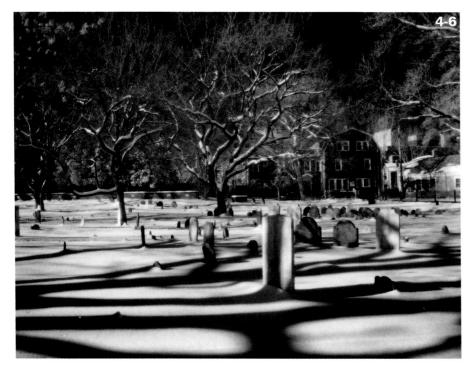

4-6

ABOUT THIS PHOTO
Dramatic shadows and fresh, fallen snow make a timeless image when photographed in IR. Photographed with an IR-converted compact camera.

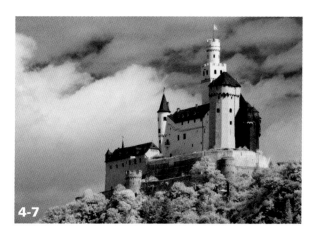

4-7

ABOUT THIS PHOTO *This beautiful castle along the Rhine River made a splendid subject in IR. Photographing from this perspective accentuates the castle's majestic look. Taken at ISO 100, f/11 1/250 sec. with a Nikkor 18-70mm lens.*

fountain in the center, as shown in 4-9. The overall image was a bit melancholy with the barren trees, the patches of snow, and the solitary person walking toward the fountain — cold and lonely, but with a certain appeal in IR. In Photoshop, I blurred parts of the image slightly, and toned it with a sepia filter. You can easily apply this type of creative effect, which I cover at length in Chapter 8.

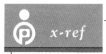 x-ref

Compositional leading lines are covered in Chapter 3.

In your IR composition, and all compositions for that matter, look for leading lines as well as interesting curves and shapes. Think about unique and creative ways to individualize your IR photographs. A fence naturally leads the viewer's eyes through the composition to the architectural subject. Stairways have the same impact. I photographed the stairway in 4-10 from a high angle, shooting downward, creating a graceful look to the image. I liked the small window, the wood grain, and the repetition of shapes of the stairway.

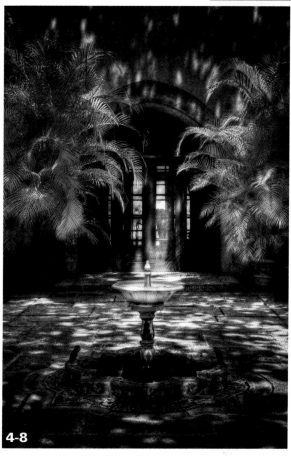

4-8

ABOUT THIS PHOTO *Patterns of light and shadow dance across the patio and fountain at the Pinewood Estate in Lake Wales, Florida. Taken at ISO 100, f/11, 1/125 sec. with a Nikkor 24-70mm lens.*

In Photoshop, I sepia-toned the image for more drama.

Interior spaces bathed in sunlight can make wonderful digital IR photographic subjects. Look for opportunities where you can shoot a sunlit interior area, such as open hallways, window-lit rooms, or open barns. There are certain situations, possibly within these conditions, where you may find that the *dynamic range*, the range of tone from dark to light, is too great for the camera to record. If this occurs, you may want to blend exposures from several frames or employ the use of High Dynamic

ABOUT THIS PHOTO *Photographed in Central Park in New York, a trio of arches creates a unique frame for the fountain in the center. Taken at ISO 400, f/11, 1/125 sec. with a Nikkor 18-70mm lens.*

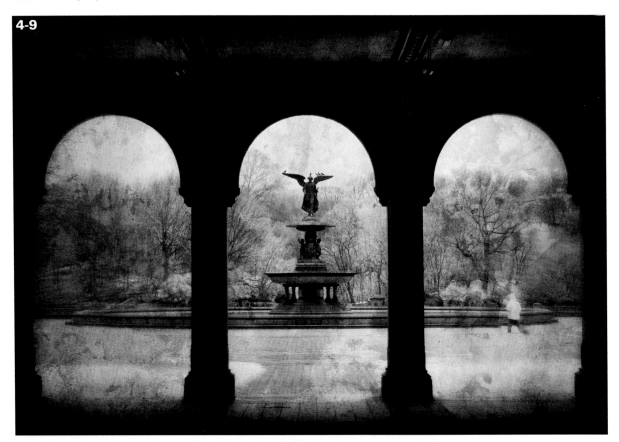

4-9

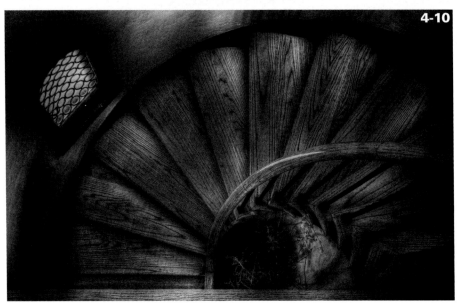

4-10

ABOUT THIS PHOTO

Casa Feliz, a beautiful historic house located in Winter Park, Florida, offered many photographic opportunities, including this stairway, which I photographed from the top landing. Taken at ISO 10000, f/16, 1/30 sec. with a Nikkor 27-70mm lens.

Range (HDR) techniques to record your image. I cover how to photograph and create HDR images in depth in Chapter 6. For example, in 4-11, I photographed this interior view of the Edison and Ford Winter Estate in IR and in HDR so there is detail in both the shadow areas and the highlight areas.

The advantage of shooting architecture using a digital single lens reflex (dSLR) camera is that you can use a variety of lenses. For an architecturally correct view, consider using a PC (Perspective Control) or TS (Tilt-Shift) lens, but they can be pricey. Instead try a wide-angle lens (14-24mm) for a wide view, or even a fisheye lens (10.5mm) for an ultra-wide view. If you can't capture the subject in a single frame, you can create a panorama or multiple-image picture.

Like squares in a tic-tac-toe grid, the scene can be photographed in sections that you merge together later in Photoshop using its Photomerge command (File ⇨ Automate ⇨ Photomerge.)

I cover this easy and fun technique in Chapter 6. To capture just the details, use a telephoto lens (100mm or longer) to select an area you'd like to bring attention to, perhaps incorporating a bit of sky and a few clouds.

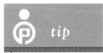 *x-ref* You can add the beautiful aura and enhancing grain associated with traditional IR film to digital IR images using digital filters in Photoshop. I cover this traditional IR film effect in Chapter 8.

Great subjects merit extra time photographing using a variety of lenses, perspectives, angles, and creative techniques. Learning to think outside the box is fun and rewarding.

tip Look for dramatic shadows that provide interesting compositional elements.

ABOUT THIS PHOTO
This HDR image allowed for a range of light to dark tones that would not ordinarily be achieved in a single photograph. Multiple exposures merged to HDR, taken at ISO 100, f/16, with a Nikkor 24-70mm lens.

4-11

LANDSCAPES

Beautiful landscapes can become even more intriguing subjects when photographed in IR. They have the drama and impact that a traditional color or black-and-white landscape offers, with the compelling interest of IR. Rocks, boulders, sand, and organic features of the landscape reflect IR light in various ways. An example of this is shown in 4-12, where shadows and light play on dunes photographed in IR in Namibia.

Including a variety of reflective subjects into your image, such as trees, grass, rocks, or sand, makes your IR photograph all the more interesting. IR light reflects differently off various subjects, materials, and surfaces. Studying how IR is absorbed and/or reflected by those subjects will help you predict how an image might look in invisible light when you use your IR camera. With time and practice, you can attain the ability to envision how color will record in IR.

4-12

ABOUT THIS PHOTO *Among the most picturesque sand dunes on earth are the Sossusvlei sand dunes in Namibia. Early morning and late afternoon casts shadows that accentuate their magnificence. Taken at ISO 200, f/11, 1/250 sec. with a Nikkor 18-200mm lens.*

Ansel Adams, one of the most famous American landscape photographers, could successfully envision how the naturally colorful scenes he saw through his viewfinder would look recorded as black-and-white photographs. With emphasis on light, shadow, form, and texture, his beautiful photography makes powerful statements without the reality and familiarity of color. We can achieve success in much the same way by training our eyes how to see what our digital cameras can record in monochrome IR. As Adams said, "There are no rules for good photographs, there are only good photographs."

FOLIAGE

Foliage is a great reflector of IR and may appear bright white when photographed by a digital camera with an IR filter. Green grass is also an excellent reflective source, and this is the reason you can use it to custom set your white balance to photograph in IR, which I cover in Chapter 2. Different genera of trees and foliage reflect light in different ways. Some may appear brighter than others.

For example, less IR-reflective conifers photograph gray compared to deciduous trees, such as maples, which appear white.

Flowers are wonderful subjects to explore in IR. A single blossom can become dreamlike in its interpretation in IR. Fields of flowers can be equally as evocative. Flowers may appear white, or they may show a slight amount of color, depending on what type of IR filter you use. In 4-13, I held a day lily up to the sky and photographed it using an IR-converted camera with an enhanced color filter. The flower remains basically white, while channel mixing changed the leaf color from pale aqua to gold.

I used Photoshop's Replace Color tool (Image ⇨ Adjustments ⇨ Replace color) to change the gold tones to a soft lavender color for a different look. Consider background elements, as a pure white subject may benefit from more contrast to successfully highlight it. Visualize your floral subject beforehand, and compose your photograph to provide the most interest. Look for opportunities to separate your subject from the background, as is shown in 4-14, where the wildflowers are composed against a clear sky.

ABOUT THIS PHOTO
Colorful day lilies are transformed by IR light. Experimentation and fun in Photoshop enables you to add some interpretation to your original image. Taken at ISO 100, f/11, 1/500 sec. with a Nikkor 18-70mm lens.

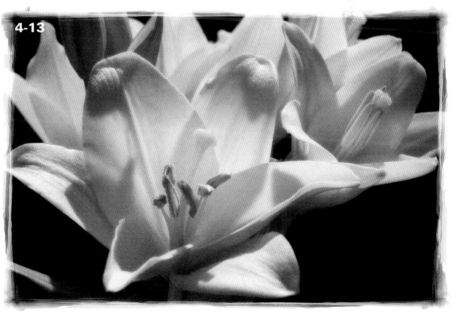
4-13

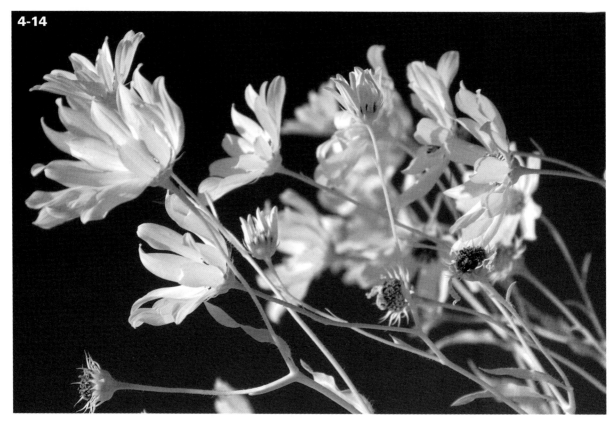

4-14

WATER

Because water absorbs IR light rather than reflects it, water often appears dark or black in IR photographs. You can use this characteristic to your advantage. A stream or river can become a leading line through your photograph, appearing dark compared to surrounding lighter foliage. Tranquil, unmoving bodies of water such as lakes or ponds often provide beautiful reflections of their surroundings. Calm days enable you to include a mirror-perfect reflection in an image, as shown in 4-15. Visualize these wonderful contrasts as you are composing your IR images to create dynamic compositions.

SKIES AND CLOUDS

Landscape photography in IR is my favorite. It can be intensely dramatic with contrasting dark skies and white clouds. Based on the angle from which you are photographing, the daytime sky can look almost black.

Clouds reflect IR light and stand out beautifully in landscape compositions. Because they are ever-changing, clouds provide a wonderful element of interest to IR photography, transforming the mood and look of an image.

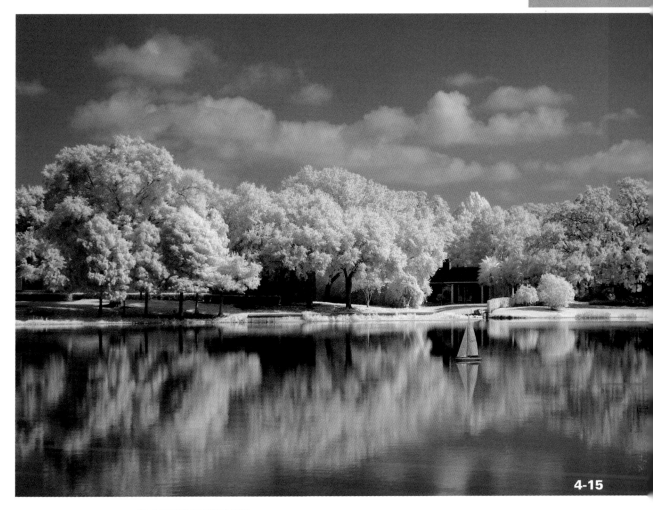

4-15

ABOUT THIS PHOTO *Mirror-perfect reflections in IR are best captured on calm, sunny days. Using the Channel Mixer in Photoshop enhanced the color in this IR image. Taken at ISO 100, f/11, 1/100 sec. with a Nikkor 18-70mm lens.*

PEOPLE

Photographed in IR, people take on a whole new appearance —the resultant skin tones appear more perfect and opalescent than in an ordinary color photograph. This can be advantageous for creating unique images.

Photographing people provides a host of creative opportunities in digital IR photography. Some professional photographers like to portray the bride and groom in IR, as shown in this photo by David Twede (see 4-16). Photographing in IR offers an elegant alternative to traditional color wedding photography.

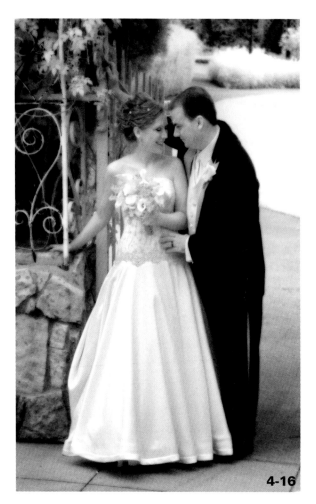

ABOUT THIS PHOTO *Professional photographer David Twede of Orlando, Florida, photographed this beautiful bride and groom using a dSLR camera with an R72 filter on the lens. David added a glow in Photoshop for a traditional wedding-effect look. Taken at ISO 400, f/4, 1/60 sec. with a Canon 24-105mm lens. © David Twede*

Fine art nude photography is also a popular subject in IR. Skin tones appear ethereal in IR light. Eyes may appear quite different than expected and this alone can be a subject to explore.

My own hazel-brown eyes appear as a blue shade when photographed in IR with a standard IR filter. Skin may have the look of perfection in IR, with barely a freckle or blemish showing.

In 4-17, I met a beautiful woman posing as a witch at a medieval festival in Europe. While her eyes are naturally dark brown, they look lighter in IR. I like her interesting face painting and dreadlocks. She almost looks like a porcelain doll, with her perfect complexion and painted accents.

For fun, try a few self-portraits or pictures of friends to see the effect that IR light has on your subjects. In 4-18, I photographed a tall musician with an IR-converted camera that has a 665nm filter.

ABOUT THIS PHOTO *The castle Vianden in Luxembourg hosts a medieval festival each year with music, events, and characters in costume as knights, beggars, and witches. This woman was dressed as a witch. Taken at ISO 100, f/8, 1/250 sec. with a Nikkor 18-70mm lens.*

light than are in color. Discovering these qualities can become an ongoing project, as the qualities are as unique as the individual. An IR photograph of Andi is shown in 4-19. Her freckles aren't visible, her skin has lovely translucence, and her tattoos have lots of definition and interest. Compare this to the color photo of her in 4-20 to see the transformation of her skin and hair in IR.

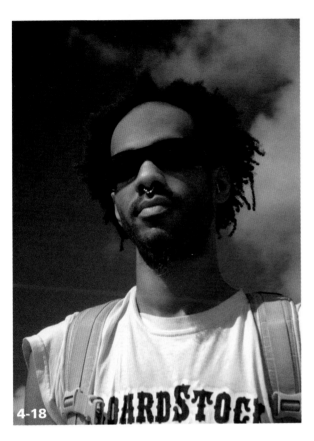

4-18

ABOUT THIS PHOTO *I liked the head-in-the-clouds perspective for my subject. Though it hints at color, IR capture gives the image added interest. Taken at ISO 100, f/11, 1/250 sec. with a Nikkor 24-70mm lens.*

This filter allows more visible light to pass through to the camera's sensor, thus providing more color in the overall image. I liked the sky and clouds behind him and took the photograph from a low angle to emphasize his towering presence. IR light gave his skin a perfect look and passed through his sunglasses so his eyes are visible.

Tattoos make an interesting subject in color photography, even more so in IR. The various qualities of ink color are represented differently in IR

4-19

ABOUT THIS PHOTO *Freckles disappear and skin looks flawless in IR. Taken at ISO 100, f/8, 1/400 sec. with a Nikkor 24-70mm lens.*

4-20

People can add scale, dimension, and intrigue to a photograph. The barren branches and patches of snow in the winter scene taken in New York's Central Park in 4-21 give the image a forlorn appearance.

The woman walking alone illustrates isolation and evokes a sense of melancholy. IR takes away the color, and some of the reality of the scene, giving it a surreal look. Sepia toning provides a timeless, nostalgic look; I discuss creating this effect in Chapter 8.

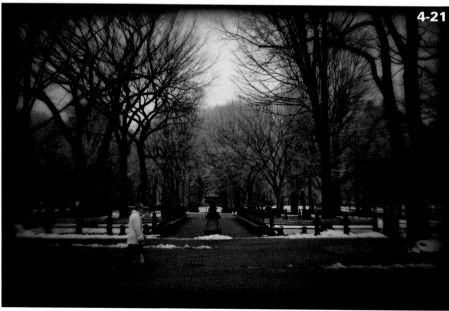

4-21

BIRDS

Birds make very attractive subjects in IR, and they are one of my favorites. I like the way the birds, along with their environments, look in IR. A bird is usually associated with its color, which is altered in IR photography. The strength of the IR photograph relies on qualities such as light, shadow, contrast, and the behavior of the bird instead.

For example, 4-22 shows a heron perched on a mangrove, photographed early one morning at the Merritt Island National Wildlife Refuge in Florida. The bird's dark feathers contrast with white leaves, which are accentuated by a softly blurred background. Morning hours have the advantage of good light, enabling you to avoid harsh shadows that detract from avian subjects.

You may find the Aperture priority mode easier to use than Manual mode, as birds are very quick to change positions. This mode is a good choice for birds in flight. For subjects that are stationary, choosing a wide aperture (such as f/4, f/5.6) on a telephoto lens, nicely blurs the background and allows the bird to stand out in the photograph. You can use exposure compensation to quickly make adjustments to exposure. Some photographers find the Manual mode the easiest one to use because they feel it gives them more control. Ultimately, of course, it's your decision. In 4-23, attractive rim light highlights the unruly downy feathers on the young tricolored heron's head.

City parks often feature lakes or ponds that are attractive habitat for birds. The simple composition in 4-24 shows a swan that was photographed posing on a city lake in downtown Orlando, Florida.

A cypress tree adds texture and interest with its fringed leaves in white, and casts a unique reflection in the foreground. The enhanced color IR filter in my converted camera allowed for slightly more color in the IR image. With a little tweaking in Photoshop, the water takes on more aqua tones and contrasts nicely with the white swan.

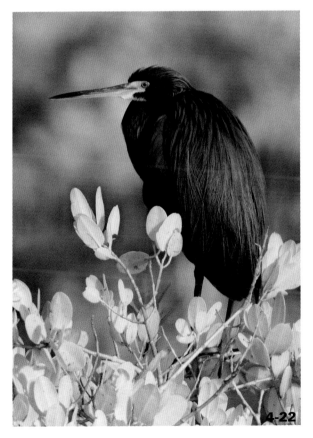

4-22

ABOUT THIS PHOTO *Merritt Island National Wildlife Refuge on Florida's east coast attracts a variety of birds throughout the year. Photographing birds in IR provides unique opportunities given you must look to qualities other than bright plumage to create an expressive image. Taken at ISO 200, f/5.6, 1/250 sec. with a Nikkor 200-400 mm lens.*

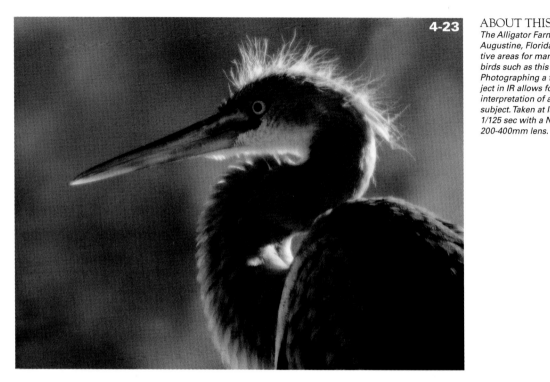

4-23

ABOUT THIS PHOTO
*The Alligator Farm in St.
Augustine, Florida, hosts attrac-
tive areas for many nesting
birds such as this young heron.
Photographing a familiar sub-
ject in IR allows for a unique
interpretation of a common
subject. Taken at ISO 400, f5.6,
1/125 sec with a Nikkor
200-400mm lens.*

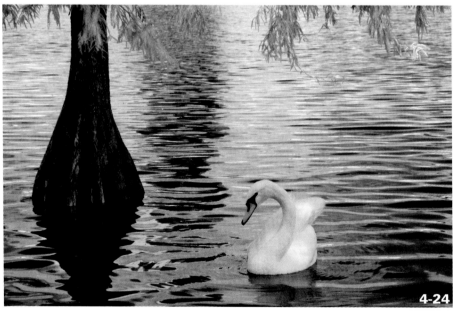

4-24

ABOUT THIS PHOTO
*I photographed this swan at
Lake Eola in downtown
Orlando, Florida. Using IR gave
me a little more creativity in the
image and my interpretation.
Taken at ISO 100, f/11, 1/125
sec. with a Nikkor 18-70mm
lens.*

ANIMALS

Photographing animals and wildlife in IR opens up great new vistas to explore. Capturing them in open fields gives them perfect backgrounds as they stand out against "white" grass and trees that IR light has altered.

With their comical faces, alpacas are adorable creatures, as you can see in 4-25. The tonality of IR keeps the attention on the two creatures and their dark, expressive eyes. Leafy foliage in IR provides neutral backgrounds, showing off animals to their advantage.

While I was photographing in Switzerland, the cow shown in 4-26 seemed to be posing for me. Rather than convert the photo to black and white, I used the color left in the original digital image to create unique IR colors using Photoshop.

To do so, I channel-mixed the colors, exchanging the blue channel for the red channel, and made contrast adjustments to the image. This gave the photo a soft, almost hand-colored effect. I explain how to do this in Chapter 8.

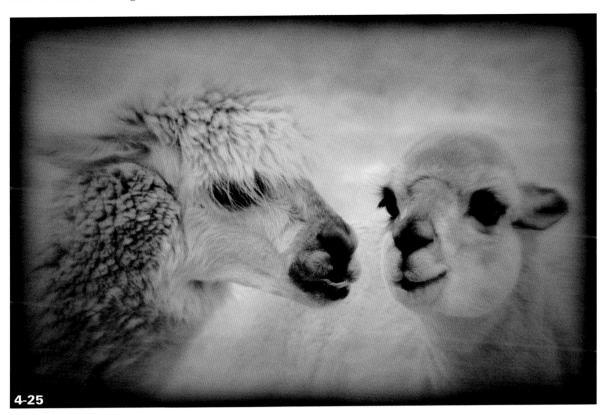

4-25

ABOUT THIS PHOTO *A pair of alpacas, photographed in Colorado, is a great subject in IR. Taken at ISO 400, f/8, 1/125 sec. with a Nikkor 70-200mm lens.*

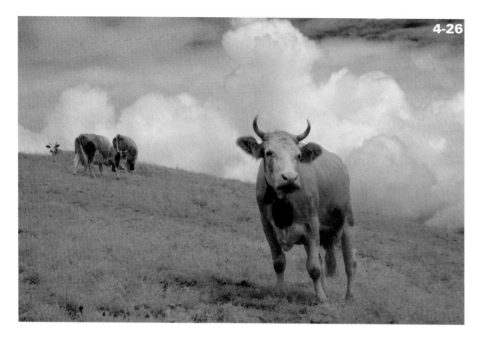

4-26

ABOUT THIS PHOTO
Friendly cows with noisy cow-bells abound in Switzerland and make fun subjects to photograph in IR. I liked the hill and cloud formations around this cow, and how IR changes how we normally see a subject. Taken at ISO 100, f/11, 1/240 sec. with a Nikkor 18-70mm lens.

I have always loved horses. I drew them when I was little, and as an adult, I love to photograph them. In 4-27, I photographed a beautiful horse standing next to a fence. I was attracted to the graceful shape of his head and I liked the dark fence that balanced the photograph in IR.

His chocolate-brown eyes photographed much lighter in IR than how they appeared in color. IR lightened the grass and background, giving full attention to his expressive eyes and pensive, thoughtful gaze.

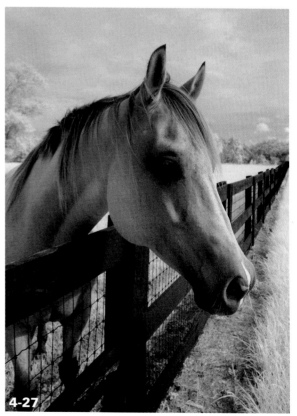

4-27

ABOUT THIS PHOTO *I liked the pose of this amiable horse and the tonality of the overall image in IR. Taken at ISO 200, f/8, 1/200 sec. with a Nikkor 18-70mm lens.*

DEVELOPING THEMES IN IR

A great way to develop a body of work, or a group of photographs that relate to each other, is to think thematically. In doing so, there is always a plan or a path to follow. You can continually add photos to existing projects and to new projects that you start along the way. Keep notes about photographs that excite you to remind yourself of avenues to explore photographically. Having projects and a body of work within each project makes it easier if you decide to exhibit your work.

Consider putting together a small or large portfolio of themed photographs in IR. This makes your photography easily accessible to others, and easy to present or submit for consideration to galleries. IR photography is memorable, as it's very different from color photography. Your name becomes associated with a particular style, and name recognition can be important as you grow in your photographic career and create your own niche.

Begin to network and find channels to exhibit your IR photo collections. Your community or city or county government may be receptive to showing unique and beautiful images of the area, illustrated in a new way with IR photography. Local galleries are a good start. Some cities have an evening reserved each month, such as First Thursday, where you can exhibit your work; it's a great way to get your name out there.

If you live near a place you like to photograph, it could become the theme of one of your ongoing projects. Historic or nostalgic buildings, a wildlife refuge, a local zoo, or a park can be an excellent starting place. For example, 4-28 shows a photograph of the 1950s art deco style Magic Beach Motel, located in Vilano Beach, Florida. I love the retro décor, the flamingos, and those magical bunnies hopping across the entrance in neon lights. Most people are familiar with historic buildings in

ABOUT THIS PHOTO
IR renders the sky black, which contrasts with white palm fronds in this vintage '50s historic motel on Florida's east coast. Taken at ISO 200, f/8, 1/200 sec. with a Nikkor 18-70mm lens.

4-28

color, but see them in an entirely new way when they're photographed in IR. Comb your area for wonderful historic buildings, signs, and structures that might not be there tomorrow. Photographing them in IR can shed a new light on old subjects.

Trees are another of my ongoing favorite themes in IR. Expressive clouds or weather conditions surrounding trees can tell an interesting story. I was taking photos in Rocky Mountain National Park during midsummer. A surprise snowfall reached the ground at the park's upper elevations. It was a wonderful chance to photograph small pines in a winter-like setting, as shown in 4-29, and add a completely different weather element to my collection of trees.

Opportunities for photographing trees are ever-changing, which makes them a perfect choice for an ongoing IR theme. Spring and summer offer trees flush with leaves, while fall shows trees in transition and barren trees tell a story of winter. Certain types of trees, palm trees for example, suggest tropical areas or warm climates, and make great subjects by themselves or in a composition with other trees.

ABOUT THIS PHOTO
A young pine tree becomes more interesting when snow provides a blanket. Taken at ISO 200, f/11, 1/125 sec. with a Nikkor 18-70mm lens.

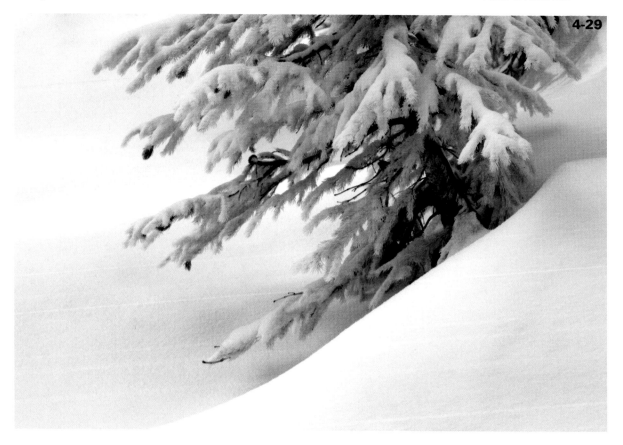

4-29

4-30

ABOUT THIS PHOTO *This color image of the St. Augustine lighthouse in Florida was taken for comparison to 4-42 to show the difference that IR light makes on a subject. Taken at ISO 100, f/11, 1/400 sec. with a Nikkor 24-70mm lens.*

Another body of work I keep adding to is light-houses. Lighting and weather conditions change, providing a different view of a familiar subject. I try to experiment with new angles, different lenses, and various techniques.

In 4-30, the famous St. Augustine, Florida, light-house appears in color. Its spiraling black-and-white stripes, and the red lantern room atop, are familiar features to area Floridians. In 4-31, you see a dramatic change, just by photographing it in IR. The lantern room appears white in IR capture, although it is red. As you might expect, the sky is very dark and the foliage is rendered bright white in IR.

ABOUT THIS PHOTO
IR renders the St. Augustine lighthouse in a classic way. Taken at ISO 100, f/11, 1/250 sec. with a Nikkor 24-70mm lens.

4-31

Assignment

Shoot for a Dramatic Sky

IR can transform a ho-hum sky and clouds into expressive, dynamic compositional elements — one that Ansel Adams would be proud of photographing. For this assignment, choose a subject that will be enhanced by the presence of a dramatic sky. It should be easy to find many prospects, such as landscapes, architecture, or even people, close to home. Include a sky filled with clouds — from the fascinating layers of stratus to the magnificent builds of cumulus, and in between — clouds that make the image more striking in IR. Photograph a specific subject of your choice, but always consider how IR capture will affect your subject and the background.

For my example, I included interesting foreground elements — a decorative, ornate fence and a lamppost. The main architectural subject has unique features and is surrounded by a sky with clouds, which accentuates the overall image. Taken at ISO 200, f/11, 1/125 sec. with a Nikkor 18-70mm lens.

Remember to visit www.pwassignments.com after you complete the assignment and share your favorite photo! It's a community of enthusiastic photographers and a great place to view what other readers have created. You can also post comments and read encouraging suggestions and feedback.

LONG EXPOSURES

REFLECTIONS

ADDING TEXTURE

ZOOMING

CREATING IMAGE OVERLAYS

SPECIAL EFFECT FILTERS

PAINTING WITH LIGHT

Now that you have tackled tricky exposures and creative compositions with your IR images, you are ready to move on to creating special effects. This is one of my favorite subjects. I'll show you how to work with your camera and lens to create impressive, one-of-a-kind effects that require little, if any, work in photo-editing software.

I'll cover photographing waterfalls in IR, and how to create the silky blur that beautifully conveys a sense of motion. Shooting through textured glass is a wonderful way to create artistic IR images, whether you are creating a mottled rain-streaked look, or a watercolor effect. Have you ever tried blending a color image with an IR image (5.1) for a hand-tinted look? Nighttime digital IR photography illustrates how you can transform a scene just by photographing at twilight or dark. I'll share with you how I created elegant IR photographs after dark by using a cross screen filter for creative effects.

Try a few of the special effects in this chapter with your digital IR photography to round out your compositions and explore creative opportunities. I'm sure you will be inspired to invent a few methods of your own.

LONG EXPOSURES

Long exposures can create artistic effects, and you can easily achieve them with IR photography. If you are using an IR filter on the lens (rather than using an IR-converted camera), exposure times

5-1

ABOUT THIS PHOTO *This image is a composite of two layered photographs, one captured in color and one in IR. I used a digital camera (unconverted) to make the first exposure. Next, I attached an IR filter to the lens to make a second exposure. I blended the two in Photoshop's Layers Palette by using the Soft Light blending mode setting the Opacity level at 80 percent.*

will be longer given that less light reaches the image sensor. Therefore, with little effort, you can create images that convey the passage of time and motion. This sense of motion can range from softly blurring the people moving through a scene, to slowing down waterfalls to create a silky, soft look. If you're using an IR-converted camera, you can create longer exposures the same way you would using a regular dSLR camera (using either available light, a polarizer, or a neutral density filter).

ABOUT THIS PHOTO *I photographed this tranquil scene after sunset and required a long exposure time. Using a cable release helped prevent camera shake from affecting the final exposure. Taken at ISO 100, f/11, 30 sec. with a Nikkor 18-200mm lens.*

CAPTURING A SUNSET

For example, photographing after sunset requires longer exposure times, as with this scene of a small boat at anchor on a lake (5-2). I did not need to use anything additional to slow down the shutter speed, such as a neutral density filter or polarizer — both of which reduce the amount of light entering the camera. The low light past sunset provided the perfect opportunity to capture and create the mirror-like reflections on the lake, creating a peaceful, sketched look. I found the IR version very pleasing in contrast to the color version, which I include here for you to compare (5-3).

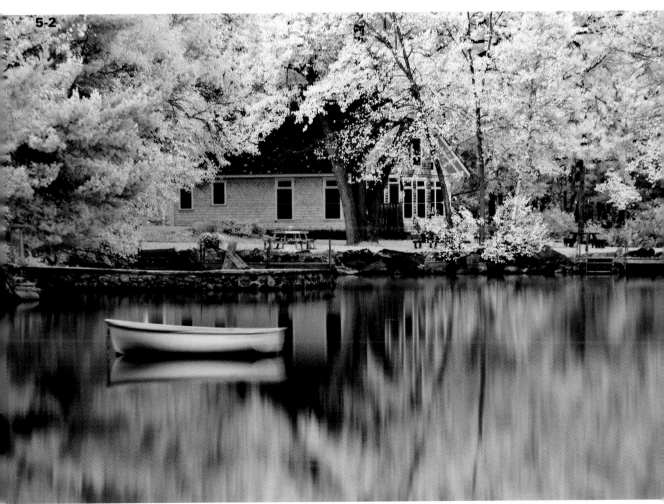

5-2

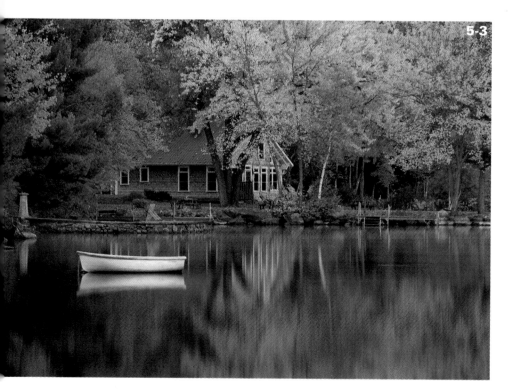

ABOUT THIS PHOTO
This color photo of the same scene as in 5-2 provides a comparison of color and IR versions of the same scene. Taken at ISO 100, f/11, 30 sec. with a Nikkor 70-200mm lens.

CAPTURING THE BEAUTY OF WATERFALLS

Have you noticed how waterfalls can be photographed in a variety of ways? You may see a waterfall image captured so that every droplet is frozen in midair (5-4), the motion suspended by a fast shutter speed and all the details captured in a split second. Or you may see a waterfall image portrayed in a softly blurred manner, creating a tranquil look that suggests the passing of time. Waterfalls can be mesmerizing, especially when photographed to suggest motion.

I photographed this waterfall (5-5) in the Endovalley area of Rocky Mountain National Park in Colorado. I like how the lichen and other organic elements were rendered in IR and how the soft blur of water flowed around and between the boulders. I wanted the viewer to be engaged by the sense of motion, to experience the rush of the water. You can accomplish this effect using a slow shutter speed, and I'll show you how to do this with your IR camera by following these steps:

1. **Set your camera on a sturdy tripod so you can make a longer exposure without producing blurry images created by camera shake.** This technique is the same as for photographing in color or with film. A sturdy tripod can make all the difference between a good shot and a bad one. You may want to use a cable release so that any movement that could cause camera shake, such as pressing or releasing the shutter, isn't transferred to the digital image. You can also use your camera's self-timer to avoid camera shake caused by pressing the shutter release button.

2. **Set your shutter speed to one quarter of a second to start with.** Experiment with shutter speeds from one to three seconds, or more.

3. **Use mirror lock-up if your camera has this option.** This flips the mirror inside your camera up before the shutter is released, reducing the opportunity for vibration that can affect sharpness in your final image. Refer to your camera's user guide on how to set your camera's mirror lock-up feature.

4. **Use a polarizer or neutral density filter to slow down the shutter speed.** A polarizer will also cut down on glare from water. You can experiment with either filter to see the effect it has on your subject.

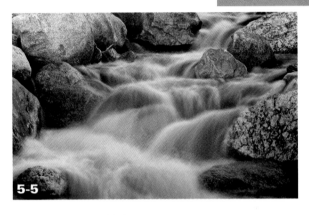

5-5

ABOUT THIS PHOTO *I waited until just past sunset to photograph the water rushing around these boulders. Low light created soft lighting (no bright patches of sunlight) and a long exposure showed the water as a silky blur. Taken at ISO 100, f/22, 1.5 sec. with a Nikkor 18-70mm lens.*

5. **When making your exposure, set your ISO at its lowest setting.** This will provide a long exposure time. A shutter speed of several seconds is desirable to convey motion. Remember that a smaller aperture provides a greater depth of field. Try a variety of shutter speeds and apertures so you have a variety of options from which to choose. The next time you photograph waterfalls, you should be able to recall certain exposures that worked well for you.

6. **Sunrise and sunset are both good times for waterfall photography because the sunlight is not as intense as it is during midday.** Overcast days also provide good options for slowing down shutter speed. A bright sunny day with direct light on the subject makes it difficult for longer exposures if you intend to create a soft blur with the water. Using an unconverted digital camera with an IR filter on the lens will automatically slow down exposure enough for the kind of long exposure that is needed to create a soft water blur.

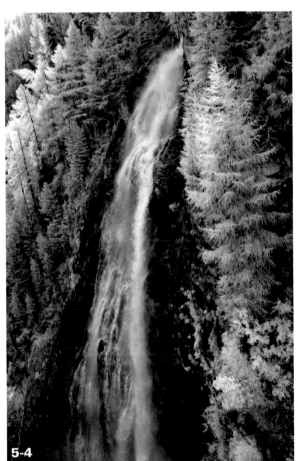

5-4

ABOUT THIS PHOTO *I photographed this waterfall image as a grab shot made through the window of a moving train in Zermatt, Switzerland. Taken at ISO 100, f/8, 1/200 sec. with a Nikkor 18-70mm lens.*

7. **When you are composing your waterfall image, look for the angle that will enhance the scene.** Look for different perspectives, close-ups and tight shots, wide angles — incorporate enough of the surroundings, such as boulders or a cliff face, to balance the subject and give a sense of place. Consider including elements in the foreground, perhaps a rock with a single leaf to add interest. Tonality, a good range of dark areas to light areas, is important in IR images; look for contrast to create a compelling image.

ABOUT THIS PHOTO *I photographed this tea room in Zermatt, Switzerland. I noticed first the wonderful baked goods, and then the reflections on the window of tourists passing by. Taken at ISO 400, f/5.6, 1/50 sec. with a Nikkor 18-70mm lens.*

REFLECTIONS

Photographing reflections is another of my favorite ways to create compelling IR images. A photo becomes very intriguing when there is double the interest, or twice the story. You can find reflections all around you: in a window, in a puddle, in a glass building, in a lake, in a glossy black car. Capturing reflections is easy — the challenging part is learning to envision them. Once you are tuned in to reflections and begin to anticipate them, you'll be on your way to photographing great reflection images.

For example, I was initially attracted to the baked goods in the window of this bakery in Zermatt, Switzerland (5-6). What I liked most was how

the window captured the reflections of the many passerby, creating an image with dual interest.

I found another example of reflections in window glass in St. Augustine, Florida (5-7). The pair of chairs looked inviting, and the window behind them reflected an interesting scene that included palm trees and boats from the nearby marina. Reflections embrace a scene within a scene. I finished with an edge effect from onOne PhotoFrame 4.0, which can create a captivating photo.

When I photographed a contemporary glass structure with a historic building reflected in its many panels, the angle and distortion of the glass created unique patterns and unexpected twists,

ABOUT THIS PHOTO *I carry an IR-converted compact camera at all times — it fits in my pocket and I never know when I'll need it. The image of these chairs makes an offer you cannot refuse. Come, sit with me, relax, and enjoy the charm of the seaside scene reflected in the window of this restaurant in St. Augustine, Florida. Taken with an IR-converted digital compact camera.*

5-7

ABOUT THIS PHOTO *I captured this reflection of a historic building in a contemporary glass structure in downtown Sarasota, Florida. Taken at ISO 400, f/11, 1/40 sec. with a Nikkor 70-200mm lens.*

5-8

similar to a kaleidoscope (5-8). The patterns of the reflections changed depending on the angle I photographed from, creating many choices in interpretation.

The simplest of reflections is often close at hand, and may be the most beautiful. One early morning I was driving past a lake that was mirror-perfect (5-9). I pulled over to photograph it before the wind could disturb the calm water. Large oak trees mirrored in the serene water reflected blue sky, providing good contrast and creating a pleasing image.

5-9

ABOUT THIS PHOTO *These reflections on a lake I photographed in downtown Orlando, Florida, were mirror perfect. I used the Channel Mixer in Photoshop to re-create the vivid blue sky reflected on the still water of the lake. Taken at ISO 100, f/11, 1/125 sec. with a Nikkor 18-70mm lens.*

ADDING TEXTURE

When you want to create a sense of dimension or a dreamlike mood or a painterly effect, add a dash of texture. Remember to keep it subtle. The idea is to complement your image in addition to making it a one-of-a-kind masterpiece!

VASELINE DIFFUSION

You can use Vaseline diffusion to create a soft, blurred vignette around the subject, similar to the Lensbaby (www.lensbaby.com) look. The only thing you need is a UV filter dedicated to diffusion use and a touch of petroleum jelly around the perimeter. This technique requires a little experimentation to see the effects, but it's very easy and creates a gently blurred vignette (5-10). This effect can give a soft, romantic look to the subject and works beautifully with portraits. Begin by applying petroleum jelly in a thin layer to only the outside edge of the UV filter (not the lens), keeping the center free of Vaseline. Experiment with adding more layers of petroleum jelly and check the camera's display to see where

5-10

ABOUT THIS PHOTO *Colored chairs make a lovely subject in IR. I used a camera with an enhanced color IR filter, and a UV filter with petroleum jelly applied around the perimeter to create a soft blur. Taken at ISO 400, f/11, 1/80 sec. with a Nikkor 18-70mm lens.*

and how the effect works with your composition. Try varying the thickness of the jelly or applying it sparingly to the center of the filter for different results. When you've finished shooting, you can wipe your filter clean (with a microfiber cloth that you can throw away afterward) and store it for use another time.

FABRICS

Like petroleum jelly, you can use fabric to create diffusion effects. If you hold a piece of translucent fabric, such as tulle or netting, in front of the lens during exposure, it can create a dreamy quality (5-11). It is a simple, inexpensive way to experiment with digital IR photography. Try it yourself.

5-11

ABOUT THIS PHOTO *Photographing this faux floral display through fabric provided diffusion for the overall image. Finished with an edge effect from onOne PhotoFrame 4.0. Taken at ISO 400, f/11, 1/3 sec. with a Nikkor 18-70mm lens.*

With a piece of fabric suspended in front of the lens, focus on your subject with a wide aperture and see the softly out-of-focus effect that the fabric has on the image. Experiment with different types of sheer fabrics and have fun! This technique is suited for wedding portraits, artistic effects with floral images, or your own creative vision.

tip Tulle or netting imbedded with small reflective glitter pieces creates highlights that are very attractive with portraits of people and floral arrangements; and gives any image a soft touch.

SHOOTING THROUGH GLASS

Another of my favorite creative techniques is to photograph through textured glass. The texture of the glass can be distinctive, creating a one-of-a-kind effect for each image.

A wide variety of glass types are available through stained glass supply stores. A great choice is Spectrum glass (www.spectrumglass.com). This company manufactures many types of clear textured glass, and you only need a small piece, approximately 12 by 12 inches in size. Try Spectrum's Artique, Hammered, Granite, and Baroque styles; or any piece of glass with enough clarity and texture to enhance your IR image.

tip Handling cut glass requires care. Cover the edges with masking or electrical tape so that you don't nick your fingers.

There are several techniques for shooting through glass. One method is to set the glass upright and photograph the subject through it. Another is to take a digital IR print and place the glass over the print and photograph the print through the glass. Both methods create very artistic effects. You can control the intensity of the distortion by slightly raising or lowering the glass when shooting down at a print. Experiment to find the best results for the print you are working with. The effect is primarily determined by the type of glass texture, and by its distance from the print.

I like to photograph IR prints directly through textured glass, usually with the glass an inch or less above the print. This way I can experiment with various types of glass to see the effect they have on my image. This technique is perfect for use on overcast days, which are less likely to cause reflections on the glass while you are photographing through it.

To create the photo in 5-12, I set up my tripod above an 8x10 print of a European castle that I photographed in IR. Directly on the print, I placed a piece of glass that had a hammered type of texture. When I photographed the print through the glass, it created wonderful wavy distortion throughout the image. When I raised the glass about a half an inch, the distortion took on a different aspect.

This is actually a lot of fun, because the results are serendipitous and vary with glass type. It's reminiscent of looking through antique windowpanes, where the glass appears almost melted and everything outside has movement due to the wavy glass pattern.

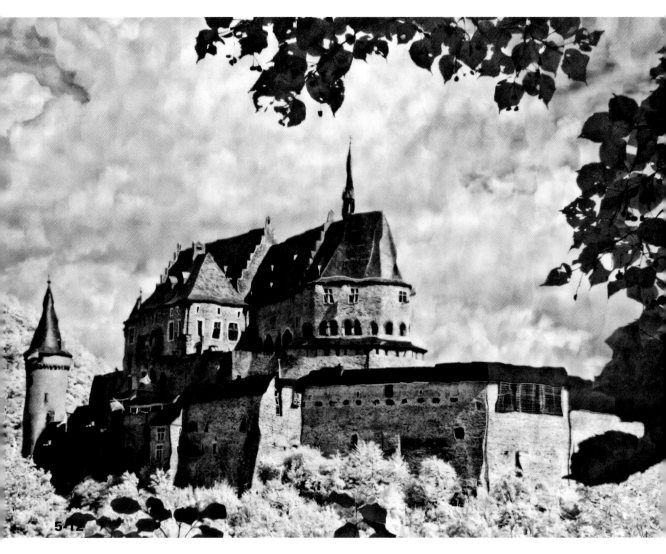

ABOUT THIS PHOTO *Photographing through glass that has a hammered texture provides interesting distortions throughout a digital print of an IR image. Taken at ISO 100, f/11, 1/2.5 sec. with a Nikkor 24-70mm lens.*

If I were looking out a window on a rainy day, I might encounter a scene like the one I was able to create shooting through glass with a granite-like texture (5-13). I raised the glass about one inch above the IR print, which distributed the texture throughout the image in a way that suggested a rain-soaked window. A close-up of the print (5-14) illustrates the effect of the glass texture.

ABOUT THIS PHOTO
I photographed this IR print of a European street scene using clear glass with a granite texture. The resultant image has an IR watercolor look. Taken at ISO 100, f/11, 1/4 sec. with a Nikkor 70-200mm lens.

5-13

ABOUT THIS PHOTO
This is a close-up of the effect of photographing a print through glass. The random texture that occurs through the glass provides unique distortions throughout the print. Taken at ISO 400, f/11, 1/40 sec. with a Nikkor 70-200mm lens.

5-14

ZOOMING

Zooming during an exposure is another creative technique that conveys a sense of motion in a photograph. You can easily achieve this using a zoom lens, with or without a tripod. I find it easier to use a tripod, as it offers more control, especially in situations where the light is low. The trick is to use a shutter speed slow enough to enable you to record the effect of rotating the lens (zooming in or out) during exposure. The effect can be quite dramatic and gives a dynamic look to the image (5-15). Another idea along these lines is to rotate the camera, rather than the lens, for a swirled effect. You do this using a lens that has a collar, such as Nikon's 70-200mm lens. When you mount the lens on a tripod, you can easily rotate the camera and lens at the same time by releasing the tension on the tripod collar.

CREATING IMAGE OVERLAYS

You can create yet another very unique effect in digital IR photography by overlaying one image with another. Some cameras have the ability to record multiple exposures. Photographers using cameras without this feature can create multiple exposures in Adobe Photoshop for a similar effect.

x-ref | I cover creating multiple exposures in Chapter 8.

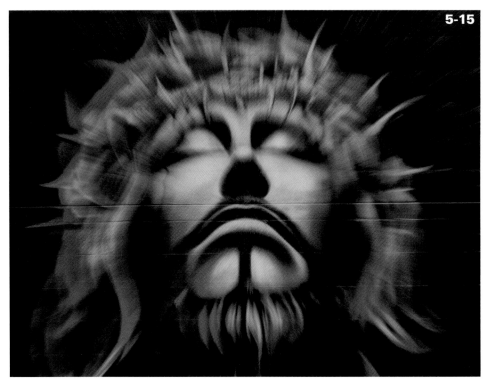

5-15

ABOUT THIS PHOTO *This graffiti art was made by RIC, who creates his art on the south wall of Pho 88 restaurant in Orlando, Florida. Using a tripod, I focused on the subject and then zoomed the lens for a creative effect. Taken at ISO 100, f/29, 1/20 sec. with a Nikkor 18-70mm lens.*

DOUBLE EXPOSURES

Some cameras, such as many Nikon cameras, are capable of creating multiple exposures. You can shoot an image, and then select a second image to incorporate with the first.

You can adjust the opacity to emphasize either image, or leave it at the default settings. Because the camera has the ability to use RAW files, the image overlay quality is excellent. The opportunities are limitless for this composite feature. Don't be afraid to experiment and try different things — after all, it's digital!

For dreamlike composites, photograph cloud formations or textures and merge them in-camera with a second image. For example, I chose a photograph of a heron to overlay with a photo of clouds that I took at the same location (5-16). This simple addition provided more interest and detail to the background, enhancing the shot of the heron as well as the overall image.

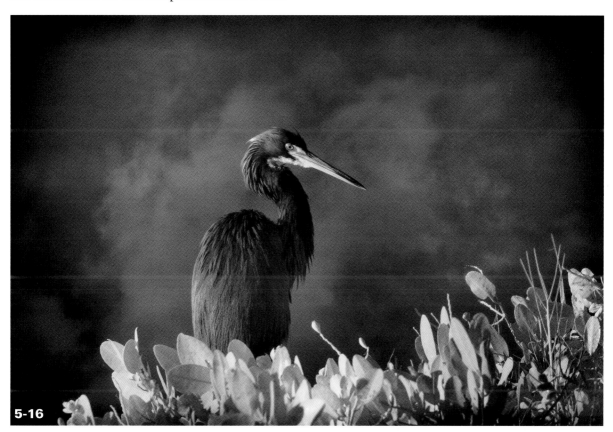

5-16

ABOUT THIS PHOTO *I created this image overlay in-camera by choosing two images to merge. The first photograph was a heron perched on a mangrove, and the second image was of clouds. I photographed both images at the Merritt Island National Wildlife Refuge in Florida. Taken at ISO 200, f/8, 1/125 sec. with a Nikkor 200-400mm lens, and 1.4 teleconverter.*

DIGITAL SANDWICH

To get an effect similar to the one you get sandwiching slides, use a camera with an image overlay or multiple exposure feature. Slide sandwiches or digital sandwiches are a popular way to create a dreamy, soft-focus look that adds interest to an IR image. Originally, this was done in film photography by sandwiching two slides together, one in sharp focus and the other softly blurred. This technique provides a glow to the image, which can be quite desirable (5-17). To create this effect in-camera, follow these steps:

1. **Photograph the subject using a tripod and a long lens using maximum depth of field.**

2. **Make a second exposure of the same subject at the widest aperture, slightly defocused so that the image is no longer sharp (creating an out-of-focus blur).** Multiple-exposure-enabled cameras can combine these two RAW files to create a new composite.

3. **The results appear right away on the camera's LCD.** If your camera doesn't have this feature, Chapter 8 covers how to create beautiful digital sandwiches in Photoshop.

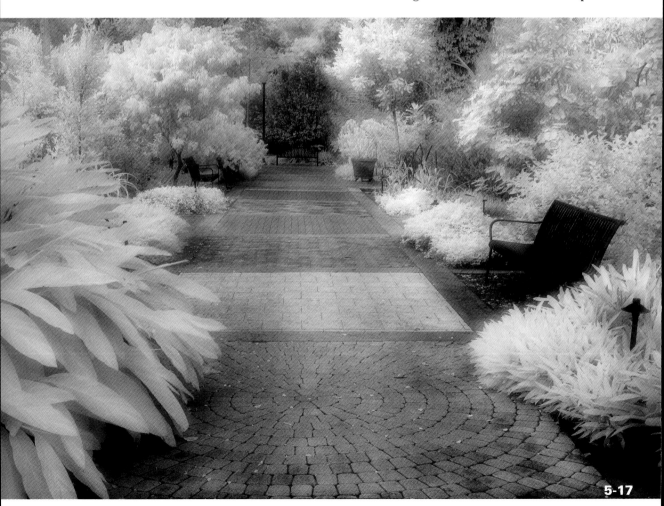

5-17

ABOUT THIS PHOTO *This digital sandwich was created in-camera by blending an out-of-focus image with a sharp image for a softly blurred, glowing effect. Taken at ISO 100 (two merged exposures) with a Nikkor 18-70mm lens.*

BLENDING A TRADITIONAL COLOR IMAGE WITH IR

Try using an IR filter on your color digital camera and photograph the same scene twice, once in IR and once in color. If you have a multiple exposure feature on your camera (many Nikon cameras and some new Olympus models do), the two images can be merged together in your camera's software. Or, you can use Photoshop to blend the two images together.

x-ref | Multiple exposures are discussed in more detail in the montage section of Chapter 8.

The image in 5-18 is the result of merging two photographs, one color (5-19) and one IR (5-20). At a local garden center, I set up my camera on a tripod and photographed some flowers in color. Then I attached a Hoya R72 filter to the lens and photographed the same scene. I blended the images in Photoshop by dragging the color image over the IR image (creating a new layer) and changing the layer blending mode to Color. I reduced the opacity of the color layer slightly and added a glow using filters in Photoshop to give the image a hand-colored look. You can experiment with various blending modes and opacities for the look that best suits your image.

5-18

ABOUT THIS PHOTO *This image is the result of blending two images together in Photoshop, one color (5-19) and one IR (5-20). I set up my unconverted camera on a tripod and photographed the flowers. Next, I attached a Hoya R72 filter, turned off the camera's autofocus, and made a second exposure of the flowers, this time in IR.*

5-19

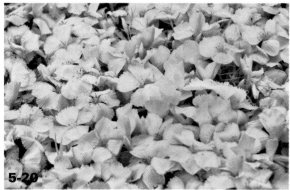

5-20

SPECIAL EFFECT FILTERS

Although there are many creative filters built into Photoshop, several special-effect camera filters work particularly well for IR photography. Two filters you might want to try with IR are a diffusion filter, which provides soft focus, and a cross screen filter, sometimes called a *star-effect* filter (creating a four-, six-, or eight-pointed star). You can also achieve a starburst effect using a small aperture (f/11-f/16), but the cross screen filter gives you a showy starburst effect on various points of light in an image anytime.

You can put the cross screen filter to particularly good use by photographing at night with digital IR using available light, such as streetlights and lights inside and outside buildings. My favorite images are the ones I photographed using a camera that was converted with a 665nm filter (an enhanced color IR filter), which allowed me to capture a scene with more visible color than my standard IR-converted camera.

I used a cross-screen 4X filter to create starburst effects on the points of light in this nighttime cityscape image (5-21). I drove to a nice vantage point and hoped to not get ticketed for stopping on an overpass! I quickly photographed a succession of images from my open car window. The starbursts vary in size from the light points and the filter created a glamorous night scene.

With color photography, red taillights are recorded as red streaks in an image using an exposure time of several seconds. With IR photography, taillight streaks are recorded as white, which worked well

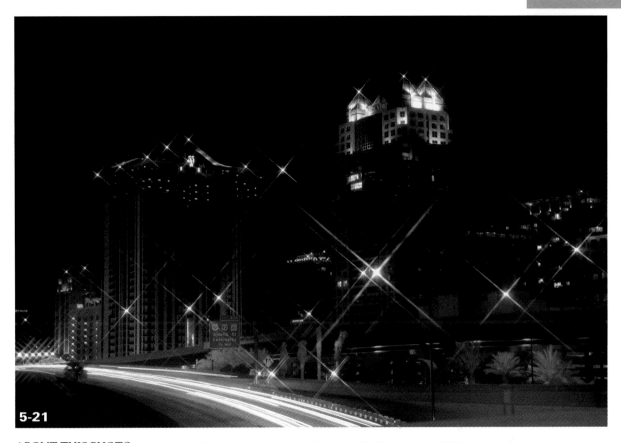

5-21

ABOUT THIS PHOTO *I photographed this cityscape in downtown Orlando, Florida. A cross-screen 4X filter created a starburst effect on many light points in the image. I used my IR-converted dSLR, which has an enhanced color IR filter that creates a more colorful night scene. Taken at ISO 200, f/7.1, 2.2 sec. with a Nikkor 18-70mm lens.*

with the color scheme of this image at night. Using a cross screen filter enhanced the glow of blue, gold, yellow, and white lights in the image.

PAINTING WITH LIGHT

I created my first digital IR image by actually painting with light. I had just received my Hoya R72 in the mail and was very anxious to try out my camera and IR capabilities with this new filter. I wanted to photograph the bottlebrush tree in my yard, but it was evening by that time. However, I knew I had an IR heat lamp, so I cut a small branch from the tree. I set my camera up on a tripod so that my hands were free to evenly

light the bottlebrush branch by waving the lamp back and forth over the leaves. The results were very exciting for a newbie to the world of IR.

Conventional painting with light works well with a variety of flashlights, penlights, or larger torch lights (they emit IR light, along with visible light). They should serve you well for IR photography, too. Try painting a large flower, or if you are particularly ambitious, try light-painting a person with light. Follow these steps:

1. **Mount your camera on a tripod.**

2. **Use the Manual mode, and time the exposure using a shutter release cable and the Bulb setting.** The length of the exposure will

103

be determined by the time you choose to press and release the shutter.

3. **Experiment by painting over or around your subject with a penlight or flashlight, depending on the size of your subject.** I painted this gerbera daisy with a penlight in a darkened room, creating several images until I was pleased with the results that I could see on my camera display and monitor (5-22).

You can also experiment with objects on a light box. The light box will provide enough IR illumination for images such as this leaf skeleton (5-23). I liked the golden tones the light box provided in contrast to the leaf and used this light source as a creative and alternative way to work with IR photography.

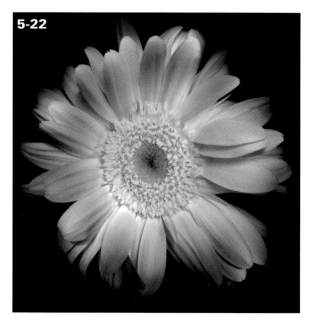

5-22

5-23

Assignment

IR Fun with Special Effects

Many of you have favorite locations. You may know the best angles, the best time of day, or the best time of year for shooting there. Still, you enjoy finding new challenges in these places or inventing a new way to portray a familiar subject. This is how I felt when I decided to photograph Lake Eola in downtown Orlando, Florida. I had photographed this lake in the morning, in the afternoon, at twilight and at night, sometimes in color and IR, but I had never photographed it at night in IR.

This is one of the things I love most about digital photography: There is always a new avenue to explore, a new technique to try. I took the opportunity to photograph it in a different way using a converted camera with an enhanced color IR filter. For this assignment I combined several special effects: a long exposure that softly blurred the water in the center fountain, the reflection on the mirror-perfect lake, and the use of a cross screen 4X filter for shimmering lights along the shoreline. This image was taken at ISO 100, f/8, 20 sec. with a Nikkor 18-70mm lens.

For your assignment, I encourage you to try something in IR that you haven't tried before. You might experiment with photographing a waterfall as a silky blur. Or, you might want to try photographing through textured glass for an artistic rendering of your IR print. Perhaps you could capture a reflection on a nearby pond or lake. Or if you are more adventuresome, try photographing in IR at twilight or night and use a cross screen filter for brilliance.

 Remember to visit www.pwassignments.com after you complete the assignment and share your favorite photo! It's a community of enthusiastic photographers and a great place to view what other readers have created. You can also post comments and read encouraging suggestions and feedback.

High Dynamic Range (HDR) photography is exciting, creative, and technically amazing. HDR entails shooting the same scene at various exposures and merging the images afterward using software applications such as Adobe Photoshop or Photomatix Pro. A very recent addition to the tools available for use in the digital darkroom, HDR photography allows you to record everything in the original scene — the highlights, the mid-tones, and the shadows — with incredible detail. You can easily shoot several exposures of a scene and merge the images through software, and the process enables you to create images with phenomenal dynamic range (see 6-1).

An IR or color photograph created using HDR techniques incorporates a range of data that your digital camera may not be able to record in a single exposure. HDR images allow you to see the brightest highlight areas, and the darkest shadows at the same time. The highlights are not washed out and the detail is not lost in the shadow areas.

6-1

ABOUT THIS PHOTO *IR and HDR work beautifully together as shown in this resultant image photographed at the Pinewood Estate in the historic Bok Sanctuary, Lake Wales, Florida. I used three exposures with various shutter speeds to merge into HDR. Taken at ISO 200, f/11, with a Nikkor 24-70mm lens.*

HDR COMPARED TO USING A GRADUATED NEUTRAL-DENSITY FILTER

In traditional, non-HDR photography, a graduated neutral-density filter (dark on the top and gradually becoming clear on the bottom) is often used to balance an exposure, such as darkening a bright sky in a landscape.

In addition, the photographer chooses to expose for either the highlights or the shadows, as most digital cameras have limited dynamic range. The result is a loss of detail in the area not exposed for — either in the highlights or the shadows.

HDR changes all that. When the scene has too much of an exposure difference between the highlight areas and the shadow areas, many digital photographers now choose to create an image in HDR by taking several exposures — each at a different exposure setting — and blending them together in Photoshop or another imaging application. This makes photographing during the middle of the day an even more attractive option for the IR photographer.

HDR SOFTWARE

Several software applications can produce incredible HDR images, including Photoshop, Photomatix Pro (www.hdrsoft.com), and the Windows-only Dynamic-Photo HDR (www.mediachance.com). You can create images with HDR right in Photoshop following these steps:

1. **Choose File ⇨ Automate ⇨ Merge to HDR.**

2. **You can then render this image as a realistic photo or incorporate an illustrative effect.**

3. **You can create an edgy, graphic look using other software applications.** Try the Photomatix Tone Mapping filter, or the Tonal Contrast filter that is part of Nik Color Efex Pro 3.0 Complete Edition of Photoshop-compatible plug-ins. Or, use Topaz Adjust to enhance the detail, color, and contrast in the image.

As an example, I made five different exposures of the engine detail of a vintage C-47 aircraft, the *Tico Belle*. I merged the exposures in Photoshop to create a final photograph (see 6-2) that shows exquisite detail in both the shadow and highlight areas. After merging the images to HDR, I used the Tone Mapping filter available in Photomatix Pro to create a very detailed, textured look. The Tone Mapping filter is also available as a Photoshop plug-in.

> **note** The talented and creative Ben Willmore (www.thebestofben.com) perfected his much-admired illustrative technique using software such as Photomatix.

Are you ready to give HDR a try with your IR photography? You are in for some exciting digital-imaging fun! The first step is to plan for an HDR image while you are out photographing. That means taking several exposures of the same scene at different exposure settings — with the goal of creating a single image showing all the varied levels of brightness. This combined HDR image will produce a great amount of detail in both the shadows and the highlights.

6-2

SHOOTING FOR HDR

When you shoot for HDR, it is important to follow these guidelines to create a captivating HDR IR image:

1. **Make sure the camera is set to record in the RAW format, which provides the widest dynamic range.**

2. **Use a sturdy tripod, and utilize the camera's auto-bracketing function or bracket manually.**

3. **Use the camera's continuous speed mode to move through the exposures quickly if you are using the auto-bracketing mode.** This minimizes the chance of camera movement and helps with the alignment of the images necessary to process HDR.

> **tip** If anything in the image is moving, it will be out of register in the final image. If clouds, trees, or people are in motion, taking the exposures quickly should help reduce alignment issues later.

4. **Set your camera to the Aperture Priority mode.** You do not want the aperture to change. If it does, your depth of field changes, and what you have in focus will change. This will also cause misalignment of the images that you choose to merge to HDR. Generally speaking, you want to use a small f-stop for maximum depth of field.

5. **Make a test exposure to find a starting place (the best overall exposure) for the rest of the exposures.** Take a look at the histogram for your starting image before executing the bracketed sequence.

6. **Once you have found the right starting place, turn off the camera's autofocus.** If the autofocus is left on, the camera refocuses, and the images will be out of alignment with each other. When you shoot manually, the starting exposure will be the image with the correct exposure for the subject.

7. **Make a second exposure two stops over the correct exposure.** Next make a third exposure, two stops under the correct exposure. You'll then have three exposures to merge to HDR. You can check the camera's LCD and determine if the shadows and highlights have enough detail.

8. **If needed, you can make additional exposures at even greater under- or overexposure.** You can decide how many stops apart are needed for your subject. If the dynamic range is very great, then you may need two stops apart. If not, then perhaps one stop over and under would work for your subject. It's always better to have more images to work with than not enough.

9. **If you are using the camera's auto-bracketing function, set it up so that you end up with five or more bracketing images.** Some cameras can auto-bracket two stops apart; if this is the case for you, fewer exposures may be needed. Other cameras can bracket one stop, and, in this case, more exposures would be needed to work within HDR.

That is all there is to it! Now you're ready to merge to HDR in Photoshop or another HDR program.

PROCESSING HDR IMAGES

There are several ways to approach processing your HDR images. You can use Photoshop to merge and optimize your HDR images. Or you can use Photomatix Pro, which includes the Tone Mapping filter to process your HDR images. The Tone Mapping filter is available as a bundle with Photomatix Pro. This choice allows you to use the Tone Mapping filter in Photoshop in addition to using it in Photomatix Pro. I use both Photoshop and Photomatix Pro to merge the HDR images and process them with the Tone Mapping filter. Sometimes one works better than the other with certain HDR images, try and see which one works best for you.

USING PHOTOSHOP FOR HDR

When you process your HDR images in Photoshop, you can begin by following these steps:

1. **Launch Bridge and then select the images to merge to HDR.**

2. **Select multiple images using the Shift or the ⌘ key.**

3. **From the Menu, choose Tools ⇨ Photoshop ⇨ Merge to HDR.** Or from Photoshop, choose File ⇨ Automate ⇨ Merge to HDR.

It will take a little time for the individual images to be processed into a single HDR image, so be patient.

When this is finished, a panel opens with the HDR image. The source images appear on the

left. You can exclude any of them at this point. Deselect an image by clicking in the check box next to each image. This is helpful if you notice one image that isn't in alignment with the others.

The image that you see in the Merge to HDR panel is only a preview. Don't be concerned if it doesn't look the way you think it should. It's simply a representation of the dynamic range. Move the slider underneath the histogram from left to right and notice how the preview changes.

To continue editing your HDR image in Photoshop, follow these steps:

1. **In the Merge to HDR panel, change the Bit Depth (from the pop-up menu) from 32 Bit/Channel to 16 Bit/Channel.**

2. **Click OK (see 6-3).** The HDR image automatically opens in Photoshop with an HDR Conversion control panel.

3. **In the HDR Conversion control panel, you can further process the HDR image.** You can make adjustments for Exposure and Gamma; Highlight Compensation; Equalize Histogram; and Local Adaptation. The application default for Method is Exposure and Gamma.

4. **Click the arrow on the right to change the Method default to Local Adaptation.** Sliders appear for Radius and Threshold, as well as a downward-pointing arrow for Toning Curve and Histogram.

5. **Click the arrow to reveal the Toning Curve and Histogram (see 6-4).** Move the endpoint on the left toward the left side of the histogram. Adjust the right side by dragging the endpoint on the top toward the curve and click OK.

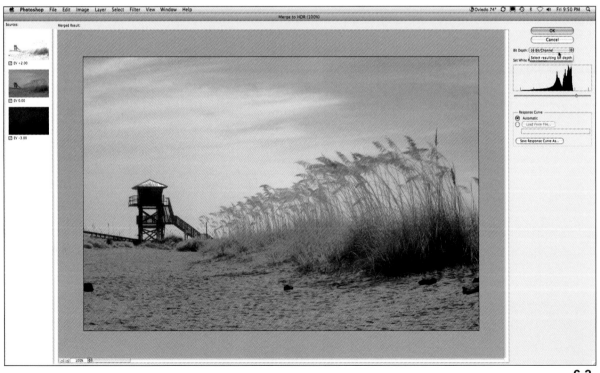

6-3

ABOUT THIS FIGURE *In the Merge to HDR panel in Photoshop, you can select or deselect images images individually using the check boxes on the left. Change the Bit Depth to 16 Bit/Channel, click OK to open the merged HDR image in Photoshop.*

ABOUT THIS FIGURE *The HDR Conversion panel shows the drop-down menu to select Local Adaptation and the Toning Curve and Histogram.*

6-4

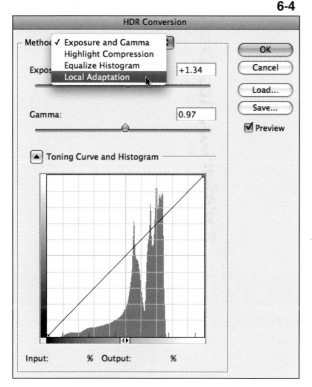

6. **Photoshop converts the image so that you can work with it a little more.** You can optimize your image in Photoshop. Or if you have Photomatix installed, you can use the Tone Mapping filter or other plug-ins depending on your desired outcome for the image.

USING PHOTOMATIX PRO FOR HDR

To use Photomatix Pro to merge HDR images instead of Bridge or Photoshop, follow these steps:

1. **Open Photomatix Pro and choose Generate HDR Image.**

2. **You can drag and drop images into the Photomatix Pro panel or can select them through the Photomatix Pro panel.** Once

you have selected the images, Photomatix Pro can merge them and will provide the Tone Mapping filter to optimize your image like the one shown in 6-5.

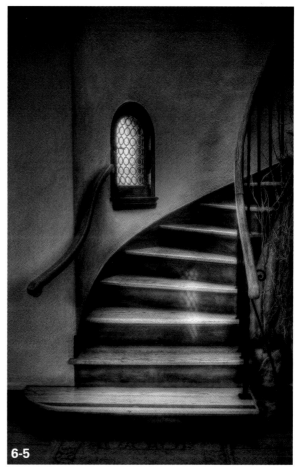

6-5

ABOUT THIS PHOTO *Indoor IR creates an elegant statement in an HDR image. This image was optimized using the Photomatix Pro Tone Mapping filter to enhance the details and create an illustrative look. Photographed in Casa Feliz, Winter Park, Florida. Taken at ISO 100, f/11, 5s with a Nikkor 24-70mm lens.*

3. **You can choose to create a pseudo-HDR image from a single RAW file in Photomatix Pro.** This may be advantageous when a scene includes people in motion or a lot of activity.

> If you are a Mac OS user, drag the RAW file into the Photomatix icon in the dock.

> If you are a Windows user, drag the RAW file into the Photomatix icon.

> The resultant image isn't a true HDR file, as only one image was used, but it allows you to make use of a single image (see 6-6) to create a faux HDR photograph.

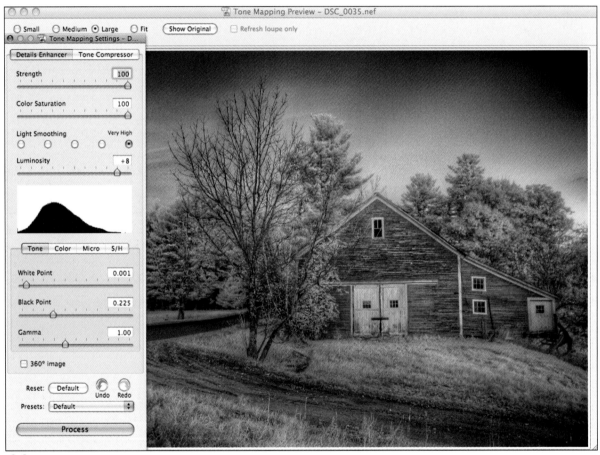

6-6

ABOUT THIS FIGURE *I used a single RAW file to create a pseudo-HDR image in Photomatix Pro. Once Photomatix Pro processes the single file, you can use the Tone Mapping filter to further process the image. This is an advantage for images that have too much motion or too many people in action.*

PHOTOMATIX'S TONE MAPPING FILTER

In both applications, the Tone Mapping filter will be of interest to you because how you use it affects the outcome of your HDR IR image.

You can take your image to a range of artistic destinations, from photorealistic (even beyond what our eyes can see) to edgy and artistic. Compare 6-7 to 6-8. It's great to have creative choices!

I like the realistic look that HDR provides in my IR images, with the intriguing amount of details in the highlights and shadows. However, I also appreciate the highly artistic look. As a creative photographer, you can go either direction using Photomatix Pro's Tone Mapping filter.

6-7

6-8

ABOUT THIS PHOTO *This photo represents three exposures of the same scene and I used the Tone Mapping filter to make it photorealistic. Taken at ISO 100, f/11, with a Nikkor 12-24mm lens.*

ABOUT THIS PHOTO *In comparison to 6.7, this image takes on a more illustrative approach. I used the Tone Mapping filter in Photomatix. Taken at ISO 100, f/11, with a Nikkor 12-24mm lens.*

After merging your IR images to HDR, you can select the Tone Mapping filter in either Photomatix Pro or Photoshop:

- After merging to HDR in Photomatix Pro, a panel opens next to your image. Choose Tone Mapping.

- In Photoshop, from the Menu, choose Filter ⇨ Photomatix ⇨ Tone Mapping.

 tip Keep in mind that photography, like any art, is very subjective. What you like may not be what someone else likes. My advice: Follow your intuition and do as you wish.

If you want to create a realistic photographic HDR image without any special effects, you can achieve this using the Tone Mapping filter with a few simple adjustments. If you want more creative effects, you can also use the Tone Mapping filter. Take a look at the following tools you can use within the Tone Mapping panel:

- **Use the Detail Enhancer to adjust the sliders to suit your IR image.**

- **The Strength slider controls the degree of the effect, and the Saturation slider controls exactly what its name implies, the overall *saturation* or intensity of any color in your image.** This may or may not be relevant depending on what type of IR filter you are using. Moving the slider to the far left produces a grayscale image.

- **Light Smoothing controls contrast through the image.** It looks more realistic with a setting of High to Very High. The Luminosity slider affects the shadow details if it is moved to the right, and gives the image a more natural appearance if it is moved to the left.

- **You can adjust White Point and Black Point from the Tone tab.** These sliders control the values for black and/or white and you can set them to suit your image.

- **The Gamma slider affects the mid-tone of the image, making it darker or lighter.**

- **You can make adjustments to color temperature, saturation highlights, and shadows, through the Color tab, although I rarely make adjustments in this tab for IR images.**

- **From the Micro tab, you can move the Microcontrast slider toward the left side for realistic-looking images and toward the right side to accentuate details.** Microsmoothing reduces noise. When you move the Microcontrast slider toward the right, the image has a cleaner look; you reduce this effect when you move the slider toward the left.

Follow these general guidelines for realistic-looking images, such as the Corvette's engine detail shown in 6-9:

1. Use lower settings for Strength and Luminosity.

2. Keep Light Smoothing as high as possible.

3. Choose Microsmoothing at a high setting.

4. Keep Microcontrast at the lowest setting.

For a more grungy detailed effect, use these suggestions:

1. Use high settings for Strength and Color (if any color suits your IR image).

2. Keep Light Smoothing at a high setting.

3. Keep Microsmoothing at the lowest setting.

4. Keep Microcontrast at a high setting.

6-9

ABOUT THIS PHOTO *I processed this HDR image of a 1971 Corvette Stingray for a photorealistic approach using the Tone Mapping filter. Taken at ISO 200, f/11, with a Nikkor 18-70mm lens.*

Once you are pleased with how the image is Tone Mapped, click OK.

You can use the Tone Mapping filter for an edgy, artistic appearance that works fantastically on IR images such as the Edison-Ford House (see 6-10). This method greatly enhances detail and texture in a scene, such as wood grain, delicate veining in leaves, and even mechanical intricacies, and provides a unique interpretation of your IR image. The effect of the Tone Mapping filter when used in this illustrative way is quite captivating.

The inside of a church in 6-11 provided a wonderful opportunity to photograph in both IR and HDR. The tone and grain of the wood pews, along with the texture of the columns and pavers, made great subject material. I used Nik Color Efex Pro's Bi-Color filter to enhance the image with golden tones.

 note Bi-Color filters are part of both Select and Complete Editions of Nik Color Efex Pro.

Metallic subjects such as the moving propeller and engine parts that I photographed on the *Tico Belle* (see 6-12) hold intriguing detail for the viewer. Every bolt and rivet is evident on the plane's underbody, and the mechanical parts are interesting to view in part due to the fine detail.

Here is how you can achieve these results with the Photomatix Tone Mapping filter, creating a very detailed artistic look with IR photography:

1. **In the Tone Mapping panel under the Detail Enhancer tab, move the first two sliders, Strength and Saturation, to the right.** You can adjust them again later.

2. **Choose High to Very High in Light Smoothing.** These selections range from Very Low to Very High.

3. **Adjust the Luminosity slider to suit your image.**

4. **Under the Tone tab, adjust the Black Point and White Point sliders.** The adjustments will vary from image to image.

5. **Click the Micro tab.**

ABOUT THIS PHOTO *The Tone Mapping filter can be used in an artistic way as shown with this HDR IR image of the Edison-Ford House in Fort Myers, Florida. Taken at ISO 100, f/16, with a Nikkor 24-70mm lens.*

ABOUT THIS PHOTO
HDR shows the detail inside the interior of the Knowles Memorial Chapel in Winter Park, Florida. The image was toned to create golden hues by using Nik Color Efex Pro Bi-Color filter. Taken at ISO 100, f/11, with a Nikkor 24-70mm lens.

6. **Move the slider for Microcontrast to the right and move the slider for Microsmoothing to the left.**
 Microsmoothing is generally used more for photorealistic images and will work against the illustrative look you are creating.

7. **Click the Tone tab, and tweak and adjust to your heart's desire.**

You can process any image a second time using the Tone Mapping filter to further push creative enhancements if you are going for an edgy, detailed look. I like to do this with most of my HDR IR images. For another creative option, I may use the Nik filter Tonal Contrast, or work from one of the Topaz Adjust presets, which gives the image a highly detailed look similar to the Tone Mapping filter.

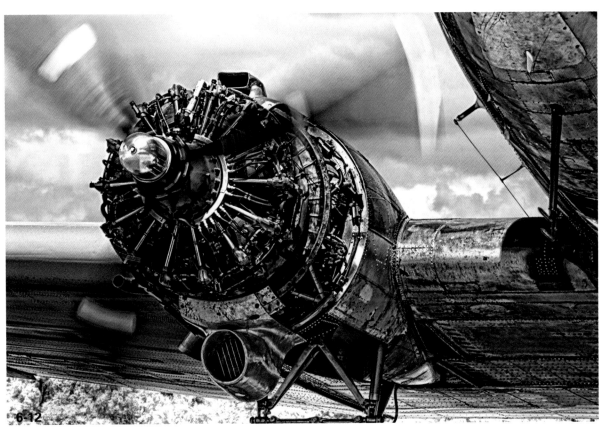

6-12

ABOUT THIS PHOTO *IR and HDR make a great combination to enhance the contrast and details of the engine detail of this C-47 airplane with the propeller engaged. Taken at ISO 100, f/16, with a Nikkor 70-200mm lens.*

CREATING PANORAMAS WITH PHOTOMERGE

The breathtaking scope of a sweeping panorama landscape can be awe-inspiring in and of itself. In the past, only a special and expensive panorama camera could capture the super-wide view — 180 degrees or even more.

Things have changed thanks to digital imaging. A compact digital camera can be used for panoramas by simply photographing sections of a scene and then stitching the images together using the Photomerge feature in programs such as Adobe Photoshop and Photoshop Elements.

Photomerge precisely stitches images together in mere minutes; they actually look like one photograph and do not have the blending issues (lines between images) sometimes found in previous versions or in other image-stitching software programs. In fact, Photomerge works so well you might not even need to use a tripod when taking the photos for your panorama.

In the panorama in 6-13 of a mountain range in Switzerland, I hand-held my camera as I took six images in succession from left to right. I needed no special equipment, no planning, and no software other than Adobe Photoshop or Elements.

Panoramas can be wide, tall, square, or freeform. Creating a panorama can be as simple as photographing two images and blending them together. For example, in 6-14 I photographed the remnants of an old aircraft and the clouds above it. I wanted a square-format image that the two blended photos would provide. The final merged image looks as though it were photographed using an expensive panoramic camera. It's practically magic and incredibly simple to do.

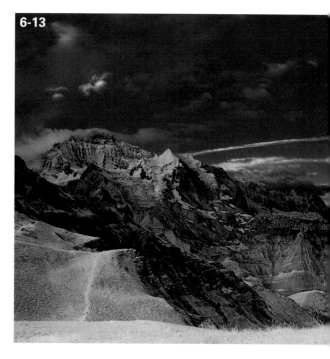

6-13

You can use a tripod, but it isn't always necessary. If you wish to create a very wide panorama, then a tripod would be helpful to keep the scene level. If you are hand-holding your camera, try overlapping your exposures by about a third, and repeat this for all consecutive exposures.

If you are holding the camera in portrait orientation, then overlap the images by about one half. Make yourself the tripod, and keep your camera position level or the images will drift in one direction or the other, not leaving you much space to work with in Photoshop.

Keep the focal length uniform — don't zoom in or out; this will cause serious alignment problems during merging. Remember to use a consistent aperture. If you plan on creating several panoramas of the same subject, make mental notes of the starting and ending points, or shoot a blank

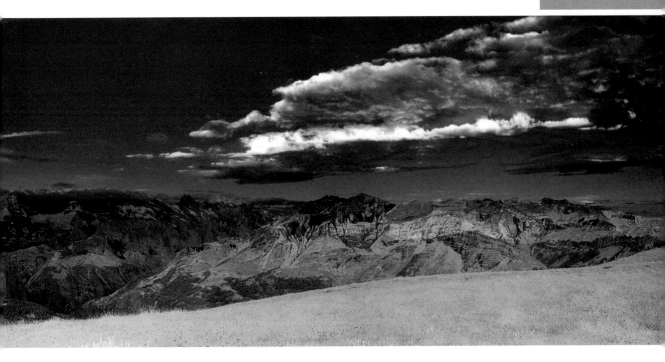

frame between each sequence. If your camera can record voice notations, provide a description of the starting and ending exposures — it will save you time later when you're trying to find which image starts the panorama. Keep in mind that you can tile panoramas vertically or in squares, or in a variety of other shapes — the possibilities are endless.

If you really want to get creative, a freeform approach can build some truly amazing panoramas. David Hockney (www.hockneypictures.com) creates wonderful contemporary panoramas, and I have always admired the "outside the box" style of Pep Ventosa (www.pepventosa.com). Ben Willmore (www.benwillmore.com) creates fascinating images combining the concept of panorama and collage. IR photography works well with many different techniques. Be inspired, use your imagination, and have fun!

ABOUT THIS PHOTO *I created this two-image panorama of an old aircraft by photographing the plane and the sky above it. I combined the images using the Photomerge feature in Photoshop. Taken at ISO 100, f/11, 1/350 sec. with a Nikkor 70-200mm lens.*

6-14

Are you ready to put together an IR panorama? Begin with something simple to see how photographing and merging for panoramas work together:

1. **In Photoshop, choose File ➪ Automate ➪ Photomerge (see 6-15).** A panel opens for you to select your files.

2. **Select the files that need to merge and click OK (see 6-16).** You can also choose your images from Bridge.

3. **Once you have selected your images, choose Tools ➪ Photoshop ➪ Photomerge.** You can also choose the type of layout option for merging. In the Auto layout mode, Photoshop chooses the layout for your images.

4. **You can choose Perspective, which uses the center image as the reference image, or Cylindrical.** Cylindrical is a good choice for wide panoramas because it reduces the bow-tie distortion you can see in 6-17. I chose Cylindrical for the six-image panorama shown in 6-13. It did a much better job than the Auto setting.

Reposition Only aligns the layers, but doesn't transform them, and Interactive Layout allows you to position the images manually. For most of the panoramas that I create, I choose Auto. With this layout, Photoshop aligns the images and merges them for you.

5. **Once you've blended your panoramic image, you can merge down and crop the layered image to eliminate the background layer and any extraneous edges (if you did not use a tripod).** The new panorama is ready for you to optimize and add any artistic effects such as creative filters or edge treatments.

6-15

ABOUT THIS FIGURE
Choosing File ➪ Automate ➪ Photomerge in the Photoshop menu.

6-16

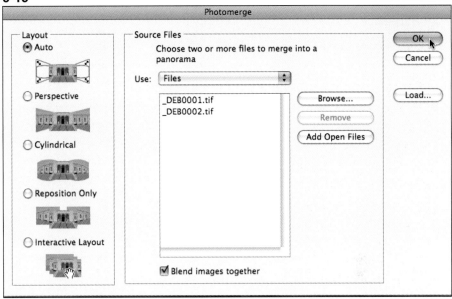

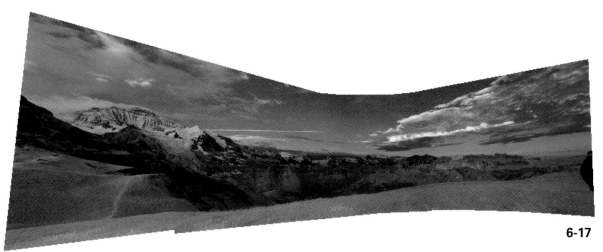

6-17

ABOUT THIS PHOTO *An example of bow-tie distortion that may occur with wide panoramas. Choosing the Cylindrical layout option may lessen this effect. Taken at ISO 100, f/8, 1/80 sec. with a Nikkor 18-70mm lens.*

Assignment

Create a Dramatic HDR or Panoramic IR Image

You can expand your creative vision by enhancing your digital IR images through HDR or Photomerge. You can choose to blend exposures to create an IR image that allows for a greater dynamic range, or create an IR panorama using Photomerge in Photoshop. The choice is yours!

For my example, I chose to record a familiar scene in a different way by using HDR. I utilized my camera's auto-bracketing mode to create a series of exposures to merge to HDR. I took this picture of an Oriental-style gazebo that overlooks Lake Eola in downtown Orlando, Florida, at ISO 100, f/11, using various shutter speeds with a Nikkor 70-200mm lens. In Photoshop, I merged the images and used the Tone Mapping filter to enhance the texture and detail in the image. I like the definition in the vegetation, clouds, and gazebo that was enhanced by using the Tone Mapping filter in an artistic way.

Remember to visit www.pwassignments.com after you complete the assignment and share your favorite photo! It's a community of enthusiastic photographers and a great place to view what other readers have created. You can also post comments and read encouraging suggestions and feedback.

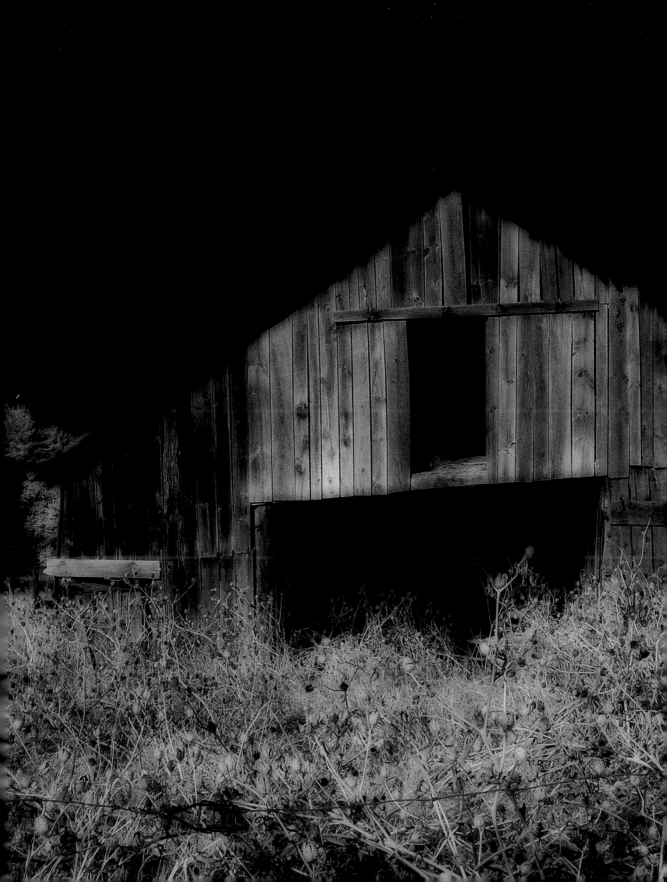

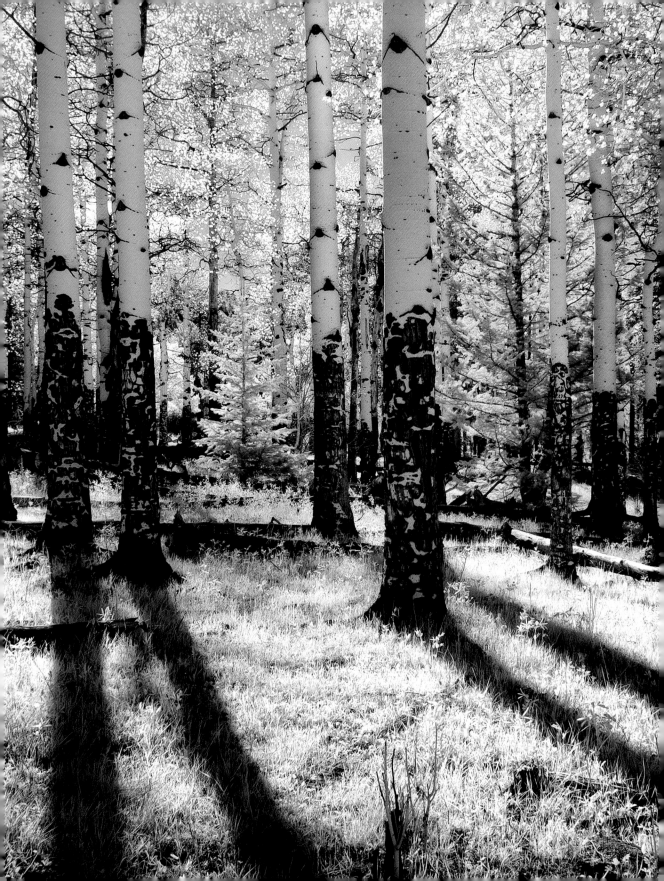

There are several creative approaches to optimizing an IR image, just as there are to optimizing a digital color photograph. You can choose from a variety of software applications, such as Adobe's Elements, Photoshop, or Lightroom, Apple's Aperture, Nikon's Capture NX2, and several others. I recommend choosing the application that is most familiar to you and easiest to use. IR photographs, as with color photographs, may benefit from a variety of basic adjustments. Optimizing your IR image ranges from removing dust spots, to making a Curves adjustment for better contrast, color, and appearance of sharpness, to dodging and burning in order to even out areas of exposure.

Some photographers begin with Photoshop Elements and upgrade later to Adobe Photoshop as their creative and technical needs evolve. If you want the most flexibility, the digital darkroom of Photoshop offers endless creative opportunities. Working in Photoshop gives you tools that range from basic editing functions, such as cropping and resizing, all the way to creative enhancements, including tonal adjustments and working with compatible plug-ins with your digital IR images (7-1).

Some camera manufacturers publish proprietary digital-editing software. For example, Nikon has Capture NX2. When editing photographs, I often optimize the image with Capture NX2 and then use Photoshop for additional creative enhancements, or finishing touches.

Good software is rarely inexpensive. If you are a student, you may be eligible for a student discount through one of the various online stores, such as the Academic Superstore (www.academic superstore.com) or JourneyEd (www.journey ed.com), or at software or photography stores. You will be required to provide proof of your student status, but the discount makes this extra step worthwhile.

7-1

ABOUT THIS PHOTO *I photographed this macaw at Butterfly World in Coconut Creek, Florida. Although parrots are often portrayed in color, IR photography enhances the contrast, vibrancy, and feather texture of these birds. I used Adobe Camera Raw (ACR) to optimize this image and Nik Silver Efex Pro (www.niksoftware.com) to convert it to black and white. Taken at ISO 400, f/11, 1/125 sec. with a Nikkor 70-200mm lens and SB-800 Speedlight.*

BASIC PROCESSING IN ADOBE CAMERA RAW

Just like your color images, your IR images will benefit from basic adjustments for optimization. When developing film and creating prints in a traditional darkroom, you may select from different papers, chemicals, and enlarger filters to achieve the best result. Similarly you will want to exercise your ability to apply options and change settings in the digital darkroom of software.

Photoshop's Adobe Camera Raw (ACR) is a powerful and creative tool for optimizing your RAW-formatted IR images. You can perform most adjustments in one place, from adjustments to artistic touches like toning.

ACR is available in both Photoshop and Elements and is easy to use. When working in Adobe Bridge, you can open and adjust JPEG and TIFF files in ACR by choosing the Open in Camera Raw option (choose Bridge ➪ File ➪ Open in Camera Raw, or press Ctrl/⌘+R).

tip Make sure you have the current version of ACR so it will be sure to read RAW files from any new cameras.

When you open your IR digital image in ACR, you are presented with a variety of processing options. Moreover, ACR provides non-destructive image editing, as do Lightroom, Aperture, and Capture NX.

Take a look at what you can do to optimize your image in ACR:

- **White Balance tab:** This gives you the option to change the white balance from As Shot to a different setting, such as Cloudy, Daylight, or Shade. You can use the White Balance tool (7-2) on a neutral area (any area without color) in your photograph to set the best white balance for your IR image.

White Balance Tool (I)

7-2

ABOUT THIS FIGURE *The controls for working with your image in ACR appear in the upper left. The arrow shows the White Balance tool.*

- **Temperature and Tint sliders:** If you are converting your image to black and white, you shouldn't need to make adjustments in color but, if you like, you can make adjustments through these sliders.

- **Retouch tool:** This tool (7-3) removes dust spots on an image — just press B to choose it. It is an impressive, timesaving tool because you can apply corrections to an image by synchronizing the data for a file you previously worked on. With the Retouch tool active, you can draw a small circle around the area you wish to clean up (such as spots from dust on the camera sensor), and a green circle identifies the area that ACR is sampling from.

- **Auto setting:** You have the option to allow ACR to make automatic adjustments. You can try this setting and fine-tune adjustments from there, or use the default setting (which allows you to begin editing from scratch, with your original image) and make your own adjustments.

- **Exposure slider:** This feature (7-4) lightens or darkens the overall image. Moving the slider to the left decreases exposure, and moving the slider to the right increases exposure. I use the exposure slider to make corrections in the overall exposure.

- **Highlight clipping warning:** Clicking the small arrow on the top right shows in red the areas of the image that have lost detail. This is a great way to see exactly where the clipping occurs aside from just viewing the histogram.

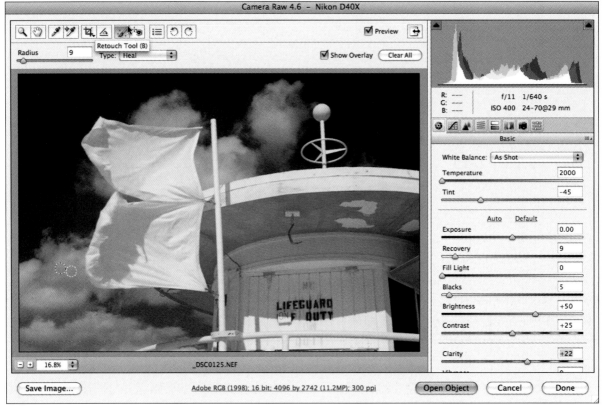

7-3

ABOUT THIS FIGURE *The Retouch tool in ACR is an efficient and easy tool for removing dust spots from a single image or from multiple images. This figure shows the location of this tool, the red circle encompassing the dust spot to be removed, and the green circle, which is the target area ACR is sampling from. Press B to quickly select the Retouch tool.*

■ **Recovery slider:** This affects areas in the photograph that may have lost details in the highlights. ACR can recover a portion of clipped areas when you move the Recovery slider to the right. Use the Exposure slider first, and then fine-tune the exposure by using the Recovery slider for highlight detail.

■ **Fill Light slider:** This affects the mid-tones in the image. Move the slider to the right to see the effect this has on your image. It's great for backlight shots and anytime a little more detail is needed in the shadow areas.

■ **Blacks slider:** This affects black in the image. Move the slider to the right to make any adjustments. When you move the Blacks slider to the right, it increases areas that are mapped to black, making the image darker—the greatest change will be in the shadows. You can hold down Option/Alt while moving the Blacks slider to identify where the black begins to show in an image.

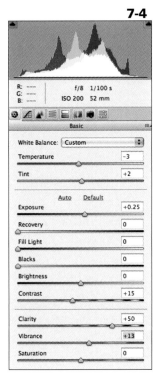

7-4

ABOUT THIS FIGURE
The histogram and various sliders are located on the right side of the ACR panel.

■ **Vibrance slider:** This affects saturation, but does not overdo it, only saturating areas that are not already saturated. Skin tones remain natural looking, while other areas become more vibrant. The Vibrance slider affects areas that appear a bit lifeless by giving them more color.

■ **Saturation slider:** This affects the entire saturation of colors in the image. This slider, along with the Vibrance slider, may not affect all IR images, but may affect those IR images with more color, such as those produced by the Enhanced color 665 IR filter. In general, you may find the Vibrance slider a better choice than the Saturation slider.

When you are finished with your adjustments, click OK in the panel to open your altered image in Photoshop.

CONVERTING TO BLACK AND WHITE IN ACR

Black and white is a classic way to portray subjects, and the advent of digital photography has not diminished its popularity. Using black and white with IR, you can produce images that are reminiscent of the timeless film era. It is exciting to be able to create a digital IR image with a nostalgic look.

You can convert your IR image to black and white without ever leaving ACR by following these steps:

1. **Use Hue Saturation Lightness (HSL) Grayscale (7-5).** Check the Convert to Grayscale box, and use the color sliders to intensify a sky or other areas of impact within your image.

■ **Brightness slider:** To make adjustments to mid-tones, move this slider to the left or right. If your image is overexposed, move the slider to the left to decrease brightness; conversely, if your image is underexposed, move the slider to the right to increase brightness.

■ **Contrast slider:** You can make adjustments in contrast by moving this slider left or right. This slider mainly affects mid-tones in the image. It makes the bright areas brighter and the dark areas darker.

■ **Clarity slider:** This enhances mid-tone contrast, and has become very popular in ACR since its release. It adds vitality to the mid-tones without going overboard with contrast. The changes are subtle, but they make a noticeable difference.

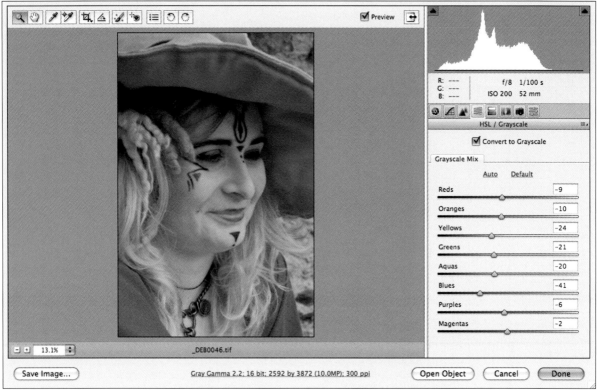

7-5

ABOUT THIS FIGURE *The histogram and various sliders appear in the ACR panel.*

2. **Use the Split Toning control to tone your IR image in ACR, if you wish to add color to your black-and-white image.** Hold down the Option/Alt key while moving the Hue slider to find a tone in the highlights and shadows of your image. Move the Saturation slider to achieve the color and intensity that you like. The Balance slider will sway the color in the highlights or shadows. This will result in a beautifully toned IR photograph.

3. **Once you are finished making adjustments in ACR, you can save your image or choose Open Image, which opens your image in Photoshop.**

USING LEVELS AND CURVES IN PHOTOSHOP

In Photoshop, Levels and Curves adjustments are designed to offer control of the white point, black point, contrast, saturation, and color. That goes for IR images too. Although Levels and Curves basically get you to the same place, Curves allows for more precision with localized adjustments. Serious image-makers only use Curves. However, with some images, a Levels adjustment may be all you need to achieve the look you desire.

LEVELS

The Levels panel includes a histogram (7-6) that is identical to the histogram that appeared on the back of your camera right after you took the picture.

7-6

ABOUT THIS FIGURE *The Levels panel showing the histogram and sliders for shadows, mid-tones, and highlights.*

Here's how the histogram and other tools on the Levels panel can help your images:

1. **After you launch Photoshop, open the Levels panel.** You can do this by choosing Layer ⇨ New Adjustment Layer ⇨ Levels, or choosing Image ⇨ Adjustments ⇨ Levels, or by pressing Ctrl/⌘+L.

2. **Position your cursor over the icons to see what each icon does (Levels, Curves, and so on).** In Photoshop CS4, adjustment layers are created automatically when you click the Levels or Curves icon in the new Adjustments panel.

3. **Use the Eyedropper tool to easily adjust your image.**

 > Choose the eyedropper on the right (for highlights) and then click in the brightest part of the image — be certain it's the brightest — to set the white point.

 > Click on the eyedropper on the left and then click on the darkest part of the image to set the black point — again, making sure that you have selected the darkest part.

 Of course, you could take the easy way out and click Auto, but I don't recommend that technique. Photoshop's Auto may be different from your ideal of auto.

x-ref As I mentioned in Chapter 2, always check the histogram when photographing to ensure the best possible in-camera exposure. The histogram is a representation of different brightness levels in the scene, and looks like a mountain range. The shadow areas are represented on the left and the highlight areas are represented on the right.

4. **You can make more custom/critical adjustments using the triangle sliders located under the histogram display.** The values range from 0 (black) to 255 (white).

> The black triangle on the bottom left of the slider lets you adjust the shadow areas. Move it to the left to darken shadows.

> The gray triangle lets you adjust the mid-tones. Move it from side to side to adjust the mid-tones in the image.

> The white triangle lets you adjust the highlights. Move it from the left to lighten the shadows.

5. **Toggle the Channel box at the top of the panel from RGB to Red, Green, or Blue for additional options.** These further fine-tune the color tones in an image.

6. **When you have completed your adjustments in Levels, click OK in the Levels panel.**

If you need increased control, a Curves adjustment layer offers even more fine-tuning options.

CURVES

The Curves control panel (7-7) is more sophisticated and has more options than the Levels panel.

Follow these steps to explore its many features:

1. **Access the Curves adjustment layer from Photoshop's Menu bar by choosing Layer ⇨ New Adjustment Layer ⇨ Curves, by choosing Image ⇨ Adjustments ⇨ Curves, or in the new Adjustment panel in CS4.** To quickly open the Curves control panel, press Ctrl/⌘+M. When the Curves dialog panel opens, you will notice a box with a grid and a line stretching from the bottom left reaching to the top right. You make your adjustments using this line.

7-7

ABOUT THIS FIGURE *You can use the Curves panel to make precision adjustments in an image. Use the keyboard shortcut Ctrl/⌘+M to quickly open this panel.*

2. **When working with an RGB file, drag the middle of the Curve line upward and to the left to make the image lighter.** If you move it downward and to the right, the image becomes darker.

3. **You can set anchor points with a simple click of your mouse or tap of your stylus along this line to make fine-tuned adjustments.**

4. **To reset Curves, hold down the Alt key (PC) or Option key (Mac) and click Cancel.** This resets the panel (or any of the control panels in Photoshop) and you can make new Curves adjustments.

5. **As with Levels, you can use the eyedroppers to set the white and black points (as well as the mid-tones, which as a rule, I don't do).** And you could take the easy way out by clicking Auto, but again, I don't advise it.

6. **You can drag unwanted points off the Curve line.** Use the Ctrl/⌘ key and click to place a control point on the curve by scrolling over your image to make an exact selection.

7. **Add a point in the center and nudge the line upward using the arrow keys to create a slight S curve.** A slight S curve will create an adjustment in contrast. The more change in direction there is to the curve you make, the more contrast there is to your image.

8. **To eliminate a color cast (the tint of an unwanted color) in your IR image, use the mid-tone eyedropper, which sets the gray point.** Click on an area of your image that is middle gray. You can move the eyedropper to different gray points in the image to find the best representation. Choosing the correct gray point will neutralize any color cast in the image.

9. **When you are finished with your adjustments, click OK in the panel to return to Photoshop.**

CONVERTING TO BLACK AND WHITE IN PHOTOSHOP

There are several very creative ways to convert your color IR image to black and white in Photoshop aside from using ACR, which is described in the previous section on ACR.

One method is to use a Black and White adjustment layer (again, you should always use adjustment layers). You can create a Black and White adjustment layer through the layers palette, or choose Layer ➪ New Adjustment Layer ➪ Black and White.

This technique provides many options for fine-tuning your IR image. In the Black and White panel, many presets are available in the drop-down menu — but most important, you can use the different color sliders to control the tones in the image (7-8). You can also use filters such as the Blue filter, the Green filter, and the High Contrast Red filter to tone images.

7-8

ABOUT THIS FIGURE *Using a Black and White adjustment layer is a great way to convert an image to black and white with many options for fine-tuning.*

The Black and White panel includes a very beneficial feature that allows you to tweak a color to affect darks and lights. You can click and drag to modify any slider by choosing the hand icon in the upper left corner. You can lighten or darken that particular color without even touching the panel. Remember that pressing Opt/Alt+Reset (Cancel) resets any adjustments you have made to the image. In CS4, to return your image to its original state, click on the circular arrow at the bottom on the adjustment panel.

Another useful feature of the Black and White adjustment layer is that you can tint your image directly within the panel. Click in the Tint box and adjust the sliders to create a beautifully toned photograph.

Another method is to make an adjustment layer using the Channel Mixer. Once the Channel Mixer panel is open, you can choose any of the Presets in the drop-down menu (much like using the Black and White adjustment layer Preset) and fine-tune color by adjusting the Source Channel color sliders to suit your image. However, I feel the Black and White adjustment is easier and has more options.

When you are finished with your adjustments, click OK in the panel to return to Photoshop.

CONVERTING TO BLACK AND WHITE USING PHOTOSHOP PLUG-INS

Photoshop-compatible plug-ins expand your creative options when you convert images to black and white. One of my favorites is Nik Silver Efex Pro from Nik Software (www.niksoftware.com). This plug-in is designed specifically for black-and-white conversion and is a powerful artistic tool. Not only can you achieve global adjustments by converting to black and white, but also you can perform localized adjustments to fine-tune your image. There are so many options at your fingertips within Silver Efex Pro, you may find you don't need other Photoshop filters — Silver Efex Pro has it all in one place. Although it's a very sophisticated plug-in, it's an efficient and easy-to-use filter for your IR images.

NIK SILVER EFEX PRO

Follow these steps to see how Silver Efex Pro works:

1. **Open your image in Photoshop.**

2. **To launch the Silver Efex Pro panel, choose Filter ⇨ Nik Software ⇨ Silver Efex Pro.** Alternatively, set the Nik Selective Window to launch as Photoshop opens. Once your image is opened in the Silver Efex Pro panel, you have a multitude of creative choices.

3. **Begin by choosing a Style for your image.** Within the Style browser (on the left side of the panel as shown in 7-9) there are various Custom Styles; you may download additional Styles from the Nik Software Web site and apply to your IR image.

4. **You can adjust the Brightness, Contrast, and Structure for the overall image by creating global adjustments.**

5. **In addition to or instead of making global adjustments, you can add Control Points for more localized adjustments to the image in selected areas.** Brightness and Contrast are familiar adjustments, while Structure is a little different. Moving the Structure slider to the left removes some of the detail from the image, and moving it to the right enhances contrast with fine details.

7-9

ABOUT THIS FIGURE *Nik software users will appreciate the familiarity of the interface in Silver Efex Pro, which makes it easy to navigate. You choose Styles on the left side of the panel and many more options are on the right.*

The option to add Control Points is an impressive feature that works beautifully to enhance your IR images, from portraits to landscapes.

For example, 7-10 is a waterfront scene I photographed in Lucerne, Switzerland. I was drawn to the expressive clouds that topped the scene and wanted to make them more prominent during conversion to black and white.

In Silver Efex Pro, I chose the Style called High Structure to accentuate the overall image. Next I tweaked the Brightness, Contrast, and Structure. Then I added a few Control Points for a bit more Contrast and Structure in the clouds. I accomplished this in a simple manner: I clicked the

Control Point icon and moved the Contrast slider to make the adjustment. I made a duplicate (keyboard shortcut Ctrl/⌘+D) of this Control Point to add to the clouds on the other side of the clock tower.

From there, I had the choice of adding more Control Points, Color Filters, Film Types, or Stylizing. I selected a film type that added a realistic-looking film grain to the image. Next, I chose Stylizing, which provides the options for Toning, Vignette, and Burn Edges. I wanted the antique look for my image that Toning provides. Within the Toning option, there are even more options and presets. I chose a subtle sepia tone.

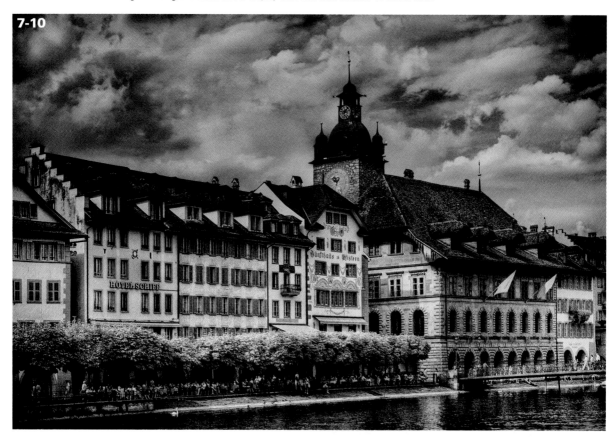

7-10

To finish, I used a Vignette from the Stylizing menu to darken the edges and bring attention to the center of the image.

Also in Switzerland, I had the opportunity to grab a shot of the Matterhorn through the window of a train in Zermatt (7-11). Shooting through glass on a lackluster day from a moving train provided its own set of challenges. But, working with the image later in Nik Silver Efex Pro allowed me to achieve the goal I had in mind (7-12) when I quickly composed the scene. I liked the cloud formations and accentuated them by adding Control Points for contrast and structure, which enhanced the details. Having the option to choose among various film types allowed me to create a black-and-white IR photo with a lot of depth and contrast.

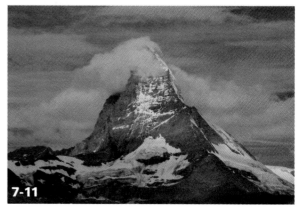

7-11

ABOUT THIS PHOTO *This is the final result of the Matterhorn photo after I converted to black and white through Nik Silver Efex Pro. I focused on contrast, structure, and the effect that film grain provides.*

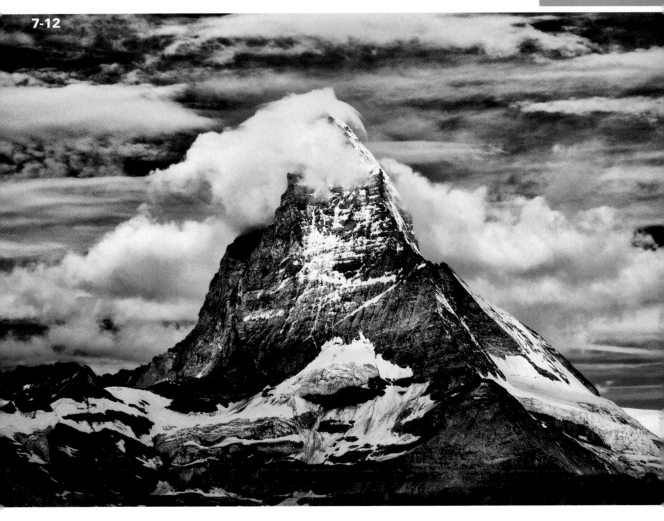

7-12

NIK COLOR EFEX PRO

In the Nik Color Efex Pro filter set, you can convert your images to black and white using the B/W Conversion filter (www.niksoftware.com). In addition, press the arrow next to B/W Conversion, and a drop-down menu allows you to choose Tonal Enhancer or Dynamic Contrast. I chose the Tonal Enhancer for the image that I was working with (7-13).

You can adjust individual sliders, such as Filter Color, Strength, and Brightness, to fine-tune the image. In addition, you can choose from several methods to further enhance the appearance of your black-and-white image. Nik Color Efex Pro offers Shadow/Highlights controls, so you can protect Shadows or Highlights. You can add Control Points to the image to remove or add the filter to specific areas of the image. As with all the filters in Nik Color Efex Pro, you can brush the effect on using a mouse or stylus to add it or brush it out to remove it, allowing for more interesting creative options.

7-13

ABOUT THIS FIGURE *This panel shows Nik Color Efex Pro and the B/W Conversion filter choice. I used Tonal Enhancer B/W Conversion for this antique Rolls Royce that I photographed with a compact IR-converted camera.*

To further complement your image, you can choose to add Film Grain to your IR image using Nik's Film Grain filter. Various sizes, ranging from Ultra Fine to Extra Coarse, are available. There are also sliders for fine-tuning the grain effect, such as Highlight Grain, Midtone Grain, Shadow Grain, and Grain Saturation.

ONONE SOFTWARE'S PHOTOTOOLS

The onOne PhotoTools (www.ononesoftware.com) filter set offers a library of creative options with many submenus containing specific effects created

by photographers such as Kevin Kubota or Jack Davis. The PhotoTools filter set is particularly appealing when you want to convert an IR image to black and white. Under Black and White Treatments, you can apply filters such as Davis–Convert to B&W–Filters, which offer choices to make your image look like you used a yellow, orange, red, green, or blue filter on your lens. Kubota–B&W GM Warm 1 and Snappy can give your image a nostalgic look (7-14).

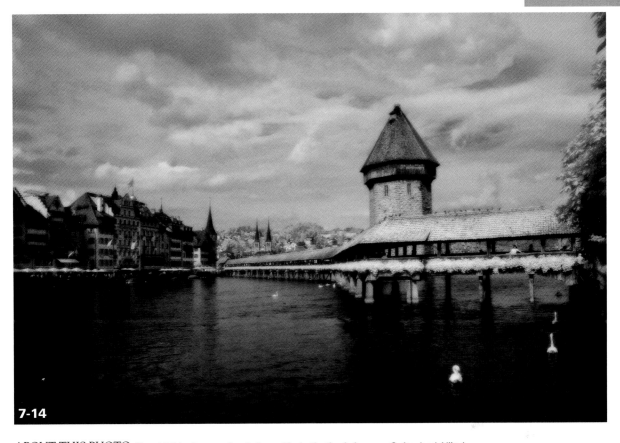

7-14

ABOUT THIS PHOTO *Chapel Bridge is a popular photographic destination in Lucerne, Switzerland. I liked the subtle vintage sepia tone and glow in this image that the onOne PhotoTools black-and-white conversion filter, Kubota–B&W GM Warm 1 and Snappy, provided. Taken at ISO 200, f/11, 1/180 sec. with a Nikkor 18-70mm lens.*

One of my favorite filters is found under Color Treatments: Kubota Modern Antique. There is an option to use it with or without Glow, and I often choose Glow for the rich, antique look it gives an IR image.

You may wish to add film grain to your image for a traditional film look. With the Film Grain–B&W filter, found under Film & Darkroom drop-down menu, you can choose grain of various sizes to suit your image.

NOISE REDUCTION

You may be wondering what digital noise is, what causes it, and how you manage it. *Digital noise* often appears as unwanted grain and colored specks on your image and is caused by several factors, such as high ISO settings, long shutter speeds when shooting in dark areas, underexposure, and JPEG file compression.

Digital cameras are manufactured with a filter that prevents IR light from reaching the camera sensor. A non-IR converted camera still has this filter in place. As a result you may need a long exposure time to successfully capture an IR image using an unconverted camera, and this may also introduce digital noise into your image.

Digital noise is usually undesirable. However, some digital photographers deliberately add noise to their images, along with glow, to lend a traditional film look to digital images. Too much noise, though, can be distracting.

You can approach noise reduction in digital IR images in several ways. You can accomplish noise reduction somewhat in-camera, although depending on the specific camera model you may not have much fine-tuning control using this method.

In ACR, you can make noise-reducing adjustments to the RAW file. In Photoshop, you can use the noise reduction filter (Filter ➪ Noise ➪ Reduce Noise). You can also use plug-ins such as Nik Software's Dfine, Picture Code's Noise Ninja, and ABSoft's Neat Image.

REDUCING NOISE IN ACR

In ACR, the Detail tab brings up sliders that affect Sharpening and Noise Reduction (7-15). You can reduce noise in ACR by adjusting the Luminance slider, which affects grayscale noise. This type of noise makes an image appear grainy.

In addition, you can adjust the Color slider to reduce *color noise*. Color noise looks like colored specks within the image. Moving the sliders to the right should decrease noise, and moving the sliders to the left will turn off noise reduction. If you moved both sliders all the way to the right, you may lose so much noise that the image loses detail and sharpness.

7-15

ABOUT THIS FIGURE
The Luminance and Color sliders under the Detail tab in ACR address noise reduction in a RAW file.

tip To get the best view of noise per channel and to better see how noise reduction affects your image, zoom in on the image.

REDUCING NOISE IN PHOTOSHOP

In Photoshop, you can use a built-in filter to reduce noise: Choose Filter ➪ Noise ➪ Reduce Noise. You can adjust several sliders to reduce noise in your image. The Overall panel, where any changes will affect the overall image, opens with the default Basic radio button clicked. You may want to click on Advanced instead, and check to see which channel has the most noise (7-16). You can work to reduce noise in that particular channel while preserving the other channels — this helps to keep the image sharp.

7-16

The Strength slider affects the intensity of noise reduction in all channels. You can adjust the slider's strength from 0 to 10.

The Preserve Details slider works to preserve detail and edges. You can easily see the effect of this slider by moving it to 0, which softens the image, or moving it toward 100, which retains the details.

You can adjust the Reduce Color Noise slider to remove unwanted color pixels. Moving the slider to the right reduces color noise. Moving the slider all the way to the left leaves the image unaffected.

The Sharpen Details slider makes the image sharper. Move the slider from left to right to control the effect of sharpness. Again, if you reduce the noise too much, your image will lose sharpness and detail.

You can use the Remove JPEG Artifact check box to improve the appearance of JPEG images. You may have noticed that low-quality JPEG images often contain halos or noise as a result of file compression, and this adjustment control helps reduce that type of noise.

NIK DFINE 2.0

Nik Dfine 2.0 (www.niksoftware.com) features an intuitive interface that allows for a variety of levels of noise reduction in an image. Nik Dfine 2.0 can determine noise reduction needs and automatically calculate the best way to solve noise in each image. The interface is similar to Nik Silver Efex Pro and Color Efex Pro, which are easy to use and target specific areas.

In 7-17, I choose Sky and painted on the effect specifically in the sky area, brushing out any JPEG artifacts and creating a smooth noise-free sky. Nik Dfine 2.0 works equally well in shadow areas where there is likely to be more noise. Brushing the effect in these areas is a very simple way to concentrate on specific noise-reduction needs.

This Dfine 2.0 panel shows a large preview, where you can see how simple it is to address noise reduction.

NEAT IMAGE

Neat Image (www.neatimage.com) is a noise reduction plug-in for Photoshop that can automatically calculate how to resolve noise issues within an image. Within the Neat Image interface (7-18), you can choose specific areas of noise to work on using the various sliders. You can generate target areas for Neat Image to profile. Click Auto Profile and Neat Image automatically profiles the area chosen for noise reduction.

DODGING AND BURNING

In the conventional wet darkroom, photographers making prints work to balance areas of exposure by burning in or dodging certain areas of a print. In the Photoshop digital darkroom, the Dodge and Burn tools accomplish that same feat.

In previous versions of Photoshop, most photographers avoided these tools because they were pixel-destructive and would degrade the image. The workaround was to create an adjustment

7-18

layer for burning in areas that needed to be darkened, or dodging areas that needed to be lightened. In Photoshop CS4, the Dodge and Burn tools have been enhanced to work better — preserving tones. These tools can be used more effectively and without worry of image degradation.

If you are using Photoshop CS3 or older, you may wish to use adjustment layers to dodge and burn. To burn in or darken an area of an image that is too light, create a new adjustment layer with the blending mode of overlay, and click in the Fill with Overlay-neutral color (50 percent gray) check box (7-19). Use a brush with approximately 25 percent opacity and paint with black to darken, or *burn in*, areas that are too light.

Create another adjustment layer identical to the first, except paint with white to lighten, or *dodge*, areas that are too dark. You can name the layers Dodge and Burn, and adjust the opacity of each layer as needed.

7-19

ABOUT THIS FIGURE *Using a new layer of Overlay to dodge or burn in areas of an image.*

TROUBLESHOOTING

In some instances, you may notice a pale circle called a *hotspot* in the center of your IR image (7-20). This is different from lens flare that can also occur and is obviously different from a flare's sharp, repeated pattern. This phenomenon may occur at random or you may notice it with certain angles or lenses. I've noticed hotspots with both my IR-converted dSLR camera and my converted compact camera, which may be caused by internal reflections. You can blend in moderate hotspots by burning in the light area in Photoshop. The best solution is being aware of hotspots as you check the camera display while you are shooting and changing the angle or perspective to avoid them.

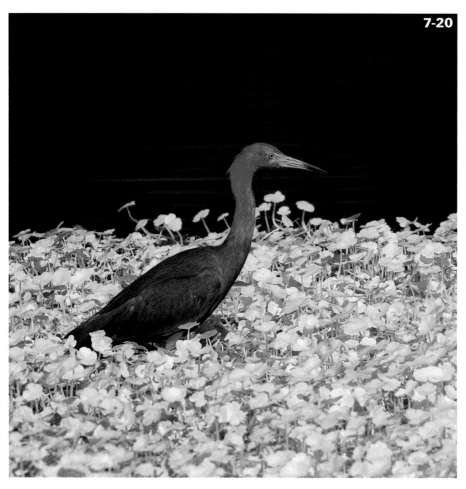

7-20

ABOUT THIS PHOTO
The hotspot in the center of the image appears as a pale halo around the bird. Taken at ISO 200, f/8, 1/200 sec. with a Nikkor 200-400mm lens.

Assignment

Converting to Black and White

It's truly magical to photograph in IR and then be able to create film grain, glow, a wonderfully nostalgic sepia tone, or traditional black and white in the digital darkroom. Black and white IR is an art form, subjective in its interpretation. There is no single, correct way to present an image — it comes from the heart and represents your personal perspective on the world.

For this assignment, I encourage you to review the chapter and experiment with the various techniques of converting your IR image to black and white. Your choice of method will be partially determined by what best suits your subject and enhances the overall image. You might choose a nostalgic film look in black-and-white IR, or a fun, contemporary IR image in black and white, absent of anything reminiscent of the past.

For my example, I wanted to create an image that could have been photographed long ago with a film IR camera. Though only recently photographed, this quaint countryside in Bacharach, Germany, appears timeless. My goal was to accentuate the image with a nostalgic look through conversion to black and white, using film grain to add depth and interest. I converted to black and white with Nik Silver Efex Pro. I brought out definition in the clouds and buildings using the Structure slider and re-created the look of film using Film Type Fuji Neopan ACROS 100. Taken at ISO 100, f/11, 1/125 sec. with a Nikkor 18-200mm lens.

 Remember to visit www.pwassignments.com after you complete the assignment and share your favorite photo! It's a community of enthusiastic photographers and a great place to view what other readers have created. You can also post comments and read encouraging suggestions and feedback.

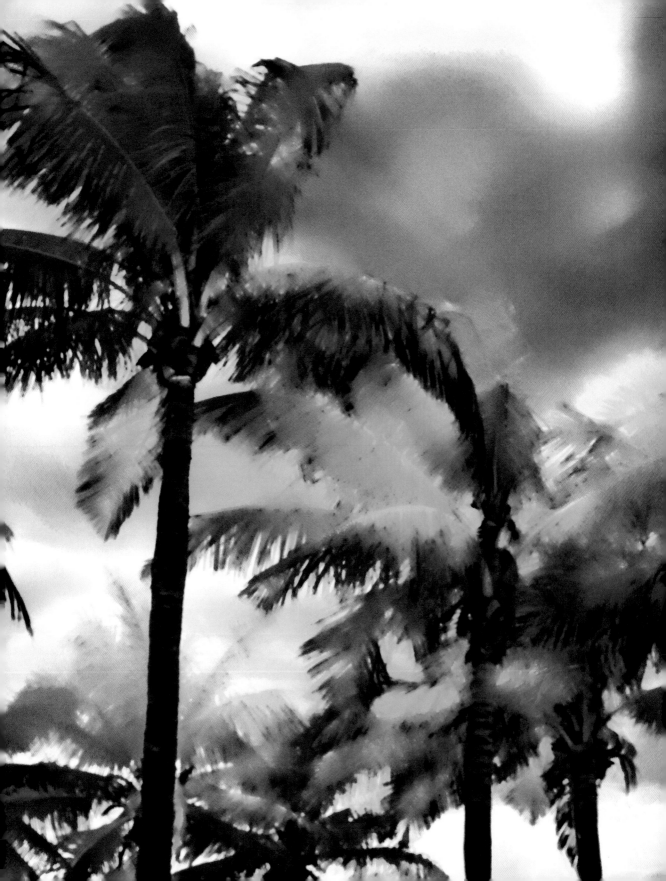

For many photographers, once they have captured a great photograph, their work has been accomplished and the final product realized. For others, capturing the image is only the start — further creativity takes place later in the digital darkroom.

In this chapter, you will explore a multitude of ways to work creatively with IR photography. You will move past simply taking pictures, discovering new and imaginative methods for expanding your photographic horizons by using a variety of artistic techniques in Photoshop.

One attraction of IR photography is its surreal beauty. IR film photography has always been held in high regard, but with digital IR photography, the opportunities for creativity are endless. Impressionist painter Edgar Degas said, "Art is not what you see, but what you make others see." This quote epitomizes this chapter.

Your photographic vision is realized when you work with your images for the most meaningful and personal end result. For example, figure 8-1 was taken with an IR-converted compact camera. Compare it with 8-2 and you can see the transformation that occurs with a few artistic touches. With IR and a little creativity, you can produce fascinating images.

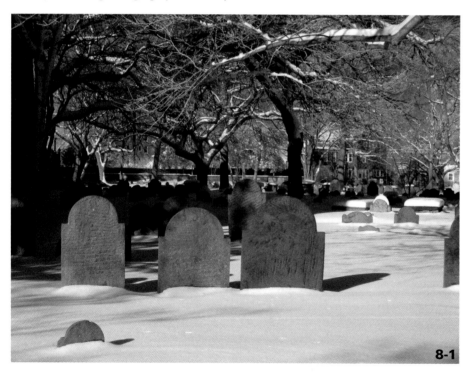

8-1

ABOUT THIS PHOTO *A winter scene photographed at a cemetery in Boston, Massachusetts, shown without channel mixing and creative enhancements. Taken at ISO 200 with an IR converted compact camera.*

ABOUT THIS PHOTO
The same winter cemetery becomes very painterly with a few artistic touches in Photoshop. I used watercolor, pattern for texture, and onOne Photoframe 4 edge treatment filters.

8-2

Digital IR photography is actually considered *near IR*. It does not produce a true monochrome image the way that black-and-white IR film does. A small amount of color remains in the visible range of a digital IR photograph, which allows you to work with your images in a way that was not possible with film.

CREATING A BLUE SKY

One of the most desirable techniques in digital IR photography to master is creating a gorgeous blue sky. A tree looks beautiful in IR with a blue sky. An example of this technique is shown in 8-3, a photograph I took at a beach on Florida's west coast.

Follow these steps to create a blue sky:

1. **From Photoshop's Menu bar, choose Layer ⇨ New Adjustment Layer ⇨ Channel Mixer.** Start with the Output Channel set to Red (default).

2. **Adjust the Source channels sliders.** Reduce the Red Channel slider from 100 percent to 0 percent, and increase the Blue Channel slider from 0 percent to 100 percent. The Channel Mixer dialog box is shown in 8-4.

3. **Change the Output Channel pop-up menu to Blue.** Increase the Red Source Channel to 100 percent.

ABOUT THIS PHOTO *A partially backlit tree provides a nice frame for blue sky and clouds photographed at the beach in Longboat Key, Florida. Taken at ISO 200, f/16, 1/200sec. using a Nikkor 18-70mm Nikkor lens.*

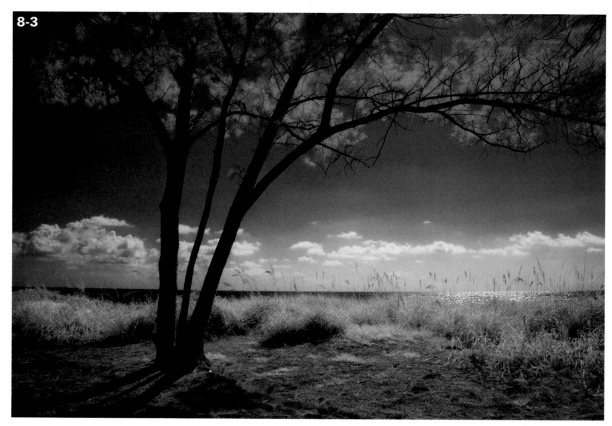

8-3

4. **Change the Blue Source Channel from 100 percent to 0 percent to exchange the Blue Source Channel for the Red Source Channel (see 8-4).**

In Photoshop, you can save this custom preset with the name Blue Sky, or your name of choice, in the Channel Mixer Preset dialog box by using the Save Preset command (the icon to the right of Preset pop-up menu) so that you never have to go through these steps again!

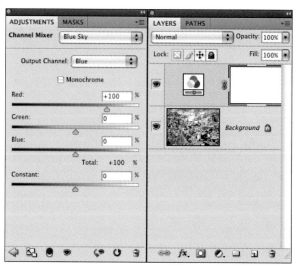

8-4

ABOUT THIS FIGURE *This screen shot shows the Channel Mixer Output Channel changed from Red to Blue, and the Red Source Channel exchanged for the Blue Source Channel, and at 100 percent. You can save this exchange as a preset for a one-click adjustment.*

The Channel Mixer blue-sky technique may surprise you with other uses, too. Take a look at the differences between 8-5 and 8-6. This cityscape from Zermatt, Switzerland, is transformed into a winter-like scene by using an IR camera and Channel Mixer.

Another option specifically for digital IR images is the Davis-Wow for digital IR. It is part of onOne Software's PhotoTools Professional collection of Photoshop-compatible plug-ins. I photographed 8-7 with a compact camera converted to IR. One click provided the beautiful blue sky and removed the blue cast from the foliage — quick and easy.

ABOUT THIS PHOTO
Summer in Zermatt, Switzerland, shows lots of green trees, grass, rolling hills, and dozens of rooftops nestled in between. Taken at ISO 200, f/16, 1/100 sec. using a Nikkor 24-70mm Nikkor lens.

ABOUT THIS PHOTO
Summer in Zermatt, Switzerland, photographed in IR creates a completely different image, and suggests winter. I used the Channel Mixer with the preset Blue Sky twice to create the appearance of icy trees and snow on the ground. Taken at ISO 200, f/11, 1/80 sec. using a Nikkor 18-70mm Nikkor lens.

8-7

ABOUT THIS PHOTO *This figure shows how easy it is to create a blue sky in an IR image by using OnOne PhotoTools's Davis-Wow for digital IR. The result was achieved with one click.*

USING SELECTIVE COLOR FOR IMPACT

Another creative technique in Photoshop, which works beautifully with an IR image, is to selectively hand-paint areas of interest with your mouse or stylus. A touch of color draws the viewer into the photograph and specifically to the subject that is colored.

Choose a scene that you can easily enhance by hand-coloring — any area of interest, such as the subject's eyes, a motorcycle, a car, or any selective part of the image. The contrast of a monochrome photograph with a subject in color can create a

very compelling result. For example, in 8-8 I painted the blue color in an umbrella from a beach scene.

Use this simple technique to hand-paint an area of interest in your photograph:

1. **Make sure your black-and-white image is converted to RGB mode (choose Image ⇨ Mode ⇨ RGB Color).**

2. **To selectively color parts of an image, create a new layer (press Ctrl/⌘+J or click the New Layer icon in the Layers palette).** Set the blending mode in the Layers palette to Color.

8-8

3. **Select a soft-edged brush at approximately 50 percent opacity and choose a foreground color by clicking on the Foreground/ Background color squares.** Adjust the opacity of the layer to suit your subject.

You can layer colors — simply repeat Steps 1 through 3 for each layer. For a soft, hand-tinted look, use a brush with low opacity or further reduce the overall opacity for each color layer. For a bold look, go for 100 percent color in your chosen area of color. Experiment! Enjoy working with your newly learned techniques.

Kathleen Carr, a professional photographer and artist from Hawaii (www.kathleencarr.com) photographed the *Molokai II* (see 8-9) and digitally

painted it in Photoshop. After opening the image in Photoshop, Kathleen hand-colored her IR photograph using a different transparent layer for each color.

Setting the opacity of the layer at 50 percent allowed her the flexibility to increase or decrease each color as needed. She set the Paintbrush tool at a low opacity to keep transparency of color without covering any of the image.

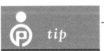 *tip*

Kathleen said to remind you that if you cover something by mistake, the Eraser tool works wonders to eliminate the error.

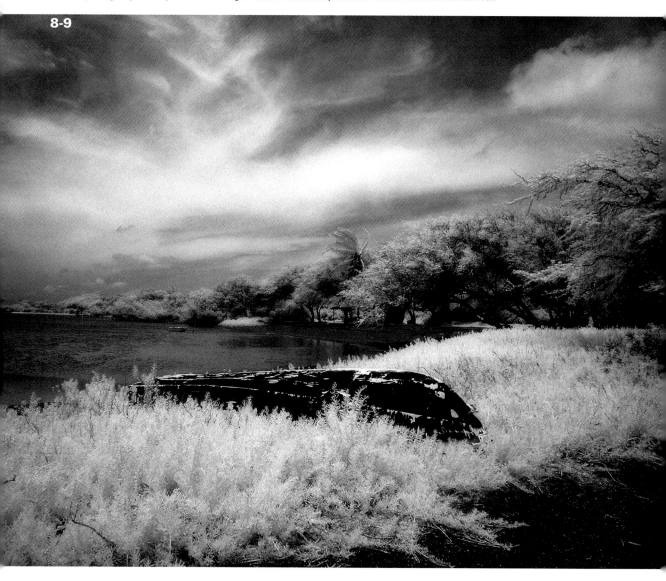

8-9

TINTING AND TONING

An IR image lends itself to many types of tinting or toning that will enhance the overall image. An example is shown in the architectural photograph in 8-10. There are several different ways to tone your IR image in Photoshop. For a beautiful, easily attainable sepia tone, use a Hue/Saturation adjustment layer.

To tint your image, you will need to make sure your IR image is the RGB color mode. Follow these steps:

1. **From Photoshop's toolbar, choose Image ⇨ Mode ⇨ RGB Color.**

ABOUT THIS PHOTO *A Hue/Saturation layer created beautiful warm tones in this image. Taken at ISO 100, f/11, 1/640 sec. using a Nikkor 18-70mm Nikkor lens.*

8-10

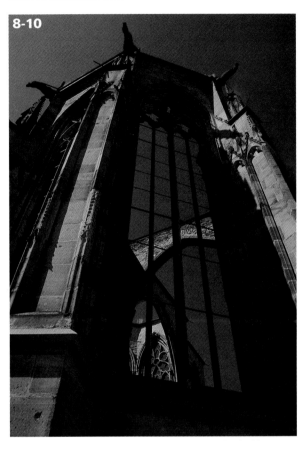

2. **Create a Hue/Saturation layer by clicking the new layer icon in the bottom of the Layers palette (choose Image ⇨ Adjustments ⇨ Hue/Saturation or simply press Ctrl/⌘ +U).**

3. **In the Hue/Saturation dialog box, check the Colorize box on the bottom right.** The Channel Mixer panel appears, as shown in 8-11.

4. **Adjust the Hue slider to 40 and the Saturation slider to 15.** Experiment with these settings to get the look that best suits your image.

5. **Click OK and voilà — you're done.**

ABOUT THIS FIGURE *The Hue/Saturation panel with the Colorize check box outlined in red. The Hue and Saturation sliders have been adjusted for the image shown in the Layers palette.*

8-11

TINTING AND TONING SOFTWARE

Nik Color Efex Pro 3 (a plug-in filter set for Photoshop; www.niksoftware.com) has a wide variety of color effects to tone your IR image. One of my favorites is the Midnight Blue filter, which gives an IR image the appearance of being photographed at night, as shown in 8-12.

In Nik's menu options, you can individually adjust Blur, Contrast, Brightness and Color for a variety of results. Experiment with the Paper Toner filter for a subtle, toned look. This delicate effect works beautifully with IR photographs, as shown in the boat and reflections photo in 8-13.

You can apply the effect globally, and can selectively remove it using a Control Point, Nik's easy-to-use U Point technology. You can also apply the filter effects selectively using the Brush option in the Nik filter palette.

onOne Software's PhotoTools (www.onone software.com) has a variety of filters that work well for tinting or toning IR images. Among them, I like Kubota's Tea-Stained toning and

8-12

ABOUT THIS PHOTO *The Bonaventure Cemetery in Savannah, Georgia, is an IR photographer's dream location. I used the Nik Color Efex Pro 3 Midnight Blue filter to tone the image and give it a photographed-at-midnight look. Taken at ISO 400, f/11, 1/60 sec. using a Nikkor 70-200mm Nikkor lens.*

8-13

ABOUT THIS PHOTO *Using the Paper Toner filter in Nik Color Efex Pro 3, boats and reflections from nearby buildings take on a subtle toned hue. Taken at ISO 400, f/8, 1/180 sec. using a Nikkor 18-70mm Nikkor lens.*

Davis-Wow Tint-Brown. An example of the effect of Davis Tint-Brown is shown in 8-14. The buildings along the Rhine River have a vintage photo appearance. You can reduce the strength of each filter by adjusting the opacity in the PhotoTools menu. Click in the Layer Mask check box to apply the filter to a layer mask.

One of my favorites for IR images is the Kubota-Modern Antique A3 filter. It gives images a rich antique look, as shown in the buildings and palm tree image I photographed in Sarasota, Florida (see 8-15).

ABOUT THIS PHOTO *I used onOne PhotoTools Davis-Wow Tint-Brown to achieve this rich toned look in this scene. Taken at ISO 400, f/11, 1/160 sec. using a Nikkor 18-70mm Nikkor lens.*

8-14

8-15

ABOUT THIS PHOTO *The palm trees and buildings along Sarasota's waterfront take on more emphasis when toned by onOne PhotoTools Kubota-Modern Antique A3 filter. Taken at ISO 200, f/11, 1/250 sec. using a Nikkor 18-70mm Nikkor lens.*

DUOTONES, QUADTONES, AND TRITONES

You can tone an IR image in Photoshop using Duotones, Quad Tones, and Tri Tones. This is a lot of fun because the color choices are endless, and this toning technique works beautifully with IR images.

The panel in 8-16 shows how to select colors to Duotone your image. I chose a warm gray Duotone for the buildings shown in 8-17.

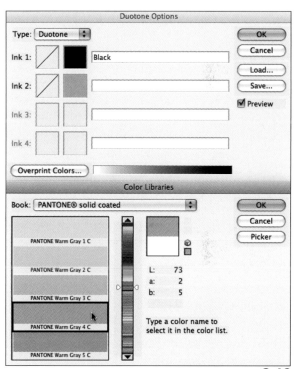

8-16

ABOUT THIS FIGURE *The Duotone panel allows for many choices in colors. Use any of the colors available in the color bar to make your selection.*

8-17

You can choose to Duotone your image, or add more color by using Tritone or Quadtone. Sometimes just a touch of color will greatly enhance an image.

When using this toning option, the image must be converted to Grayscale. To do so, follow these steps:

1. **Convert your image to grayscale.** From the Menu choose Image ⇨ Mode ⇨ Grayscale. A pop-up box will ask you if you want to discard color information, choose Discard.

2. **Make sure the image is 8 bits/Channel.** From the Menu choose Image ⇨ Mode ⇨ 8 Bits/Channel.

3. **Make a duplicate of your image.** Drag the original down to the New Layer icon in the Layers palette, or use the keyboard shortcut Ctrl/⌘+ J.

4. **From the toolbar, choose Mode ⇨ Duotone and in the Duotone dialog box.** Choose Duotone from the Type pop-up menu.

5. **Choose the colors for your Duotone by selecting the ink color square.** I leave Ink 1 set to black and select Ink 2, which brings up the Color Picker.

6. **Once you've selected your color, click OK to close the Color Picker and click OK to exit the Duotone dialog box.**

REPLICATING A TRADITIONAL IR FILM LOOK

If you like the look of traditional IR film, you can use the Diffuse Glow filter in Photoshop, which simulates the grain and glow of IR film (from the Menu choose Filter ⇨ Distort ⇨ Diffuse Glow). It has three adjustable sliders for Graininess, Glow Amount, and Clear Amount.

The Clear Amount determines how much detail is revealed. Try this setting at 10 to 12. You can adjust Glow Amount and Graininess to best suit your image. Try settings 2 or 3 for Glow Amount, and 4 for Graininess to start, as shown in 8-18.

ABOUT THIS PHOTO *This digital IR image has a traditional IR film look that was created with the Diffuse Glow filter in Photoshop. Taken with an IR-converted compact camera.*

8-18

This easy technique makes your digital IR image resemble traditional IR film. You can combine the atmosphere that Diffuse Glow provides with the techniques I have discussed for a beautiful IR image that has a more dimensional look.

Another alternative for giving a digital IR image a traditional IR look is to use a combination of filters found in Nik Color Efex Pro 3. For the old barn I photographed in 8-19, I chose Film Grain and selected a grain size of Medium. To give a

slight glow to the image, I used Glamour Glow at the default settings.

onOne's PhotoTools 1.0 provides several filters that also give your digital IR image a traditional IR film look. One of my favorites in this Photoshop-compatible plug-in is Kubota–B&W TastyGlow II. This filter converts the image to black and white and provides a glow effect in a single selection, as shown in this waterfall in 8-20.

8-19

PhotoTools offers several film grain effects. Another one of my favorites is in the presets: the Holga Black and White. It is a wonderful vintage-camera effect that softens and blurs a deep vignette around the image and converts it to black and white in the process. This completely transforms the look of a digital IR image and works beautifully where you want a more nostalgic and dreamy effect.

CREATING A DIGITAL SANDWICH

Another way to work with your digital IR image is to create a digital sandwich. You may be familiar with this technique if you have ever worked with film slides. This effect replicates the way photographers used to stack slides together. More specifically, it creates an image similar to Michael

ABOUT THIS PHOTO *I used onOne PhotoTools Kubota–B&W TastyGlow II for this waterfall that I photographed in Grafton Notch State Park, Maine. Taken at ISO 200, f/22, 1/4 sec. using a Nikkor 70-200mm Nikkor lens.*

8-20

Orton's much-admired slide technique. It works beautifully with color images, and it also works well with digital IR images.

You can achieve a similar look in Photoshop and depending on your equipment, even in-camera. My digital IR camera is enabled for multiple exposures and image overlay, a capability that many Nikon dSLR users enjoy. You can use this ability to create this beautiful effect in-camera. It provides a dreamy glow that works magic on flowers in particular, but I bet you will be tempted to try it on just about every subject. A digital sandwich has an ethereal effect on traditional black-and-white IR images, and is equally

as compelling when used on images that have a little color or subtle tinting.

Traditionally you would shoot a subject with a tripod and a long lens, using f/16 to f/22 for maximum depth of field. Next, you would make a second exposure of the same subject at the widest aperture, overexposed by a stop and slightly defocused so that the image is no longer sharp.

If you are using a camera that supports double exposures or image overlays, you can photograph your subject with the steps above and see the results right away on your LCD. Otherwise you can easily combine these two images — the sharp image and the out-of-focus one —in Photoshop by following the steps supplied in a moment.

You can change the opacity of the blurred layer to suit your image. If you want to try this technique on an existing digital IR image, as shown in 8-21, open your image in Photoshop and make a copy of your original. Then simply follow these easy steps:

1. **Lighten the image (choose Image ⇨ Apply Image).**

2. **In the Apply Image dialog box, choose Screen as the blending mode with the Opacity at 100 percent.** This replicates the overexposed part of the image as if you were photographing it for slides.

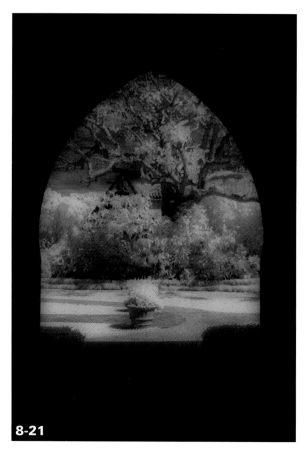

8-21

ABOUT THIS PHOTO *The digital sandwich technique created the soft glow in this image. Taken at ISO 200, f/16, 1/50 sec. using a Nikkor 24-70mm Nikkor lens.*

3. **Make a duplicate of this lightened image by dragging it down to the Create New Layer icon in the Layers palette.**

4. **Blur the duplicate (choose Filter ⇨ Blur ⇨ Gaussian Blur) by selecting a pleasing radius that works for the image.** Try starting with a radius of 25 and work up or down from there, depending on the size of your image. The higher the setting, the more blurred the effect. The smaller the image, the less blur needed.

5. **In the Layers palette, choose Multiply as the blending mode**—and your digital IR image has been transformed into a dreamy work of art.

6. **To finish, merge the layers down (press Ctrl/⌘+E).**

CREATING MIRRORED IMAGES

Mirrored images provide the visual treat of perfect symmetry. They can be created so that one side of the photograph is an exact duplicate of the other, or so that it is not quite identical but believable enough to pass as an actual reflection. You can do this creative technique easily in Photoshop with a single IR image. When two opposite but identical sides are placed next to each other, they join in a way that is simply bewitching, as shown in 8-22.

Follow these steps to make an image that is perfectly symmetrical on both sides:

1. **Open your selected IR image in Photoshop.**

2. **Select the image (press Ctrl/⌘+A) and then copy the image (press Ctrl/⌘+C).**

166

ABOUT THIS PHOTO *A mirrored image created on the diagonal results in perfect symmetry that seems impossible in reality. Taken at ISO 100, f/11, 1/320 sec. using a Nikkor 24-70mm Nikkor lens.*

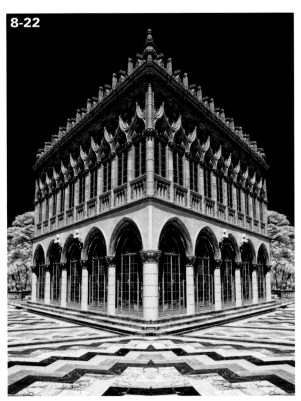

8-22

3. **Increase the canvas size to double your image size.** You can do this by selecting Image ➪ Canvas Size from the Menu bar. When the panel opens, choose a size that doubles your image.

4. **In the Canvas Size dialog box select the direction in which you want a new enlarged part of the canvas to appear by choosing the arrow direction.** I make a selection with the crop tool, and then drag the crop handle toward the area where I want more canvas. Press return to add the canvas to the selection.

5. **Copy your selection using Ctrl/⌘+C and paste using Ctrl/⌘+V.** Then rotate the new selection by choosing Edit ➪ Transform and choose Flip Horizonal (or Vertical depending on your image orientation).

6. **Align the images so that they are mirrored exactly.** Zoom in to double-check alignment by pressing Ctrl/⌘+ and then flatten the layers by choosing Layer ➪ Flatten Image or pressing Ctrl/⌘+E.

7. **Crop the image so any excess canvas is eliminated.**

That's all there is to it. It is a very simple but dramatic way to mirror images. Because the image is perfectly symmetrical, you might want to try adding a colorful subject that is in context with the image, such as a single red leaf on one side of a mirrored tree image.

CREATING WATERY REFLECTIONS

Now that you've mastered the technique of mirrored images, you're ready for the next step: creating watery reflections. This is as easy as mirroring, with a few extra steps. The addition of ripples and darkening will make your mirrored reflection believable. Follow these easy steps:

1. **Open your selected IR image in Photoshop.**

2. **Select the image (press Ctrl/⌘+A) and then copy it (press Ctrl/⌘+C).**

3. **From the Menu, select Image ➪ Canvas Size.**

4. In the Canvas Size dialog box, click the shaded box to select the direction where you want the new area to reside.

5. In the Canvas Size dialog box, choose a size that roughly doubles the size of your image.

6. To paste your selection to the new area, use **Ctrl/⌘+V.** Rotate the selection by choosing Edit ⇨ Transform, or by pressing Ctrl/⌘+T, and choose Flip Vertical.

7. Align the images with the Move tool, so that they are mirrored exactly.

8. From the Filter menu, choose Filter ⇨ Distort ⇨ Ocean Ripple. In the dialog box, move the sliders for Ripple Size and Ripple Magnitude until you are pleased with the result. You are almost finished.

9. Select the new watery reflection, and choose Image ⇨ Adjustments ⇨ Levels from the Menu.

10. Move the middle slider just a notch over to the right to make the reflection a bit darker and more realistic, as shown in 8-23.

ABOUT THIS PHOTO *This image was enhanced with a watery reflection using the mirrored image technique. Taken at ISO 100, f/16, 1/500 sec. using a Nikkor 18-70mm Nikkor lens.*

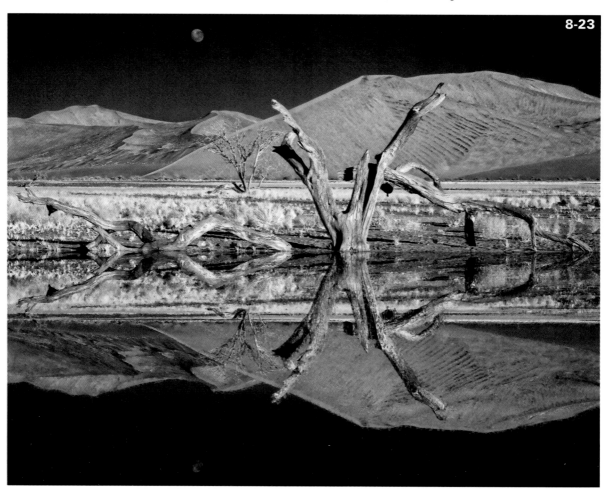

8-23

ABOUT THIS PHOTO *Here's an image I had fun with. This cathedral features a lake, but it was too windy for a nice reflection. I had a vision of a glossy reflection and I was able to create it with the use of the Flood filter in Photoshop. Taken at ISO 100, f/11, 1/250 sec. using a Nikkor 18-70mm Nikkor lens.*

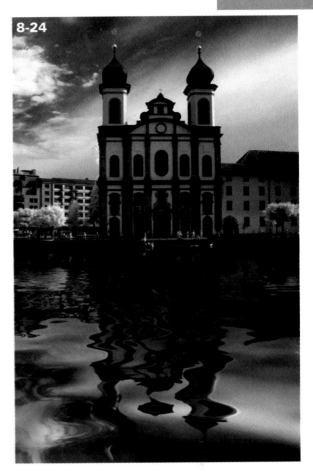
8-24

11. **Crop your image to eliminate any excess canvas area and flatten your image by selecting Layers ⇨ Flatten Image or simply pressing Ctrl/⌘+E.**

If you become interested in the concept of reflections and would like to try another fun filter, experiment with the Flood Photoshop-compatible plug-in from Flaming Pear (www.flamingpear.com). An example of this dramatic effect is shown in 8-24.

The existing reflection in the pool at the actual scene was affected by wind; I chose to make a new one that better fit the vision I had in mind for the photo. The Flood filter creates a multitude of reflections that you can modify or choose by clicking the dice icon for a random effect. This filter is one of my very favorites to create watery reflections. To use this filter, increase the canvas size as discussed in the previous steps and follow these steps:

1. **Choose Filter ⇨ Flood.**

2. **In the panel, adjust the Horizon slider so that it abuts the bottom of your image.**

3. **Adjust the sliders to suit your image, or for fun, just click the dice.**

4. **Select OK to return to the Photoshop menu and enjoy your IR image with a new, beautiful reflection.**

WORKING WITH MULTIPLE EXPOSURES

You can create impressionistic-style images with digital IR photography through multiple exposures. Through repeated exposures of the same subject, the final image has an effect with tremendous visual appeal, like that of impressionist paintings. Subject matter can vary greatly, and the image can convey anything from texture to motion. This is the classical appeal of multiple

exposures. It takes some time to learn what will make appealing multiple exposures, especially with the lack of color in IR images in general. As a digital IR photographer, you look at texture, shape, and line, and how these are visualized when the image is repeated. The rewards can be quite satisfying as you experiment with a variety of subjects, and any failures will only lead you to more creative approaches and more successes.

Certain camera models, such as Nikon's, have a multiple exposure and an image overlay feature. These enable the photographer to create interesting effects, which are combined in-camera. If you are using a compact camera or a dSLR that does not have these functions, you can create multiple exposure effects in Photoshop.

Multiple exposure subjects include cityscapes, flowers, barren trees, or any subject with enough contrast to set it apart from the background. For example, I photographed a propeller from an antique aircraft. I set the camera for eight exposures. Using a tripod and a zoom lens, in between exposures I zoomed outward in small, even increments until I had taken eight successive shots. The end result gives a sense of motion to a static image, as shown in 8-25.

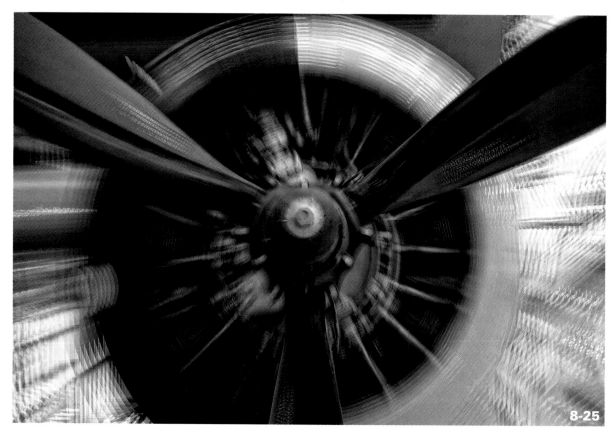

8-25

ABOUT THIS PHOTO *This engine detail became less static and more dynamic when I photographed it with eight sequential exposures, zooming out in small increments in between shots. Taken at ISO 100, f/11, 1/2.5 sec. using a Nikkor 24-70mm Nikkor lens.*

There are many alternatives to zooming. Experiment and have fun exploring the results. You can create multiple exposures that swirl, zoom, or move diagonally, up or down — there are no rules. Try a variety of ways for impressionistic images.

Follow these steps when photographing multiple exposures with cameras that have this capability:

1. **Mount the camera securely on a tripod.** This gives you more precision and control.

2. **Choose an aperture with maximum depth of field, such as f/16 or f/22.**

3. **Take a test shot and double-check the LCD.** Look for any distractions and make sure the composition is evenly exposed. If you're pleased with the test shot, you are ready to move on to making multiples.

4. **From the camera's Shooting Menu, select how many exposures you would like to work with.** Leave the default auto gain on so the camera will adjust each exposure and create a final correct exposure once the images are blended.

5. **Once you've composed, metered, and focused for the subject, turn off autofocus.** As you're making each exposure, you want to prevent the camera from dramatically changing the focus area for subsequent exposures.

6. **Make your first exposure.** Next, reposition in tiny increments for each subsequent exposure. Try to keep the increments as evenly spaced as possible for a more uniform result. After you've reached the total number of exposures, the camera will blend the images together, ending with a single, correctly exposed image of your multiple exposures.

Multiple exposures don't have to be identical. Try photographing two different subjects for the camera to merge or combine as I describe in the next section. You might want to try a single flower blended with a second image of many flowers. Use your imagination to see what combinations create unique, striking multiple exposures.

CREATING A MONTAGE

A collage or *montage* offers a dynamic way to work with digital IR images. A montage has an evocative look that interests and engages the viewer. Digital IR photography lends itself to this technique, because photos in black and white blend so easily. The final image can be nostalgic, abstract, or dream-like in its rendering. The possibilities are virtually endless.

A montage can be as simple as combining two photographs to create a new image and meaning, or it can be as complex as layering several images to tell an entirely different story. You can work with your IR images or combine them with color images for a completely new composite photograph. These are really fun to do. Composites can be made of unrelated images, or images that have a thematic bond, such as shells and the sea. Allow yourself the freedom to experiment with a variety of images to share your new vision.

> *tip* I maintain a library of textures: I photograph them as I see them and add them to my collection to use in montages. Textures exist everywhere, from cracked concrete sidewalks, to rippled water, to art paper, to granite, to old, peeling, painted walls, to rusted metal surfaces.

Start by creating a simple montage. Select an IR image that you like and select a second image that you feel might work well with the first. Begin with images that are similar in size. If you have already put together a digital sandwich as I described earlier, the steps I discuss next will be easy for you.

I chose a photograph of roses (see 8-26) on which I used the digital sandwich technique. I then layered it on top of a second photograph, an old gravestone in IR (see 8-27) with a beautiful inscription; the finished result is shown in 8-28. Open both images in Photoshop and dragged the roses on top of the gravestone image. I chose Edit ➪ Transform to adjust the size and placement of the overlay on the gravestone text. I wanted to achieve a bit of a ghostly look, as if the roses had been left by a long-lost love. Using a blending mode of Multiply, I lowered the layer's opacity of the roses layer so that the text could be seen through them.

ABOUT THIS PHOTO *Roses photographed on a white foam core board, with the digital sandwich technique described in this chapter applied. Taken at ISO 100, f/11, 1/250 sec. using a Nikkor 24-70mm Nikkor lens.*

8-26

ABOUT THIS PHOTO
A gravestone I photographed in a historic cemetery in North Carolina. Taken at ISO 400, f/11, 1/320 sec. using a Nikkor 70-200 Nikkor lens.

8-27

ABOUT THIS PHOTO
The final image of roses upon a gravestone is completely different from either image I started with. It reflects more of the vision I had in mind when I came upon the gravestone and read the inscription.

8-28

CREATIVE ENHANCEMENTS USING FILTERS AND PLUG-INS

There are multitudes of creative and artistic enhancements you can use with your digital IR image in Photoshop. I will begin with a few of the filters that are native to Photoshop and then look at a few available plug-ins.

First take a look at a great feature in Photoshop that was introduced in CS3 called Smart Filters:

1. **Once you have opened your image in Photoshop, choose Filter ⇨ Convert for Smart Filters.** This automatically sets up the layer to be edited (see 8-29), providing a layer mask so you can brush in or out the effects of a filter.

8-29

ABOUT THIS FIGURE
This screen shot shows the Smart Filter and the layer mask that enabling the Smart Filter provides. You can erase the Watercolor effect from selected parts of the image.

2. **Choose Filter ⇨ Artistic from the menu, and choose a filter from the submenu.** A panel opens with your image showing the filters in the Artistic folder, and many others to choose from.

3. **Choose any of the filters to see the effect each has on your image.** Adjust the sliders to see how they affect your image. I chose Watercolor to give the building in 8-30 a painterly look.

4. **Experiment with a variety to see what works with your image.** I used the Watercolor filter and increased the Brush Size to 5, set the Shadow Intensity to 2, and used the Texture to 2.

5. **Click OK to open the image in Photoshop.** Once the image opens in Photoshop, you can decide if you are pleased with the result or you may modify the effects by using the Smart Filter.

6. **Click the layer mask.** To remove some of the filter effects, paint in black using a soft brush with the opacity of your choice. If you removed too much, switch to white by pressing X. This changes the color of the brush from black to white and paints the filter effects back into your image.

Plug-ins from third-party developers are also a great way to extend your creative vision. A wide variety is available for purchase for Photoshop. Plug-ins range from creative effects, color enhancement, black-and-white conversion . . . the list is endless and constantly changing. Bokeh, available from Alienskin (www.alienskin.com) is perfect for blending distracting background elements into a soft blur allowing full attention to the subject. Bokeh also creates exquisite focus effects that complement an IR or color image.

8-30

ABOUT THIS FIGURE *In the Filter panel, many choices are available for effects, as shown in the folders beside the image.*

Nik Color Efex Pro is one of my favorite collections of plug-ins. Filters such as Classic Soft Focus, Midnight, and Contrast Color Range work beautifully with IR images. Tonal Contrast is another one I like. It brings out a lot of detail in an image. To see examples of the effects of these various filters visit www.niksoftware.com.

Topaz Adjust is a very versatile and easy-to-use creative exposure plug-in that provides a variety of effects. These effects can enhance detail, remove or simplify detail, and enhance color and contrast. It's quickly becoming a favorite of many photographers for its ease of use and affordability (www.topazlabs.com).

> **note** Not all Photoshop-compatible plug-ins are fully compatible with Elements and even fewer are compatible with Aperture and Lightroom because they use a completely different architecture. Check the individual software company's Web site for detailed information on compatibility.

onOne PhotoTools (www.ononesoftware.com) is another of my preferred filter sets to use with digital IR images. In its filters menu, it offers a wide variety of effects, from toning to artistic effects. There are painterly effects under One Click Art — such as Watercolor and Crayon — that work well with IR images.

ABOUT THIS PHOTO *The Ponce Inlet Lighthouse, on Florida's east coast, makes a wonderful subject for IR photographers. I used the Photoshop action Strokes to give the image a finishing touch. Taken at ISO 200, f/11, 1/160 sec. using a Nikkor 18-70mm Nikkor lens.*

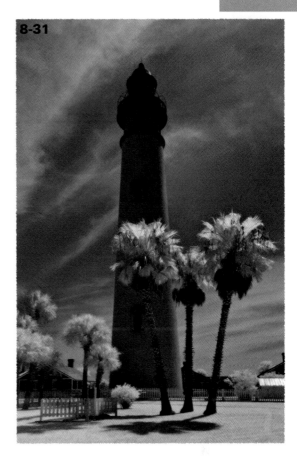

8-31

FINISHING TOUCHES

Once you have adjusted your digital IR image and applied the creative effects you would like, it is time to add the finishing touches. Finishing touches can be simple, such as adding a white border, or more elaborate, such as using a film edge effect. Within Photoshop's Actions palette there are several actions that provide finishing touches, such as Vignette or Strokes frame. The lighthouse photo shown in 8-31 is an example of using Strokes to create an artistic edge to finish an image.

If you want more options, try onOne Photoframe 4 for instant edge effects, borders, and frames that are fully customizable. There are more than 4,000 edge effects you can use individually or combine for a new look.

Frames that replicate film work beautifully with digital IR photos. I liked an image from Namibia of dunes and the moon (see 8-32), but I wanted to take the next step and give it a vintage look with toning and an aged photo border (see 8-33).

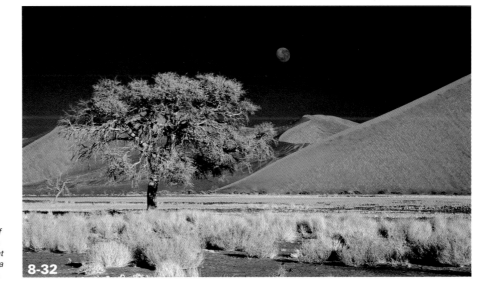

ABOUT THIS PHOTO
The moon, trees, and dunes of Sossusvlei, Namibia, make an interesting scene in IR. Taken at ISO 100, f/11, 1/200 sec. using a Nikkor 18-200mm Nikkor lens.

8-32

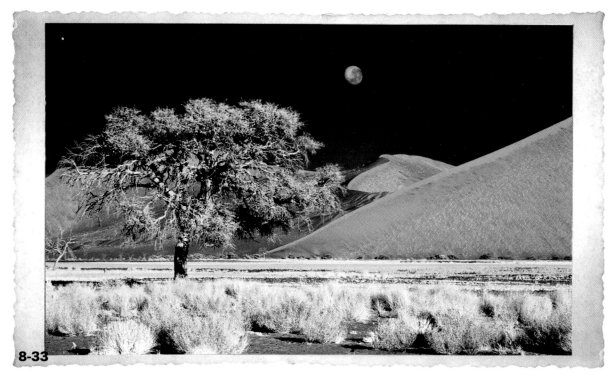

ABOUT THIS PHOTO *The onOne Photoframe film edge effect along with sepia toning was just the finishing touch this image needed to look like a vintage photograph. Taken at ISO 100, f/11, 1/200 sec. using a Nikkor 18-200mm Nikkor lens.*

In 8-34, I photographed a biplane at the Valiant Air Command Warbird Museum in Titusville, Florida. I used a Nik filter called Old Photo to give the aircraft a vintage look, and I finished the image by using one of onOne Photoframe's Instant film edge effects to make the image look like an old photograph.

Sometimes a very subtle effect is all that is needed. In 8-35, I photographed the Park Central Hotel in South Beach, Florida. I used Lucis Pro for an artistic rendition and finished the edges with a painterly effect using onOne Photoframe 4.

ABOUT THIS PHOTO *I liked the vintage effect that Nik Color Efex Pro gave this biplane image. The finishing touch was to provide a film edge effect produced by onOne Photoframe. Taken at ISO 100 with an IR-converted compact digital camera.*

ABOUT THIS PHOTO
The overall effect of Lucis Pro on this image was very painterly. I chose a brushstroke edge treatment to complete the look. Taken at ISO 400, f/7.1, 1/60 sec., using a Nikkor 24-70mm lens.

8-35

Assignment

IR Fun in Photoshop

Choose any technique or combination of techniques discussed in this chapter to create an image that transcends a simple digital IR capture. Use the Channel Mixer to create a blue sky, and then tone your image for a vintage look or selectively color a part of it for visual impact. This assignment is meant for you to stretch your creativity and have fun. Try any of the techniques discussed in this chapter to transform your IR image.

For my example, I photographed the rooftops of a town nestled between hills in Europe. I was drawn to the singular church that towered overhead and reached toward the sky. I liked how IR rendered the trees white and wanted to enhance the sky color. I used the Channel Mixer to create a vivid blue sky that complemented the image. Taken at ISO 100, f/11, 1/160s using a Nikkor 18-70mm Nikkor lens.

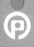

Remember to visit www.pwassignments.com after you complete the assignment and share your favorite photo! It's a community of enthusiastic photographers and a great place to view what other readers have created. You can also post comments and read encouraging suggestions and feedback.

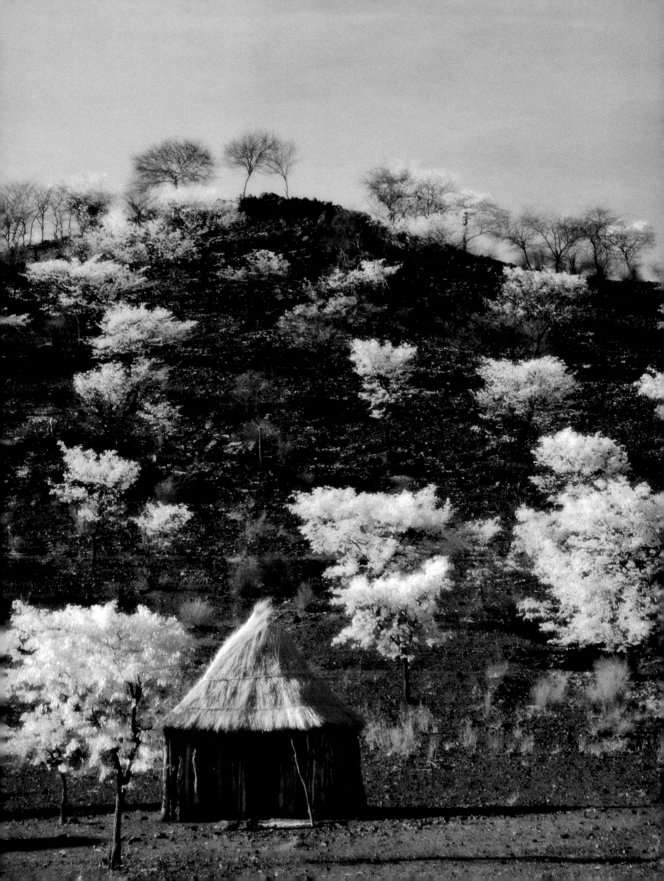

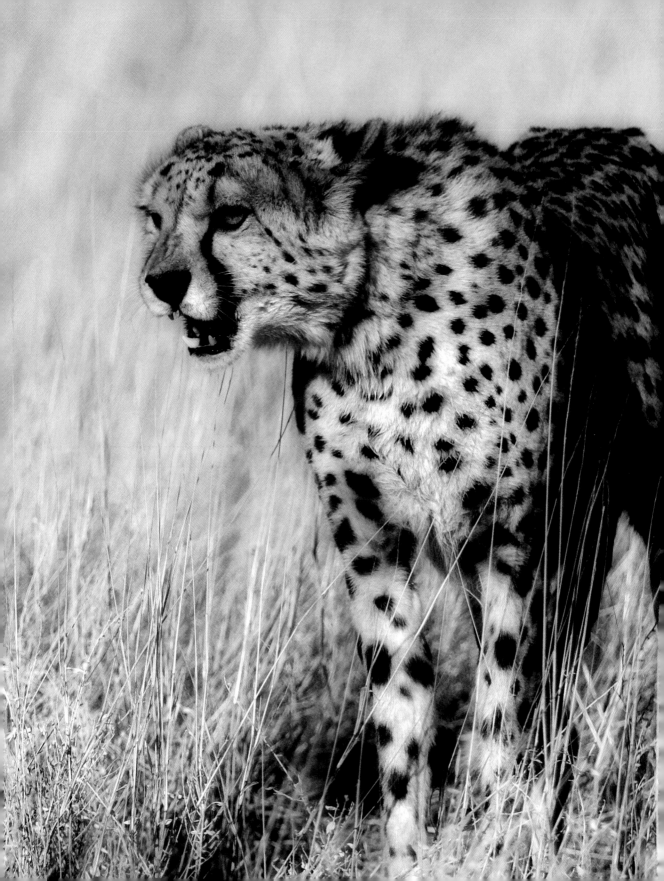

USING TECHNIQUES IN PHOTOSHOP FOR AN IR LOOK

USING PHOTOSHOP PLUG-INS FOR AN IR LOOK

When I review my own work and browse through digital photographs I've taken in the past, sometimes I come across a few that I wish I had photographed in IR instead of color. Or I simply wonder how they would look in IR. Although I frequently photograph in IR, not every color photo in my collection has an IR equivalent. Although you might not expect to be able to convert a color photo to IR, you might be surprised to learn ways you can emulate an IR look in many cases. For example, compare these two images (9-1 and 9-2) that I photographed in Damaraland, Namibia. To accomplish the very dramatic transformation I used IR effects in Photoshop.

Certain color images will come to life when re-created with an IR effect; others can't come close to a true IR image. Particularly, foliage and the translucence of skin tones in IR are a challenge to reproduce. Not every color image succeeds at achieving a photographed-in-IR look, but you can try various techniques to see if one works best.

There are several ways to work with your color images for an IR look, or to replicate a traditional IR film appearance through various software applications and plug-ins. The techniques I cover in this chapter show you how to transform a color image so it has a photographed-in-IR look.

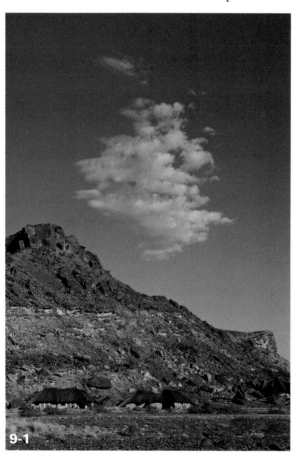

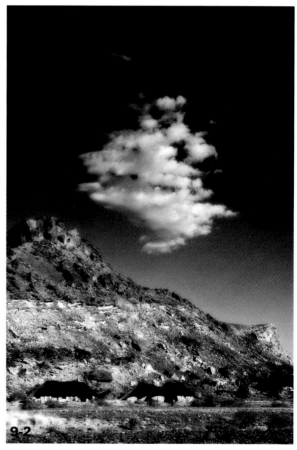

ABOUT THIS PHOTO *A single cloud punctuated a blue sky, which created an interesting color composition of the Twyfelfontein Lodge in Damaraland, Namibia. Taken at ISO 100, f/16, 1/180 sec. with a Nikkor 24-70mm lens.*

ABOUT THIS PHOTO *I liked how the conversion to an IR look transformed this image. The vegetation is white, and the sky looks very dark, which is the characteristic of an IR photograph. I used the Infrared Film filter from the Nik Color Efex Pro 3 (www.niksoftware.com) filter set for the photographed-in-IR look.*

USING TECHNIQUES IN PHOTOSHOP FOR AN IR LOOK

One of my favorite methods for creating an IR look in Photoshop is to use a Black and White adjustment layer. Follow these steps:

1. **Open your image in Photoshop.**

2. **Click the New Layer icon in the Layers palette, which opens a submenu of choices, and choose Black and White.**

3. **When the Black and White control panel opens, click on the Preset pop-up menu and choose Infrared.** You can then adjust each color slider to fine-tune your image. However, a great way to accomplish this is to use the Eyedropper tool rather than the sliders. This tool becomes active when you open this panel.

4. **To cause the Eyedropper to become a scrubby slider, click on the image where you want to make adjustments. The Eyedropper becomes a scrubby slider (as described in optimizing IR images in Chapter 7).**

5. **Drag your mouse across the photo to scroll the scrubby slider left and right to make adjustments.** I selected the sky by pressing down with the Eyedropper tool to enable the scrubby slider. This affected the blue tones in the image and the Blues slider, which I could see in the Black and White panel, and I simply moved the scrubby slider to the left in the image to darken the sky.

In CS4, you can also use the new Adjustments panel to create a Black and White adjustment layer, located above the Layers palette in the default workspace.

Use the drop-down menu and choose Infrared. In the Adjustments panel, click the Hand double arrow icon located next to the Tint check box to enable the sliders to fine-tune the image as previously described with CS3.

In addition, if you want to tint your image, you can click in the Tint check box on the bottom-left corner of the Black and White dialog box and adjust the Hue and Saturation as desired for a subtle shade of color. I like the settings of around 36 for Hue and 12 for Saturation to create a subtle sepia tone. Experiment with both to see which best suits your image.

Compare the color image of women of the Himba tribe (9-3) to the converted IR counterpart (9-4). This image lends itself to effective portrayal in IR for several reasons. Using the IR preset in the Black and White adjustment layer, I could customize the effect to suit the image. It succeeds because of the dark sky and white foliage, typical of IR photographs. I like the color version, and I also like the faux IR version: It emphasizes the stark environment and tells the story of the women in a different way.

Another way to create an IR effect is to use a Channel Mixer adjustment layer. Choose Image ➾ Adjustments ➾ Channel Mixer, or click the new adjustment layer in the Layers Palette. Click Presets in the Channel Mixer panel. The very first preset is Black and White Infrared. (In CS4, click the drop-down menu and choose Black and White Infrared). Select this preset and you have instant IR! You can fine-tune the effect by moving the individual Red, Green, and Blue sliders left or right, although this method doesn't offer the adjustment range compared to the previous one.

ABOUT THIS PHOTO
I took this color photograph of the women of the Himba tribe in a village outside of Opuwo, Namibia. Taken at ISO 100, f/11, 1/160 sec. with a Nikkor 18-70mm lens.

ABOUT THIS PHOTO
With this particular photo, I was able to re-create an IR look noticeable in the trees, sky, and the hut the women stand beside.

I used the Channel Mixer with the Infrared preset to create an IR look for this photograph of the chief of the Himba village in Opuwo, Namibia (9-5). The IR look transformation (9-6) portrays the foliage behind him as white, which is typical in an IR photograph and gives definition to the pipe smoke and his regal pose.

You can use the Channel Mixer to create an IR look if the preset isn't available to you because you have an earlier version of Photoshop. Check the Monochrome box in the Channel Mixer panel. The following settings are approximate — adjust the sliders until you are pleased with the effect.

■ Red channel slider –70 percent

■ Green channel +200 percent

■ Blue channel –30 percent

Those of you who have photographed with Kodak's black-and-white high-speed IR film (HIE) are familiar with the halation effect, which causes the glow that often appears in the highlighted areas of the photograph. With direct capture digital IR photography, this effect isn't present, but it is often desired to create an authentic IR film look.

9-5

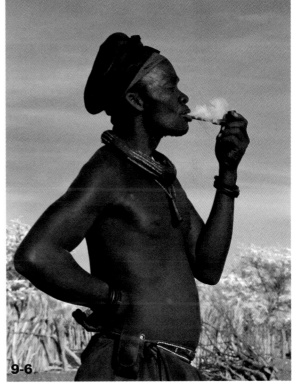

9-6

ABOUT THIS PHOTO *I like the pose of this pipe-smoking village chief who I photographed in a Himba village outside of Opuwo, Namibia. Taken at ISO 100, f/11, 1/160 sec. with a Nikkor 24-70mm lens.*

ABOUT THIS PHOTO *Creating an IR look for this image emphasizes the chief's commanding figure and makes him stand out from his environment.*

If you would like to create the aura and glow associated with IR film, reminiscent of the halation effect, follow these steps:

1. **Use the Diffuse Glow filter (choose Filter ⇨ Distort ⇨ Diffuse Glow).** There are three adjustable sliders for Graininess, Glow Amount, and Clear Amount. The Clear Amount determines how much detail is revealed.

2. **Start with setting the Clear Amount at 10 to 12.**

3. **Set Glow at 2 and Graininess at 4.**

4. **Adjust the sliders to create a pleasing glow that is reminiscent of the halation effect.**

Take a look at a comparison (9-7 and 9-8). I accentuated the photographed-in-IR look by adding a slight glow using the Diffuse Glow filter in Photoshop.

tip

To create a beautiful soft glow without grain, make a digital sandwich as described in Chapter 8.

ABOUT THIS PHOTO *Window shoppers admire a storefront accented by colorful potted plants. Taken at ISO 100, f/11 1/200 sec. with a Nikkor 24-70mm lens.*

ABOUT THIS PHOTO *Using the Channel Mixer, I used a Black and White adjustment layer with an IR preset to give this image an IR look. I enhanced the image with a slight glow using the Diffuse Glow filter in Photoshop.*

9-8

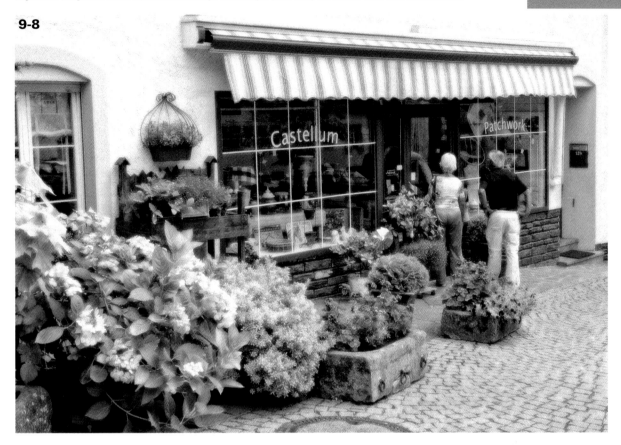

USING PHOTOSHOP PLUG-INS FOR AN IR LOOK

Nik Color Efex Pro 3 (www.niksoftware.com) has a filter set called Infrared Film that replicates the look of IR film and can be used to create compelling images with the look of IR. There are several methods offered in a pop-up menu in this filter set to choose from, including four black-and-white IR choices and five color IR choices.

You can make adjustments to the Infrared Film filter through the plug-ins interface. You can use the Lighten Highlights slider to adjust highlight intensity. You can use the Brightness and Contrast sliders to control overall the brightness and contrast in the image. And with control points, unique to Nik Color Efex filters, you can

make localized opacity adjustments in the image. In addition, you can brush the Infrared Film effect onto chosen areas for an artistic effect.

Following are several examples of what you can accomplish with various IR filters in Nik Color Efex Pro, starting with a color image. I began with an image of one of the many colorful lifeguard stands found on the beaches of South Florida (9-9). I used the Infrared Film filter to create a classic black-and-white IR film look (9-10). This filter emulated an IR look with a lot of contrast and glow. Then, just for fun, I used another, different filter called Infrared Thermal Infrared (9-11). This filter created a vivid and colorful version of an image rendered in the far spectrum of thermal IR (compared to what our camera's capture in the near IR range).

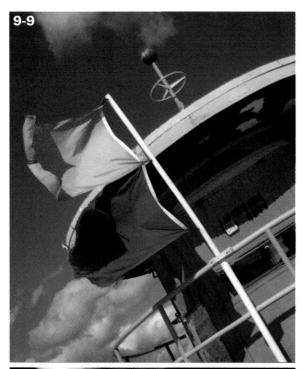

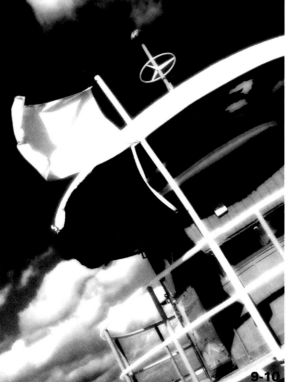

ABOUT THESE PHOTOS *Figure 9-9 shows one of the many colorful iconic lifeguard stations found in "SoBe" (South Beach) Florida. Taken with an IR-converted compact camera. The image in Figure 9-10 was transformed to a classic IR film look, represented by the dark sky and glow in the highlight areas, suggestive of the halation effect produced with high-speed IR film. You can find the Thermal IR filter in the Nik Color Efex Pro filter set. In figure 9-11, this filter generated a colorful photographed-in-thermal-IR look.*

Orlando-based photographer Anna Cary used Nik Color Efex Pro 3 to creatively enhance a barn she photographed in upstate New York. Anna's artistic choices in replicating IR completely transformed her image of a barn in summer (9-12) to the portrait of a frosty barn in winter (9-13). Anna used the Infrared Film filter twice with different settings to give the barn an IR look, and then used a layer mask to reveal the original red barn color for a creative and colorful touch.

ABOUT THIS PHOTO *Anna Cary's vision of her summery barn photograph as a winter IR scene was achieved with the help of Photoshop and creative filters. ©Anna Cary*

ABOUT THIS PHOTO *Photographer and Photoshop instructor Anna Cary photographed this quaint scene in upstate New York in early June. Taken at ISO 250, f/25, 1/60 sec. with a Nikkor 18-200mm lens. ©Anna Cary*

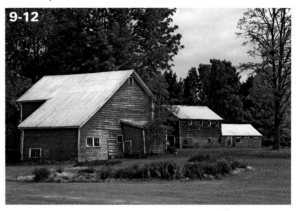

9-12

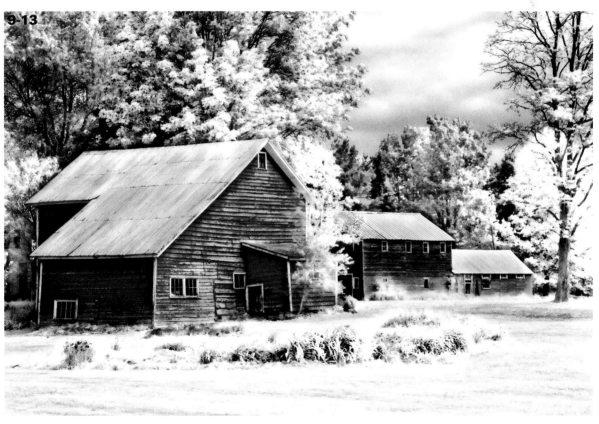

9-13

The Nik filter set Silver Efex Pro has several filters that create an IR look. For this aging barn that I photographed in Maine (9-14), I used the Infrared Film Normal preset. It gave a timeless IR film quality to the image and brought out the unique texture in the aging wood (9-15). There are more IR-look Custom Styles you might want to try, which you can download from the Nik Software Web site (www.niksoftware.com) and add to the Styles menu.

ABOUT THIS PHOTO *I photographed this ancient barn with a faded door in Maine in fall. Taken at ISO 100, f/16, 1/25 sec. with a Nikkor 18-70mm lens.*

9-14

ABOUT THIS PHOTO *Giving this image an IR look enhanced the various textures. I used Nik Silver Efex Pro, which allowed me to add localized contrast and structure through its Control Points feature.*

At the Bagatelle Kalahari Game Ranch in Namibia, there are several beautiful cheetahs that can't be released into the wild. Instead, they are expertly cared for in containment, offering photographers a wonderful opportunity to get close to these amazing creatures. (I even had the chance to actually pet one.) I photographed a magnificent cheetah in tall grass (9-16).

I transformed the image to an IR look using onOne Phototools, Black and White treatments, Convert to B&W IR (www.ononesoftware.com). This filter lets you create an IR look in Light, Medium, or Heavy versions, and I chose Light in this case (9-17). The tall grass was rendered white with this IR effect, which allowed the cheetah to stand out nicely in his environment.

One of my favorite presets in the onOne Phototools filter set is the Holga Infrared (located in the onOne PhotoTools submenu). This creates a wonderful vintage camera effect that softens and blurs a dark vignette around the image, creating an IR look in the process. This completely transforms the look of a color image, and works beautifully where you want a nostalgic, dreamy effect (9-18). In this image, the flowers represented in white worked well to complete an IR look.

tip

You can provide a subtle hand-tinted look to your photo by slightly reducing the opacity of the IR effect layer.

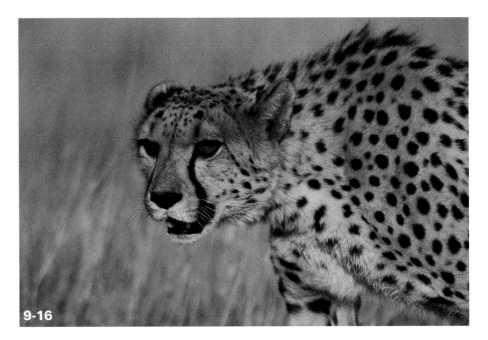

ABOUT THIS PHOTO
This cheetah was amazing to watch and photograph, possessing incredible speed and grace. Taken at ISO 200, f/5.6, 1/640 sec. with a Nikkor 70-200mm lens and teleconverter.

9-16

9-17

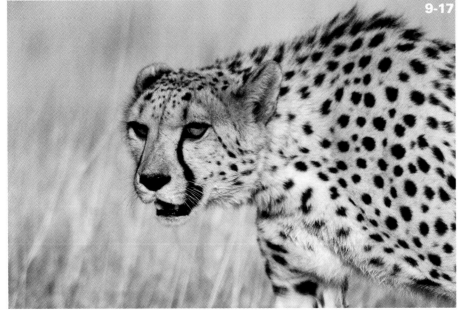

ABOUT THIS PHOTO
This image was well suited for re-creating an IR look, with the tall grass around the cheetah rendering white. I experimented with several different methods before deciding that the IR effect in onOne Phototools worked best.

9-18

ABOUT THIS PHOTO *This cemetery scene was modified to resemble an IR look using an OnOne Phototools Infrared preset. This filter gave the image a nostalgic look as if it had been photographed with a vintage camera with IR film. Taken at ISO 100, f/16, 1/10 sec. with a Nikkor 12-24mm lens.*

Another Photoshop-compatible plug-in that can give a color photograph an IR look is Alien Skin's Exposure 2 (www.alienskin.com). The filters found in this plug-in are designed to imitate many different film types, including Kodak's HIE (high-speed IR film), with the associated halation effect and provides many choices and adjustments for tailoring an IR look.

For example, I converted this photograph of a cemetery in Boston, Massachusetts (9-19), using the filter that re-creates Kodak's HIE film and then fine-tuned the effect for a subtle glow (9-20).

If you are looking for a free IR effect, Adobe Photoshop Exchange (www.adobe.com/cfusion/exchange) has various Photoshop IR effects available for download. Type Infrared in the Search the Exchange box to find the one of the many IR effects to try on your color image.

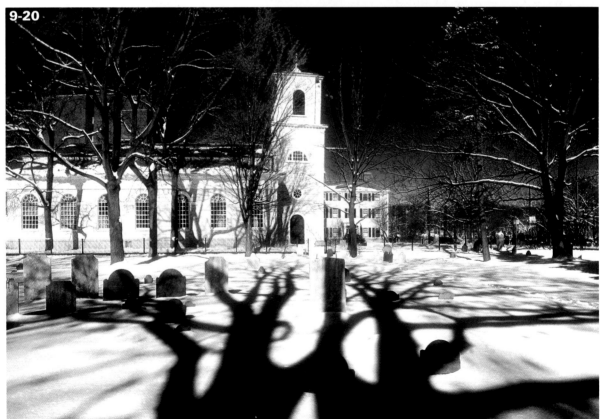

Assignment

Creating Pseudo IR Images from Color Photographs

For your assignment, I encourage you to revisit some of your favorite color photographs and explore the various methods and techniques for creating an IR look. You may find certain methods work better than others, depending on your image. Try a variety of techniques to see which are best. If you are ambitious, explore a few creative techniques. Create a subtle glow that suggests the halation effect, or introduce a hint of color reminiscent of hand-tinting.

For my example, I looked for a color image that would best represent a photographed-in-IR look by including the sky and foliage. The castle Rheinstein that I photographed in Germany along the Rhine River provided a great opportunity to experiment with pseudo IR. Taken at ISO 200, f/11, 1/180 sec. with a Nikkor 70-200mm lens.

In Photoshop, I used a Black and White adjustment layer with the Infrared preset to create an IR look. This effect worked well for the castle, which now has a timeless, illustrative look.

 Remember to visit www.pwassignments.com after you complete the assignment and share your favorite photo! It's a community of enthusiastic photographers and a great place to view what other readers have created. You can also post comments and read encouraging suggestions and feedback.

BE INSPIRED

KATHLEEN T. CARR

ANNA CARY

JOE FARACE

LEWIS KEMPER

JEAN MIELE

JOSEPH PADUANO

KEN SKLUTE

DAVID TWEDE

ANDY WILLIAMS

Developing photography skills goes beyond just using a camera and related software. No matter how comfortable you are technically, you will become a complete photographer only when your own personal style and artistic perspective is reflected in your work. As you learn to appreciate others' work, your own style will naturally evolve.

What inspires and motivates you? What are your primary interests? Whatever they are, you can cultivate these interests by exposing yourself to different photographic styles and techniques. This chapter introduces IR artwork from a variety of respected photographers. It is an opportunity for you to critique and practice identifying those elements that you like and enjoy. Images from nine different photographers may serve as a directional springboard as you develop your own IR artistic identity.

KATHLEEN T. CARR

Professional fine art photographer, author, and teacher Kathleen Carr (www.kathleencarr.com) received her bachelor of fine arts degree in photography from Ohio University in 1970. Her photographs have been published internationally in numerous books, periodicals, and art posters, and have been widely exhibited at galleries and museums.

10-1

ABOUT THIS PHOTO Dorothea, *Hawaii. Taken with an IR-converted Canon XTi, ISO 100, f/6.3, 1/60 sec. © Kathleen Carr*

ABOUT THIS PHOTO Country Road, *Hawaii. Taken with a Minolta Dimage 7, ISO 100, f/4, 1.5 sec. using a Harrison & Harrison 89B IR filter. Photography © Kathleen Carr*

10-2

Carr pursues her photographic work with digital IR, Photoshop techniques, and hand-coloring. In any of her chosen mediums, her images are strikingly beautiful (10-1) and, at the same time, intimate and ethereal (10-2). Carr continually takes a fresh look at the world around her, translating her vision and experiences into her photographic work.

ANNA CARY

Anna Cary's interest in photography (www.annacary.com) began with Photoshop and graphic design in 2001. Her passion for trying new things led her to photo restoration and digital painting, broadening her expertise.

Uniquely creative and highly qualified in Photoshop, she is much in demand as an instructor and one-on-one teacher. Her fascination with IR inspired her to create faux IR images in Photoshop and later to convert a camera with a deep black-and-white IR filter for traditional IR images.

Her goal in IR photography is to draw viewers into the scene by inviting them to participate in the ethereal and mystical qualities of IR light (10-3). Cary photographs water, reflections, vintage cars and trains, old structures, bridges, and dilapidated barns (10-4).

10-3

ABOUT THIS PHOTO Flag Cemetery *was photographed in upstate New York. Taken at ISO 200, f/7.1, 1/800 sec with an IR-converted Nikon D70 using a deep black-and-white IR filter (87C) and Nikkor 18-70mm lens. © Anna Cary.*

ABOUT THIS PHOTO Cattle Call *was photographed on a country road near Amsterdam, New York. Taken at ISO 200, f/13, 1/250 sec with a IR-converted Nikon D70 using a deep black-and-white IR filter and Nikkor 28-70mm lens.* © *Anna Cary.*

10-4

She has extensively photographed her native California, as well as North Carolina and upstate New York, and her work has been exhibited in several Florida galleries. Cary does freelance photography and is an in-house photographer for central Florida *Lifestyle* magazine.

ABOUT THIS PHOTO The view of the shoreline at Barr Lake State Park, Colorado, was captured using a Singh-Ray I-Ray filter attached to an Olympus E-420 using the Monochrome mode. The shoreline was increased on the left side of the frame using Flaming Pear's Flood, a Photoshop plug-in filter. Taken at ISO 400, f/3.5, 6 sec. © Joe Farace.

10-5

JOE FARACE

Professional photographer, writer, and teacher Joe Farace (www.joefarace.com) has been creating imaginative and unique color and black-and-white IR photographs (10-5) since the early 1970s.

Through his use of IR filters and converted cameras, Farace has continued to probe the unexplored edges of the world of invisible light (10-6). He has authored more than 30 books and has written more than a thousand magazine articles covering photography, digital imaging, and computing. Farace's avid interest in photography and digital imaging emerged from a combination of his engineering education from Johns Hopkins University and his fine art photography training at the Maryland Institute College of Art.

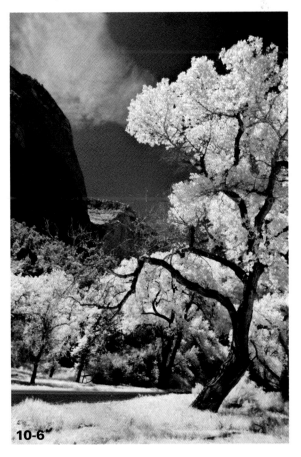

10-6

ABOUT THIS PHOTO *The IR golden hour in the middle of the day provided the perfect opportunity for digital IR photography at Zion National Park. Taken at ISO 200, f/9, 1/125 sec. with a Tamron 11-18mm lens. © Joe Farace.*

LEWIS KEMPER

For nearly three decades, professional photographer, author, and teacher Lewis Kemper (www.lewiskemper.com) has been ranging North America, photographing the natural beauty of the parklands in 47 states. His fine art photographs are in many museums, galleries, and collections, both private and permanent, throughout the world. Kemper's images have been used in more than 16 different countries in magazines, books, and calendars, as well as on book covers and national ads.

Kemper received a bachelor's degree in fine art photography from the George Washington University in 1976, before the grandeur of the West beckoned. He relocated to Yosemite National Park, where he lived for 11 years.

Working at the Ansel Adams Gallery from 1978 to 1980 was influential in Kemper's development as a photographer and allowed him opportunities to meet, observe, and learn from a number of world-renowned photographers. When shooting in IR, Kemper photographs images with a lot of texture and older looking, man-made objects (10-7). He shows how the stark contrast of IR emphasizes details and textures in wood and stone. Kemper uses a converted Canon G9 for his IR photography and has developed a Photoshop technique that lets him emphasize texture in his images (10-8).

Follow these steps to emulate Kemper's Photoshop technique for emphasizing texture in an IR image:

1. **Duplicate your selected image twice.** This gives you three layers to work with in Photoshop.

2. **Turn off the visibility of the upper layer.**

3. **On the middle layer, run an Emboss filter.**

4. **Attach a Black and White Adjustment layer to this layer to remove all traces of color.**

5. **Merge the Black and White Adjustment layer with the Emboss layer.**

6. **Adjust the opacity of the merged layer to somewhere between 50 percent and 80 percent, depending on taste.**

7. **Slightly move the merged layer to get an alignment that gives you good 3D relief.** Try moving two pixels up and two pixels to the left for a start.

ABOUT THIS PHOTO *Lewis Kemper photographed this old-fashioned bicycle in Silverton, Colorado, and creatively enhanced his image using the included tip. Taken with an IR-converted Canon G9, ISO 100, f/4, 1/320 sec. © Lewis Kemper*

8. Turn the visibility back on the top layer and lower the opacity of this layer to some-where between 25 percent and 45 percent to add more color back into the image.

9. Add a Curve adjustment layer to work on the contrast.

ABOUT THIS PHOTO
Lewis Kemper photographed chairs at the Sandestin Resort in Florida using an IR-converted Canon G9, ISO 100, f/5.6, 1/180 sec. © Lewis Kemper

10-8

JEAN MIELE

Jean Miele (www.jeanmiele.com) is an American photographer whose interest in mysticism and spiritual growth has inspired his artwork since the mid-1980s. He has often used IR photography for his black-and-white landscape photographs — images of solitary places, strong and quiet (10-9).

"It's tempting to believe photography's power lies in its ability to show a moment in time, or to tell a story about a particular person or place," Miele said. "I make photographs to remind myself that we live in a magical world and that anything is possible." Because IR photographs allow us to see the unseen, Miele uses them to explore the borderlands between fiction and reality (10-10).

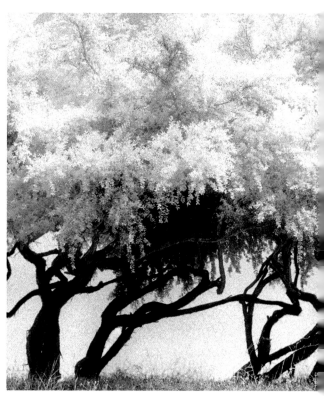

ABOUT THIS PHOTO *Miele made this photograph from the series,* Trees: Landscapes of the Mind *with a 105-210 zoom lens and Konica B&W IR film with a 25A red filter. © Jean Miele.*

"IR depicts people and plants as light sources in themselves, which mirrors the idea that people are metaphorically luminous beings," Miele said, "and literally made of the same stuff as stars!"

Miele's images have appeared in thousands of publications, ranging from books and magazines to advertising and annual reports. His photographs have also been widely exhibited, and his original prints are in numerous collections. Though based in New York City, Miele is internationally known, and he has been an instructor for Adobe Systems, Apple Computer, Maine Media Workshops, Fuji USA, the Norwegian Fotografiakademiet, International Center for Photography (ICP) in New York, and many others.

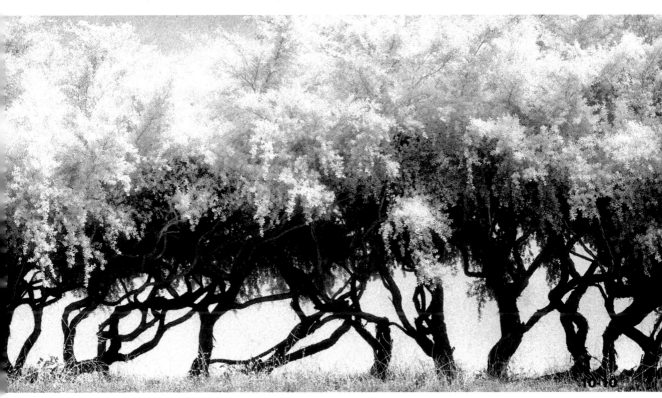

ABOUT THIS PHOTO *Miele made this picture, from the series* Water, Rocks, and Other Signs of Mystical Life, *in San Francisco, California. Exposed on 35mm Kodak HIE B&W film, with an 80mm lens and a 35mm panoramic back with a deep red filter.* © *Jean Miele.*

JOSEPH PADUANO

Professional photographer, instructor, and author Joseph Paduano (www.joepaduano.com) has been working exclusively with black-and-white and color IR film for more than 20 years. His favored subjects of old homes, beach scenes, landscapes, seascapes, and nudes, have a soft, dream-like quality (10-11). The interplay of sunlight and shadow create an intriguing altered reality with a dynamic visual impact.

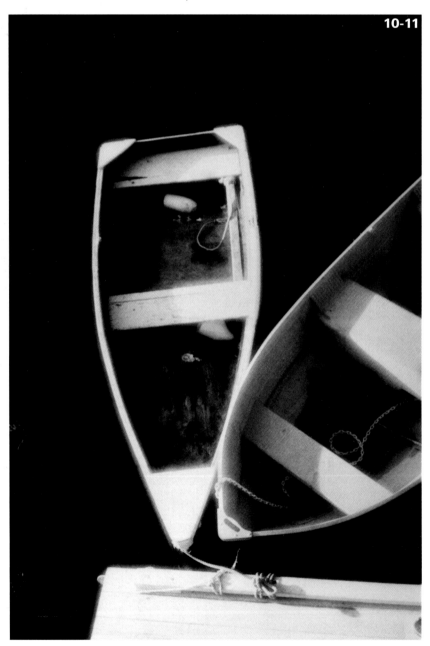

10-11

ABOUT THIS PHOTO
Photographed in Nantucket. Taken using IR film at, f/16, 1/60sec. with a Sigma 18-35mm lens and #25 red filter. © Joseph Paduano.

His skillful blending of subjects and varied lighting, as well as warm-tone photographic paper, creates the impression of a time when photography was in its infancy. Paduano's work now stretches the frontiers of black-and-white IR film as he uses shapes, textures, light, and shadows to create both powerful and dramatic scenes of architecture and landscape (10-12).

ABOUT THIS PHOTO
Photographed in Nantucket. Taken using IR color film at, f/16, 1/60sec. with a Sigma 18-35mm lens and #25 red filter. © Joseph Paduano.

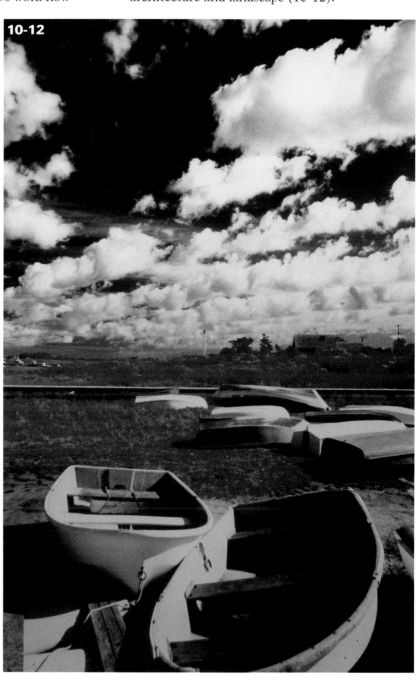

10-12

KEN SKLUTE

The romance of digital photography echoes throughout the 35 award-winning years of Ken Sklute's work (www.kensklute.com). For more than 20 of those years, Slute has never failed to

have an IR camera with him and shoots regularly in IR.

Tending to include sky and clouds as part of his vision (10-13), he is moved by the strong contrast, deep blacks, and ethereal highlights of his

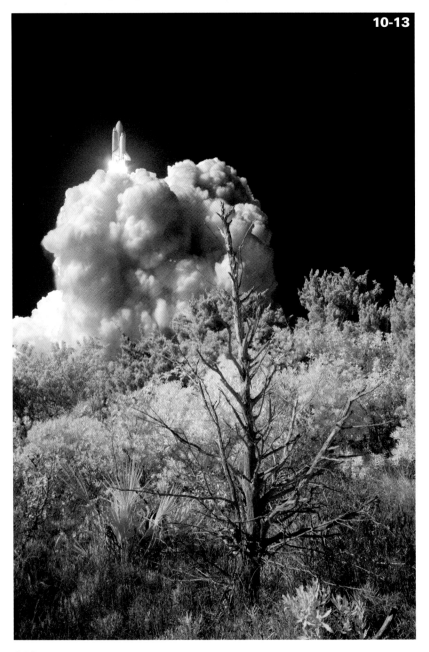

10-13

ABOUT THIS PHOTO *Ken Sklute had to visualize where the shuttle would come up and chose to offset it with the magnificent dead tree to balance the composition. He used an IR-converted dSLR, f/8, 1/1000 sec. with a 35mm lens. © Ken Sklute.*

subject scenes. Slute received his master of photography and photographic craftsman degrees from the Professional Photographers of America, and has received numerous accolades for his exceptional talent.

Whether his subject is weddings, waves, or windswept dunes, people, pastures, or plateaus, when Ken puts his hand to the camera, legendary magic happens (10-14). Internationally renowned, he spends much of his time lecturing and teaching the art and craft of photography.

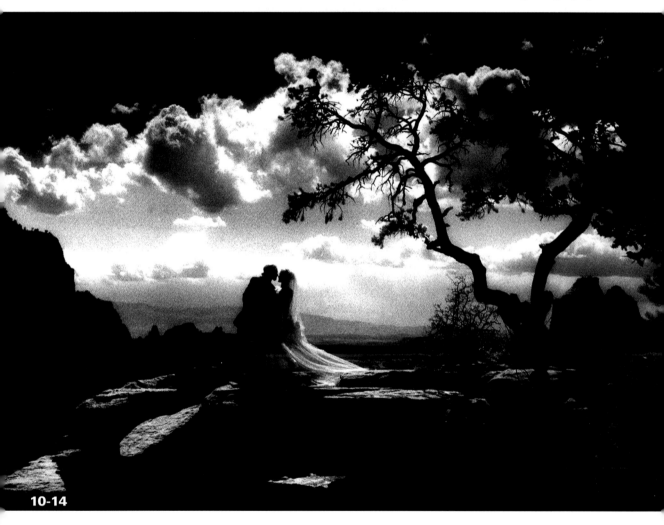

10-14

ABOUT THIS PHOTO *This award-winning wedding image was photographed in Sedona, Arizona, at noon. It took 35 minutes to travel 5 miles on a primitive road and 10 minutes to make the image. Taken with Kodak High Speed IR film, f/16, 1/250 sec. © Ken Sklute.*

DAVID TWEDE

David Twede considers himself a selective-spectrum photographer. He shoots a combination of ultraviolet, visible, and IR using specific optical filters to select portions of the full spectrum, depending on the desired outcome (10-15). Though he works as a scientist and writer, spirituality and unordinary reality color his photography (10-16).

A motivating factor in Twede's work is the preservation of natural resources, recording landscapes that are disappearing due to over development. Twede has begun capturing dual or trio photo sets of these soon-to-be forgotten sites in IR, normal color, and ultraviolet. When displayed side by side, they can imply going from the actual past to an elusive future. His works are in galleries in Manitou Springs, Colorado, and you can view some online at www.surrealcolor.com.

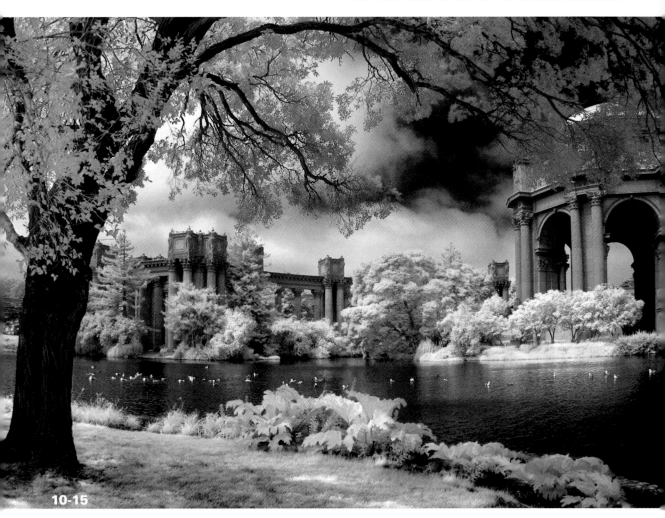

10-15

ABOUT THIS PHOTO *Photographed at the Palace of Fine Arts, San Francisco, California. Taken at f/8, 1/200 sec using a custom selective spectrum filter. © David Twede.*

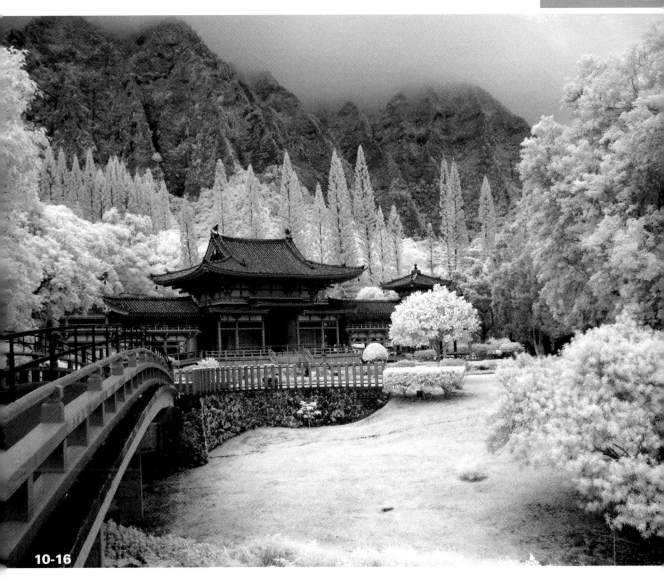

10-16

ABOUT THIS PHOTO *The Byodo-in Buddist Temple, Oahu, Hawaii. Taken at f/13, 1/200 sec. using a R66 filter. © David Twede.*

ANDY WILLIAMS

Andy Williams, chief operating officer and general manager of SmugMug, a digital photography-sharing Web site, has been a photographer all his life. Shooting professionally for the past 20 years, Williams has been in love with digital IR since he first put an R-72 filter on a Sony F717 Cybershot years ago. He does portrait and event work, as well as landscape and street photography. He enjoys teaching and does several workshops each year.

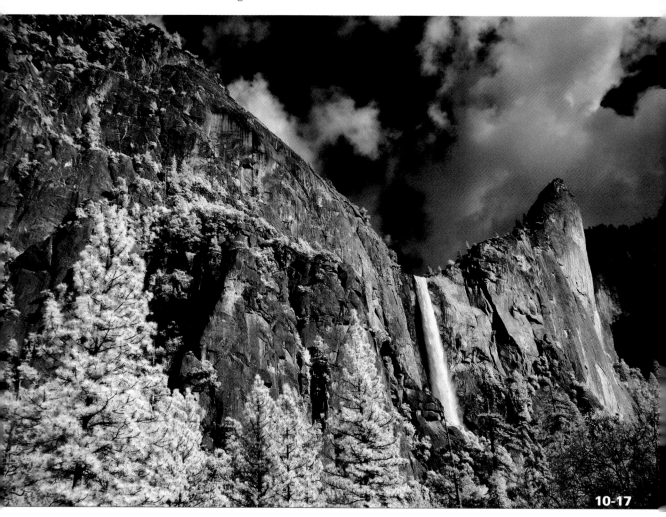

10-17

ABOUT THIS PHOTO *Andy Williams photographed this dramatic scenic view at Yosemite National Park. Taken at ISO 100, f/8, 1/320 sec with an IR-converted dSLR. © Andy Williams.*

After visible light's magic hour in the early morning, Andy puts his color cameras away and midday becomes IR time. Williams looks for big skies, lots of contrast, and sweeping vistas (10-17 and 10-18). For more information and Williams's online galleries, visit www.moonriver photography.com.

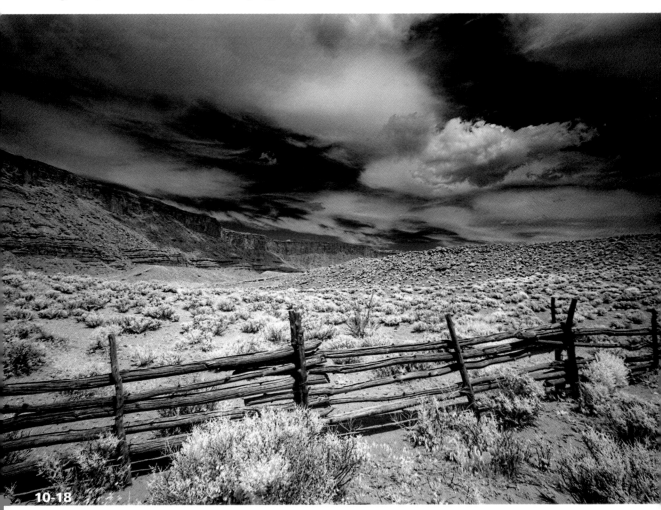

10-18

ABOUT THIS PHOTO *This fence line and stunning vantage point was photographed near Moab, Utah. Taken at ISO 100, f/11, 1/160 sec. with an IR-converted dSLR. © Andy Williams.*

Assignment

IR Inspiration

Gain inspiration from the photographers in this chapter and others whose work motivates you. Move forward, have fun, and develop your own personal style in IR photography. Upload a favorite image and be creative with it using what you have learned throughout the study of this book.

The Sossusvlei dunes in Namibia are magnificent to witness, truly an opportunity of a lifetime. I was in awe at the sheer magnitude of each dune and how the wind endlessly reshapes them over time. Getting to the dunes is a challenge, a long drive in an open Land Cruiser on rough unpaved roads, and even further in dry sand. On a very foggy morning at sunrise, the dunes became clearer and peeked through the fog as we neared our destination. For my example, I liked how IR cut through the haze of the morning and provided a wonderful opportunity to capture this beautiful windswept dune. Taken at ISO 400, f/5.6, 1/200 sec. with a Nikkor 18-70mm lens.

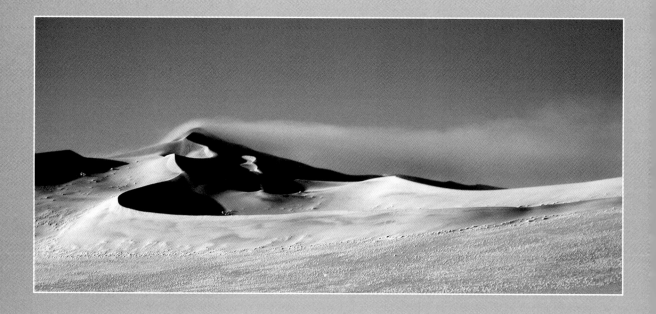

 Remember to visit www.pwassignments.com after you complete the assignment and share your favorite photo! It's a community of enthusiastic photographers and a great place to view what other readers have created. You can also post comments and read encouraging suggestions and feedback.

To learn more about IR filters and IR conversion companies, software products, accessories, and other online resources, visit these Web sites:

IR FILTERS

B&H	www.photovideo.com
LDP Net	www.maxmax.com
Life Pixel*	www.lifepixel.com
Singh-Ray	www.singh-ray.com

CAMERA CONVERSION COMPANIES

LDP Net	www.maxmax.com
Life Pixel	www.lifepixel.com

> **tip**
>
> If you are ordering camera conversion from Life Pixel, use the coupon code DEB for free ground shipping.

IMAGE-EDITING SOFTWARE

Adobe Photoshop	www.adobe.com
Capture NX2	www.nikonusa.com

NOISE-REDUCTION SOFTWARE

Neat Image	www.neatimage.com
Nik Dfine 2.0	www.niksoftware.com
Noiseware	www.imagenomic.com

HDR SOFTWARE AND PLUG-INS

Dynamic-PHOTO HDR	www.mediachance.com
FDRTools	www.fdrtools.com
Photomatix	www.hdrsoft.com
Topaz Adjust	www.topazlabs.com

PHOTOSHOP PLUG-INS

Alienskin Bokeh	www.alienskinsoftware.com
Alienskin Exposure 2	www.alienskinsoftware.com
Flaming Pear Flood	www.flamingpear.com
Lucis Pro	www.lucispro.com
Nik Capture NX2	www.niksoftware.com
Nik Color Efex Pro 3.0	www.niksoftware.com
Nik Dfine 2.0	www.niksoftware.com
Nik Silver Efex Pro	www.niksoftware.com
OnOne FocalPoint 1	www.ononesoftware.com
OnOne PhotoFrame 4.0	www.oneonesoftware.com
OnOne PhotoTools	www.ononesoftware.com
Photoshop Exchange	www.adobe.com/cfusion/exchange/
Topaz Adjust	www.topazlabs.com
Topaz Simplify	www.topazlabs.com

OTHER ACCESSORIES

Gitzo Tripods	www.gitzo.com
Hoya Filters	www.hoyafilter.com

Induro	www.indurogear.com
Lee Filters	www.leefilters.com
Lensbaby	www.lensbaby.com
Really Right Stuff	www.reallyrightstuff.com
Singh-Ray	www.singh-ray.com
Spectrum Glass	www.spectrumglass.com
Tiffen	www.tiffen.com

PHOTOGRAPHERS

Kathleen Carr	www.kathleencarr.com
Anna Cary	www.annacary.com
Joe Farace	www.joefarace.com
David Hockney	www.hockneypictures.com
Lewis Kemper	www.lewiskemper.com
Jean Miele	www.jeanmiele.com
Joe Paduano	www.joepaduano.com
Deborah Sandidge	www.deborahsandidge.com
Ken Sklute	www.kensklute.com
David Twede	www.surrealcolor.com
Pep Ventosa	www.pepventosa.com
Vincent Versace	www.versacephotography.com
Andy Williams	www.moonriverphotography.com
Ben Willmore	www.thebestofben.com

MAGAZINES

Double Exposure	www.doubleexposure.com
Fotoaldia	www.fotoaldia.com
Layers	www.layersmagazine.com
Nikon World	www.nikonnet.com
Photoshop Creative	www.pshopcreative.co.uk
PhotoshopUser	www.photoshopuser.com
Photonet	www.photonet.com
Shutterbug	www.shutterbug.com

ONLINE COMMUNITIES

BetterPhoto	www.betterphoto.com
Double Exposure	www.doubleexposure.com
Flickr	www.flickr.com
League of Creative Infrared Photographers	www.irleague.com
Photonet	www.photonet.com
Photoworkshop	www.photoworkshop.com
SmugMug	www.smugmug.com

EVENTS

FOTOfusion	www.fotofusion.org
Macworld	www.macworld.com
PMA	www.pma-show.com
PhotoPlus Expo	www.photoplusexpo.com
Photoshop World	www.photoshopworld.com

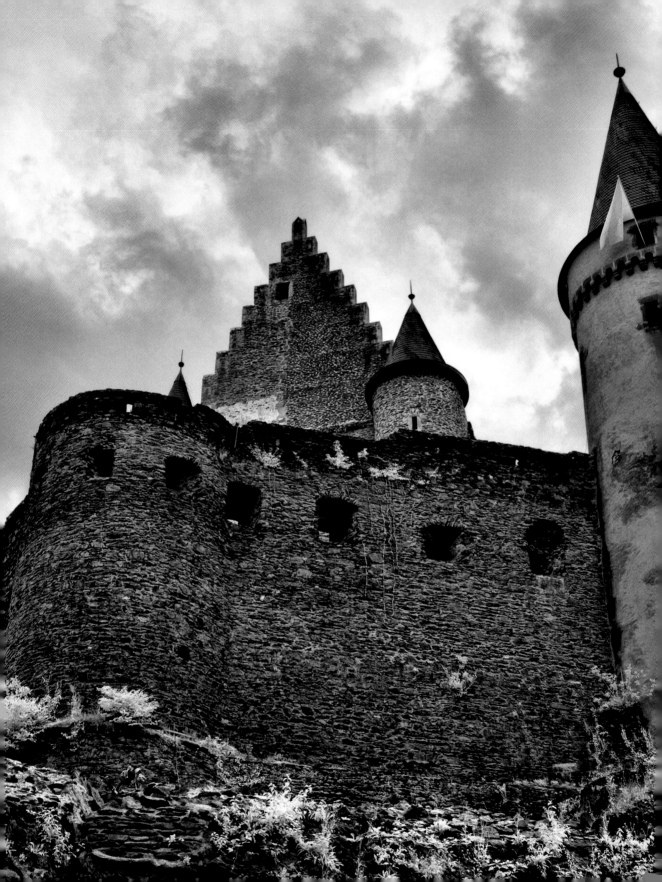

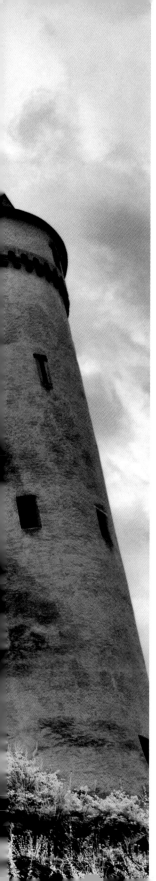

ACR Adobe Camera Raw, the RAW converter plug-in that's found in Adobe Photoshop and Photoshop Elements.

aperture The opening in the lens diaphragm that's measured in f-stops that allows light to reach the digital camera's sensor (or film).

backlighting A condition in which the light falls on the subject from behind. This can create dramatic shadows and silhouettes.

Blending mode Method of blending Photoshop layers such as Multiply, Screen, Darken, and Lighten.

blinkies Flashing on and off that occurs on the dSLR's LCD screen when the camera's highlight overexposure warning is set to alert, which shows the photographer where detail is being lost.

burn The term applied to burning in or darkening specific areas in an image. It originates from the traditional darkroom technique in which areas of the print were burned and made darker by using longer exposure times in selective parts of the photograph.

cable release A camera attachment that allows the photographer to release the shutter without touching the camera, thereby reducing the possibility of camera shake.

channel swapping Using the Channel Mixer in Photoshop to create false color IR images; used often in processing IR images for the blue-sky effect.

collage The process of creating a composite using multiple images.

compact flash A type of memory card used by many digital single lens reflex cameras.

contrast The range between the dark and light tones in an image.

depth of field The total area within the image that is sharp. Many digital cameras have a depth

of field preview button that will stop the lens aperture down to the working apertures to display the depth of field in a potential photograph in the viewfinder.

desaturate To reduce or remove color from an image.

digital sandwich The process of layering two images to make a final image with more impact.

dodge The traditional wet darkroom term applied to lightening specific areas of an image. Photoshop contains dodge and burn tools.

edge effect Border, frame, or treatment design to enhance the edges of an image.

exposure The combination of light and the length of time allowed for it to reach the camera sensor; determined by the shutter speed, aperture, and sensitivity (ISO).

exposure bracketing The setting used to create several different exposures of the same subject. Auto-bracketing can be set in digital cameras and is often used for capture of High Dynamic Range (HDR) images.

eyedropper A tool used in Photoshop to sample color within an image.

f-stop F-stop values are defined by the size of the aperture, where f/2.0 is a wide opening with shallow depth of field and f/22 is a very small aperture opening with a greater depth of field. The size of the aperture determines how much light passes through to the lens along with the shutter speed.

file format Various format choices that digital cameras record in, such as JPEG, TIFF, and RAW.

filter Specially designed glass or resin that serves a variety of purposes, such as providing polarization, neutral density, or IR. These filters can be can be mounted on the lens of a camera. IR filters can also be installed inside a digital

camera for IR conversion. In Photoshop, digital filters create various effects in an image, and also simulate the use of actual filters designed for use on a lens for color and creative effects.

focus The process of adjusting the lens to create an image that is sharp.

framing Composing a subject so that it is surrounded with elements that enhance the total image, thereby framing the main subject.

global adjustment An optimization that affects the entire image, rather than selective areas (localized adjustments).

grain The metallic silver dots that appear randomly, creating a visually textured look in film. Higher ISO film shows more grain. The appearance of traditional film grain can be applied digitally to an image in Photoshop by using the Film Grain filter.

halation effect The glow around the highlight areas in film photography that results because the back of Kodak HIE (high-speed IR) film doesn't include an anti-halation layer. This layer would normally absorb any scattering or glow around the highlight areas in the film. Some other IR films, such as Efke, have an anti-halation later.

HDR High Dynamic Range. The technique of combining and merging various exposures of the same image through software applications. This process creates a single image that has detail in both the highlight and the shadow areas that wouldn't be possible in a single exposure.

highlights The brightest areas in an image.

histogram The representation of an image's exposure in a graphical form found on camera displays and in Photoshop. The histogram indicates where the shadows, midtones and highlights are within the image. Although there is no ideal histogram, it shows how the image was recorded and exposure adjustments can be made based on this information.

hot mirror The filter inside a digital camera that blocks ultraviolet and infrared light, and allows only visible light to pass through to the camera sensor.

hot mirror filter The filter inside a digital camera that is designed to transmit light in the visible spectrum and reflect invisible light in the infrared or near-infrared spectrum.

hotspot The pale circle that can sometimes be found in the center of an IR image that is difficult to remove in post-processing.

IR Infrared. Wavelengths are produced in the near-IR range from 700 nanometers (nm) to 1,000nm.

ISO The International Standards Organization number indicating the sensitivity of the digital camera's sensor to light, or indicating film speed.

JPEG Joint Photographic Experts Group. A commonly used file format that compresses (and discards) image data. Depending on the software, image quality may degrade each time an image is opened and saved in this format.

layer A term for storage of adjustments on sheets or *layers* such as curves, levels, saturation, or text that can be manipulated individually or in groups. Layers are a feature of Adobe Photoshop and other imaging programs as well.

LCD Liquid Crystal Display. Digital images, data, and camera information can be displayed on the camera's LCD screen.

Lensbaby A proprietary and bendable lens designed for softly blurred images with a sweet spot of focus.

lens flare Bright areas in an image that are circular, or streaks that can occur when light strikes the lens or unwanted light enters the camera. Using the lens hood helps prevent this occurrence.

lightbox Opaque glass or plastic with a light source underneath contained in a box, traditionally used to view negatives or slides. It can be used for illuminating objects to be photographed.

localized adjustment Fine-tuning optimization that affects a chosen area of the image, rather than the entire image.

memory card A solid state storage device designed to store data, such as CompactFlash (CF) cards and Secure Digital (SD) cards.

metering To measure the available light for an exposure.

Mirror lock-up A setting used to reduce vibration before taking the photograph, and for sensor cleaning.

monochrome Of one color, such as grayscale, or other singular tone, such as sepia.

multiple exposures A camera feature that enables successive exposures and combines them into one final photograph.

nanometer One billionth of a meter.

neutral density filter A gray filter that allows for a more balanced and even exposure of the overall photograph by reducing the amount of light entering the camera.

noise Undesirable grain in a digital photograph that is a result of low light conditions, long exposures, or high ISO.

noise reduction Software applications or technology within a digital camera that reduce the amount of noise in a digital image.

opacity A term meaning by which a layer's transparency can be increased or decreased.

overexposure The point at which too much light reaches the camera sensor and the image becomes washed out or loses detail.

panorama A wide, scenic view that can be produced by stitching together several images.

Photomerge A Photoshop tool designed to combine multiple images into a panorama.

Photoshop Software application for editing, optimizing, and creatively enhancing images.

plug-ins Software add-ons designed to work with Photoshop and any other imaging program that follows the compatible standards and is used to creatively alter or enhance digital images.

polarizing filter A filter that results in the reduction of glare and reflection on various surfaces, such as water or glass.

PSD The file format for a Photoshop document; can be saved as a layered file.

R72 filter A commonly used IR filter and a term used to describe Hoya-branded IR filters, often threaded to fit a specific lens size that allows IR light to pass through the lens and reach the camera sensor.

RAW The file format used by many photographers that provides all the information captured by the camera. This format allows the most flexibility in post-processing.

reflector A panel designed to reflect light toward the subject; usually silver or gold coated.

rule of thirds A compositional rule that states that images can be divided into nine equal parts. When important compositional elements are placed at intersecting points, they create images with strength and impact.

saturation The intensity of color in an image. High saturation provides intense color; lowering the saturation 100 percent results in a grayscale image.

shadow The darkest part of an image.

shutter Movable blades or a curtain that controls the time that light can reach the camera sensor.

shutter speed The exposure time for a photograph. Different shutter speeds can be used for creative effects. For example, a long shutter speed blurs waterfalls, and a fast shutter speed freezes action.

side lighting The direction in which light strikes the subject from the side, creating visually interesting textures and shadows.

SLR Single lens reflex camera, also dSLR (digital SLR).

specular highlights The areas within an image that are bright spots created by the reflection of light sources.

thermal infrared Long wavelengths in the mid to far IR range that represent heat.

TIFF Tagged Image File Format. The universal image file format that uses lossless compression.

tone-mapping Image-processing technique designed for photographs created with HDR (High Dynamic Range).

tripod A stand with three legs used for stabilizing the camera.

tripod head A device that attaches the digital camera to the tripod. A variety of tripod heads are available, such as ballheads, panning heads, and gimball heads.

underexposure The point at which not enough light reaches the camera sensor and the resultant image is too dark.

vibration reduction Technology used by Nikon for its lenses that reduce vibration; also called *image stabilization* by Canon, or Anti-Shake by others.

white balance A digital camera adjustment that accommodates the temperature of the light source. Custom white balance settings can be made for digital IR photography.

zoom lens A lens that allows the photographer to use variable focal lengths; examples are wide-angle zoom lenses and telephoto zoom lenses.

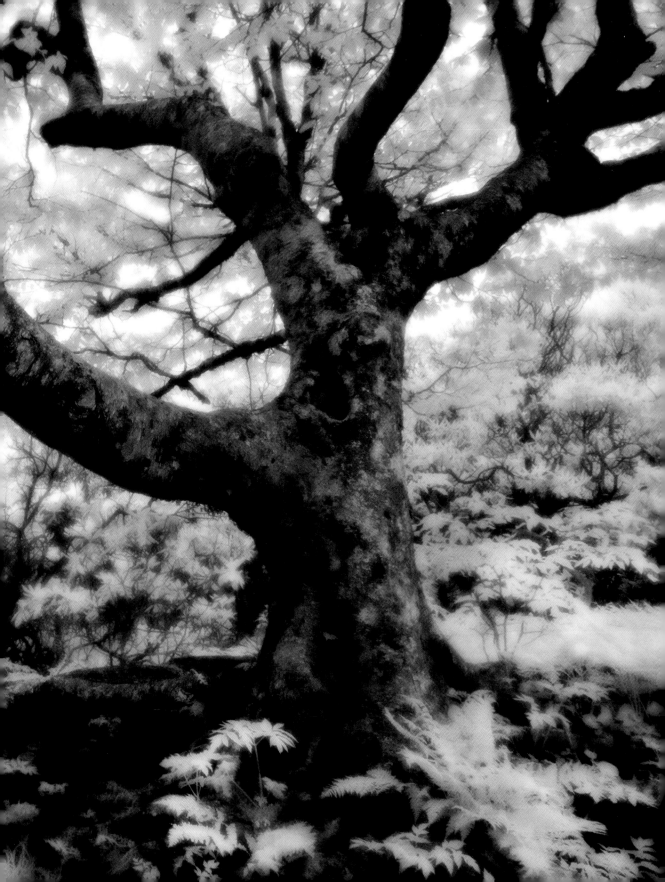

continued

Develop your talent.

Go behind the lens with Wiley's Photo Workshop series, and learn how to shoot great photos from the start! Each full-color book provides clear instructions, sample photos, and end-of-chapter assignments that you can upload to pwsbooks.com for input from others.

978-0-470-11433-9

978-0-470-11876-4

978-0-470-11436-0

978-0-470-14785-6

978-0-470-11435-3

978-0-470-11955-6

978-0-470-421932

978-0-470-11434-6

978-0-470-41299-2

978-0-470-11432-2

978-0-470-40521-5

For a complete list of Photo Workshop books, visit photoworkshop.com — the online resource committed to providing an education in photography, where the quest for knowledge is fueled by inspiration.

Available wherever books are sold.

WILEY
Now you know.